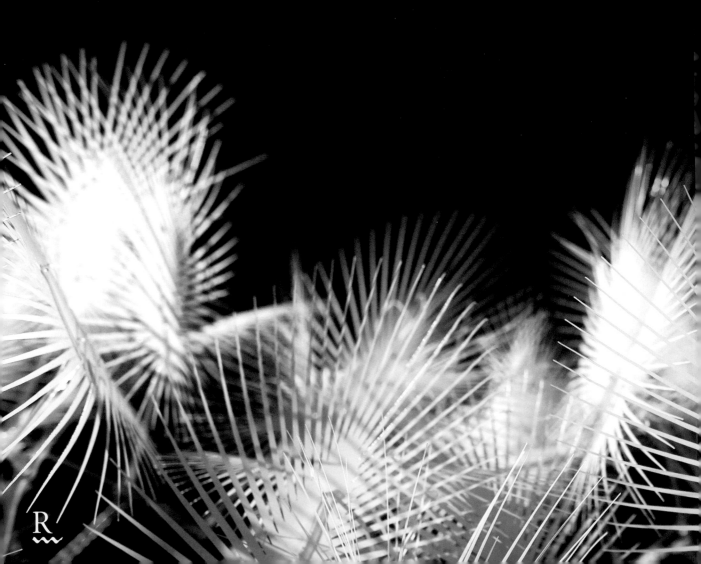

contributions by Rob Gorbet
Michelle Addington
Rachel Armstrong
William Elsworthy
Eric Haldenby
Jonah Humphrey
Christian Joakim
Geoff Manaugh
Detlef Mertins
Neil Spiller
Cary Wolfe

edited by Pernilla Ohrstedt & Hayley Isaacs

HYLOZOIC GROUND

LIMINAL RESPONSIVE ARCHITECTURE

PHILIP BEESLEY

RIVERSIDE ARCHITECTURAL PRESS

Published by Riverside Architectural Press
www.riversidearchitecturalpress.com

Library and Archives Canada Cataloguing in Publication

Hylozoic Ground : liminal responsive architecture : Philip Beesley /
contributions by Rob Gorbet ... [et al.] ; edited by Pernilla Ohrstedt & Hayley Isaacs.

Includes bibliographical references.

ISBN 978-1-926724-02-7

1 Beesley, Philip, 1956- --Exhibitions.
2 Kinetic sculpture--Canada--Exhibitions.
3 Interactive art--Canada--Exhibitions.
4 Geotextiles--Canada--Exhibitions.
5 Art and architecture--Canada--Exhibitions.
6 Sculpture, Canadian--21st century--Exhibitions.

I. Gorbet, Rob II. Ohrstedt, Pernilla, 1980- III. Isaacs, Hayley, 1980- IV. Beesley, Philip, 1956-

NB1272.H85 2010 735'.230473 C2010-903638-7

Publication Design and Production PBAI
Art Director Hayley Isaacs
Graphic Designers Eric Bury, Carlos Carrillo Duran, Elie Nehme, Adam Schwartzentruber, Jonathan Tyrrell
Copy Editor Robin Paxton

Printing by Regal Printing Limited
This book is set in Zurich Lt BT and Garamond

Hylozoic Ground, Canada's entry to the Biennale di Venezia 12th International Architecture Exhibition, is part of a series of collaborative installations that have developed during the past four years. This work extends landscape and gallery installations that began in Rome during 1995. The first of the Hylozoic series was commissioned for the Langlois Foundation's e-art exhibition at the Montreal Museum of Fine Art in 2007–8. Early versions were installed in 2008–9, at the VIDA 11.0 festival in Madrid, and at Ars Electronica's Museum of the Future in Linz. An expanded version employing modular meshwork elements and suspended lower filter strata was developed for SIGGRAPH 2009 in New Orleans, and was subsequently mounted at Medialab Enschede in the fall of 2009. Preliminary portions of the 2010 Venice Biennale installation were installed earlier this year at Recto-Verso's Meduse facility in Quebec City, and at the Laboratorio Arte Alameda for the Festival de Mexico, Mexico City.

The project documented within this book was developed with research colleagues from Toronto, Waterloo, London, and Odense, supported by volunteer teams mounting work in Mexico City, Quebec City, Enschede, New Orleans, Madrid, Linz, and Montreal. The work is developed by a collective of designers, engineers, and contributors associated with the School of Architecture and the Faculty of Engineering at the University of Waterloo, and is manufactured by digital fabrication within the PBAI studio.

Key individuals include associates Hayley Isaacs, Eric Bury, and Jonathan Tyrrell, principal collaborator Rob Gorbet and the Waterloo-based Gorbet lab, and experimental designer Rachel Armstrong. The team for the Venice Hylozoic Ground project includes production director Pernilla Ohrstedt, promotion team Poet Farrell and Sascha Hastings, designers Carlos Carillo Duran, Federica Pianta, Carlo Luigi Pasini, and Adam Schwartzentruber, and engineers Brandon DeHart and Andre Hladio. Over 1500 students and professionals have taken part in the conception and assembly of the Hylozoic series.

Profound thanks are due to Hayley Isaacs, Pernilla Ohrstedt, and the members of the PBAI studio for their primary roles in creating and shaping this book. This book has been enriched by the texts of collaborators Rob Gorbet and Rachel Armstrong, writings by Michelle Addington, Geoff Manaugh, Detlef Mertins, Neil Spiller, and Cary Wolfe and photography by Pierre Charron. Will Elsworthy, Jonah Humphrey, and Christian Joakim's detailed texts reflect their direct roles within early generations of the design work. Meticulous copy editing was contributed by Robin Paxton-Beesley.

The support of the Canada Council for the Arts, Royal Architecture Institute of Canada and RAIC Foundation, National Gallery of Canada, and University of Waterloo, as well as that of numerous agencies and funding partners, is gratefully acknowledged. Deepest appreciation is extended to the generous individual, institutional, corporate, and public supporters who have made this work possible.

The lives and personal histories of my beloved partner Anne Ogilvie Paxton, my children Robin, Alex, Tommy, Olivia, and Michael, my parents Birgitt Traute Popper Beesley and Pierre Michel Beesley, are intertwined in this work.

This book is dedicated to Dr. Thomas Seebohm.

Philip Beesley
Cambridge, Toronto, and Venice, 2010

In presenting Hylozoic Ground at la Biennale di Venezia 12th International Architecture Exhibition Canadian architecture shows itself to be at the limits of the field—exploring the boundaries between environment, building, technology, and human experience. The roots of the work lie in Professor Beesley's research during his Prix de Rome fellowship. The University of Waterloo's Rome Program has provided fundamental support for the evolution of this work. The Hylozoic Ground project is deeply rooted in the Italian soil, and presents rich evidence that the architecture of Rome and Italy continue to offer inspiration and renewal to contemporary architecture. By questioning what the nature of architecture could be, Hylozoic Ground proposes vivid possibilities for a renewed responsive relationship between humanity and the built environment.

Eric Haldenby
O'Donovan Director, School of Architecture, University of Waterloo

Philip Beesley's interactive installations—part creatures, part environments; part mechanical, part biological—remind us that the cosmological point of reference for architecture has shifted from the human to the non-human: from the Vitruvian man, inscribed in a circle and a square as the guarantor of universal validity, to the tangled web of creatures and environments within which humanity lives a promiscuous life. Following Leon Battista Alberti's counsel that architects emulate nature's methods of construction and production of unity, the 'organic' became an unattainable ideal that drove restless invention.

While beauty was typically the hallmark of this classically conceived nature, its myriad others—the picturesque, sublime, grotesque, and ugly—attended the various Gothic revivals. Art Nouveau, and even more so its German counterpart Jugendstil, often ventured into terrifying territories beyond rationality, sending the observer into the fluid spaces of the unconscious, ominous emotions and deep yearnings—above all the yearning for re-integration into the primal soup of creation. Yet it is precisely this yearning, Beesley's constructions remind us, that is the most problematic.

In an age when genetic engineering works invisibly to the human eye, Beesley's Hylozoic Ground is emphatically constructed and, in fact, anachronistic in its reliance on mechanical technologies of assembly that the early twentieth century had already sought to supersede with the then-new science of bionics. The appearance of the mechanical here, in structures that move (sometimes fitfully) and nervous systems that breathe (sometimes convulsively) should remind us, not of the supposed authority of biomorphic forms, but rather of nature's inclusiveness. For humanity never was divorced from nature, nor were any of its creations. We must, finally, learn to think without this opposition, recognizing that, warts and all, we have always been part of nature. The technologies of life being developed today offer no more guarantee of value than those of old. Beesley's architecture leads us to recognize the organic/non-organic opposition as a version of 'good versus bad,' and invites us to explore other, more dexterous and effective terms of judgment.

Detlef Mertins
Professor of Architecture, University of Pennsylvania

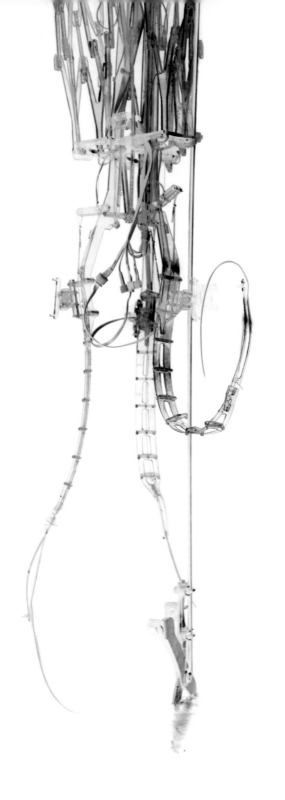

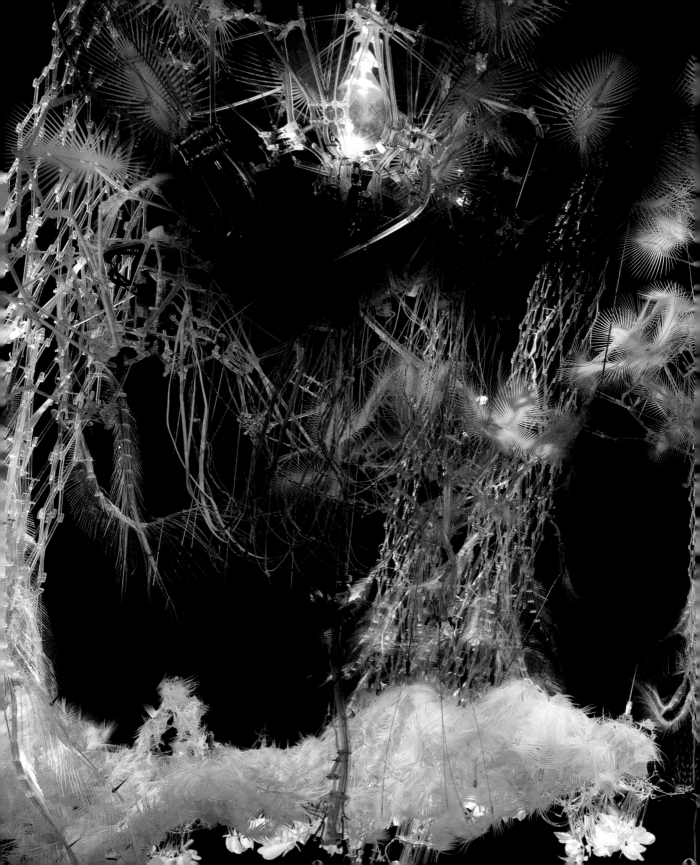

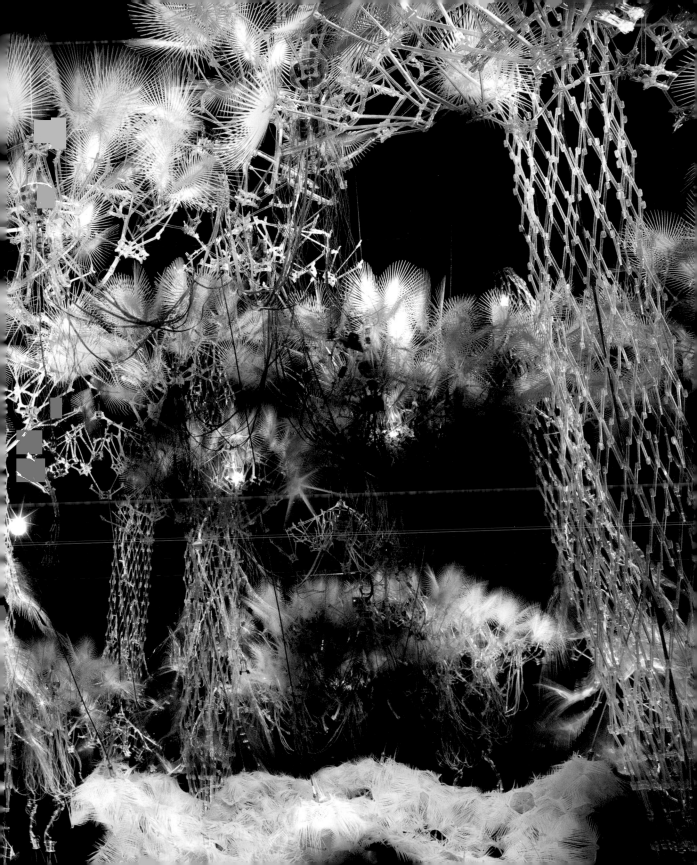

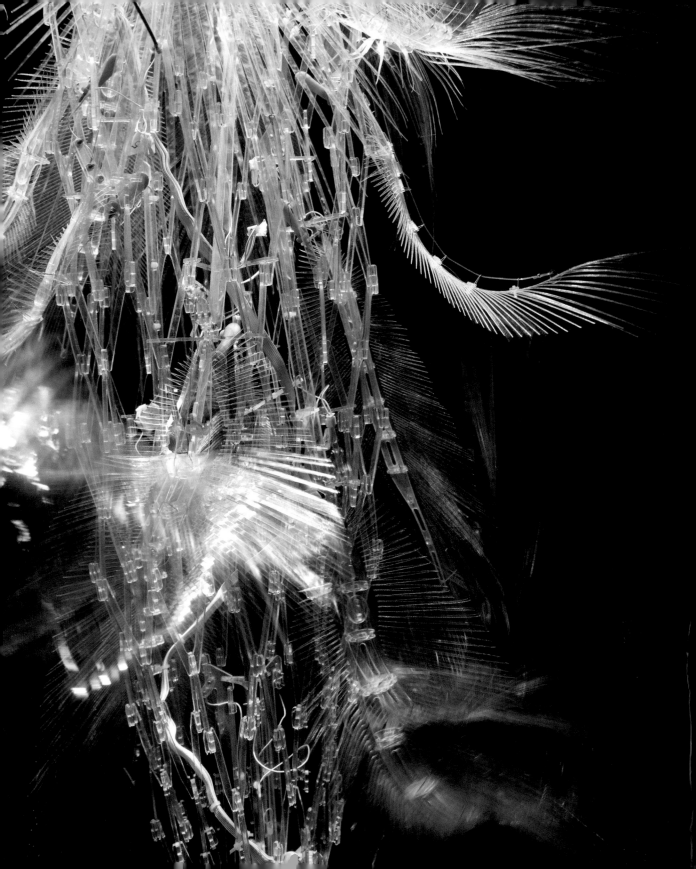

Introduction
Liminal Responsive Architecture

PHILIP BEESLEY

"Words and tones, since they can hurt, are no doubt made of material stuff"
Titus Lucretius Carus, *De Rerum Natura*

When Lucretius watched motes of dust quivering and darting within the sunbeams of his Roman window, he saw atoms play. Rivers of motion took the particles in laminar flows, bringing degrees of certainty into the sight of barely tangible things. Darting and wavering, the dust spoke of decay and loss; possibility; specious circumstance in flux: corrupted, damaged, and dying swerves. And a vague, shaded shift of life arising too—the rising semiquaver of living seeds. This quickening leads into the earth.

The Hylozoic project seeks abject fertility. In the footsteps of Lucretius, it imagines new layers of hylozoic soil. Hylozoism is the ancient perception of life arising out of material. Lucretius followed earlier, Grecian thinkers in seeing life arising from the chaos-borne quickening of air, water, and stone.

facing page

1 Detail of breathing column.
Hylozoic Soil, "(in)posición dinámica,"
Festival de Mexico, Laboratorio Arte
Alameda/Ars Electronica México,
Mexico City, 2010

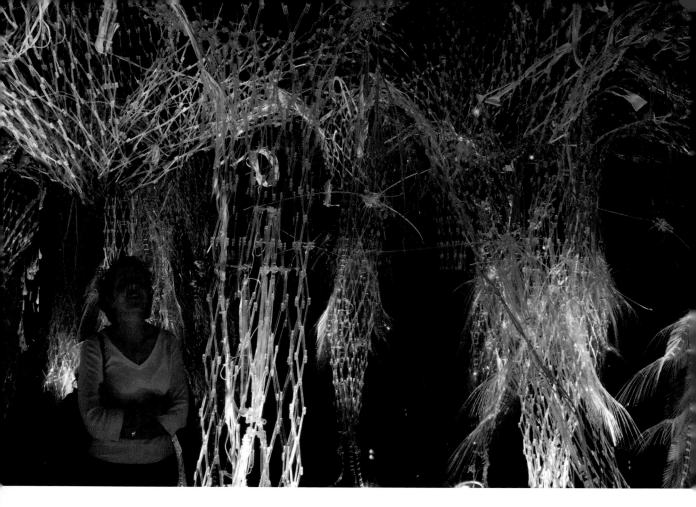

Hylozoic Ground is an immersive, interactive sculpture environment organized as a textile matrix supporting responsive actions, dynamic material exchanges, and 'living' technologies—conceived as the first stages of self-renewing functions that might take root within this architecture. The Hylozoic Ground environment can be described as a suspended geotextile,[2] gradually accumulating hybrid soil from ingredients drawn from its surroundings.

Akin to the functions of a living system, embedded machine intelligence allows human interaction to trigger breathing, caressing, and swallowing motions and hybrid metabolic exchanges.[3] These empathic motions ripple out from hives of kinetic valves and pores in peristaltic waves, creating a diffuse pumping that pulls air, moisture, and stray organic matter through the filtering Hylozoic membranes.

2 A civil engineering material which provides temporary earthen support for landscapes that will eventually be taken over by organic growth.

3 Lucretius dwelt also on measurement of this flux. His writing speaks of an approximate geometry within curves shearing away from lines, calibrated within the infinitesimally small angle called clinamen. A clinamen is the angle that occurs when a straight line meets the tangent of an arc. Hylozoic Ground employs the conceptual terrain of the clinamen as a launch into the realm of hyperbolic forms.

PHILIP BEESLEY

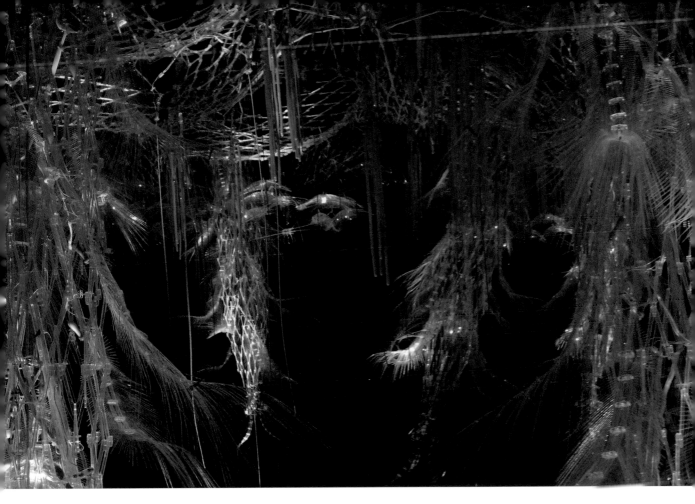

4 Immersive environment.
 Hylozoic Soil, "e-art
 Communication Vessels,"
 Montreal Museum of Fine Arts,
 Montreal, 2007.

A distributed array of proximity sensors activates these primitive responsive devices, stirring the air in thickened areas of the matrix. Dense groves of frond-like 'breathing' pores, tongues, and thickets of twitching whiskers are organized in spiralling rows that curl in and around its mesh surfaces. A trickling water source connects the matrix to the Venice lagoon.

The structural core of the Hylozoic environment is a flexible meshwork skeleton of transparent, lily-shaped ribbed vaults and basket-like columns. The meshwork stretches and billows, creating a hyperbolic grid-shell topology that surrounds occupants in the space. It is assembled from small acrylic chevron-shaped tiles that clip together to form a pleated diagrid textile structure. Columnar elements extend out from this membrane, reaching upward and downward to create tapered suspension and mounting points.

LIMINAL RESPONSIVE ARCHITECTURE

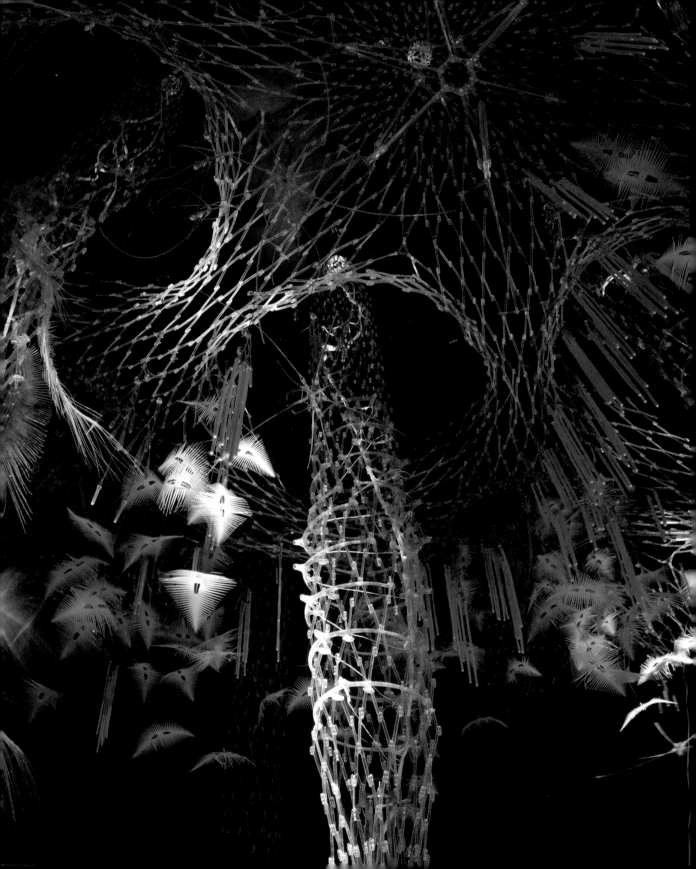

Tension rods support the scaffold with toothed clamps that bite into the ceiling and floor surfaces.

Pure, distilled spheres and pyramids from Plato's cosmology might hover as ghosts that inform this environment, but that family of reductive crystal forms does not govern. Far from transcendent perfection, the formwork that organizes the space boils out of local circumstance. As with the fabric that emerges from the steady cadence of knitting or crocheting, the chevron links are combined in repeating rows, and their numbers tend to drift and bifurcate. Adding links within linked rows crowds the surface, producing warped and reticulated surfaces that expand outwards in three dimensions.

Similarly, the linking systems that form scaffolds for the filtering systems use a tessellated geometry of self-healing hexagonal and rhombic arrays that readily accommodate tears and breaks within their fabrics. In opposition to design principles of the past century that favoured optimal equations where maximum volume might be enclosed by the minimum possible surface, the structures in Hylozoic Ground prefer diffuse, deeply reticulated skins.[5] These forms turn away from the minimum surface exposures of pure spheres and cubes as they seek to increase their exposure and interchange with the atmosphere.[6]

Although the surface topologies of these forms are generous, their material consumption is reduced to a minimum by employing form-finding design methods, textile systems, and tensile forces. Strategies include the use of thin tensile component arrays with floating compression elements within interlinked fields of tension fibres. Three-dimensional forms are derived from thin, two-dimensional sheets of material, organized in nested tessellations to nearly eliminate waste during digital fabrication. In pursuit of resonant, vulnerable physical presence, components use materials stretched near to the point of individual collapse. The space formed from these materials expands a thousand-fold, filling the volume of the containing building.[7]

The responsive devices fitted into the expanded Hylozoic topology function similarly to pores and hair follicles within the epithelial skin layers of an organism. Breathing pores are composed of thin sheets shaped into outward-branching serrated membranes, each containing flexible acrylic tongue stiffeners fitted with monofilament tendons. The tendons pull along

5 The geometries of this system are 'quasiperiodic,' combining rigid repetition with corrupted inclusions and drift. A tiling system invented by the contemporary British physicist Roger Penrose, based on multiple angles following the ten-way division of a circle, alternates with close-packed regular hexagonal geometry.

6 Such lavish exfoliation has borne disapproval in twentieth-century design education. Perhaps inflected by mid-century cold war preoccupations, North American design has tended to equate energy conservation with heat retention and has prioritized resistance and inert barriers. Reticulated surfaces, despite their inherent ability to foster free cooling and heating through increased energy exchanges with their surroundings, have often been judged excessive and wasteful. The American engineer Buckminster Fuller's 1975 opus Synergetics: Explorations in the Geometry of Thinking exemplifies this view.

7 Some twenty cubic feet of acrylic and elastic polymers, two hundred pounds of copper wire and glass, aluminum sheeting, and handfuls of specialized alloys were expended in the Venice installation.

facing page

8 View of hyperbolic meshwork canopy. Hylozoic Soil, "VIDA 11.0," Matadero, Madrid, 2009.

LIMINAL RESPONSIVE ARCHITECTURE

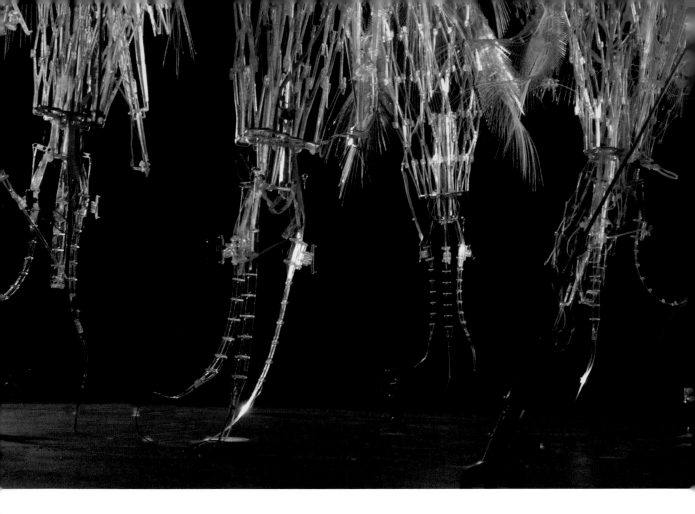

the surface of each tongue, producing upward curling motions that sweep through the surrounding air. Sensor lashes, carried by the lower tips of meshwork columns, are cousins of the breathing pore. These are fitted with a fleshy latex membrane and offer cupping, pulling motions.

A further kind of swallowing actuator is fitted inside the meshwork columns. Its chained air muscles are organized in a segmented radial system to produce expanding and contracting movements, causing convulsive waves in their surrounding halo of hooked whiskers, while at the same time delivering an incremental siphoning transport of lagoon water within their cores. Wound-wire pendant whiskers are supported by acrylic outriggers with rotating bearings. Tensile mounts for these tendrils encourage cascades of rippling and spinning movements that amplify swelling waves of motion within the mesh structure.

PHILIP BEESLEY

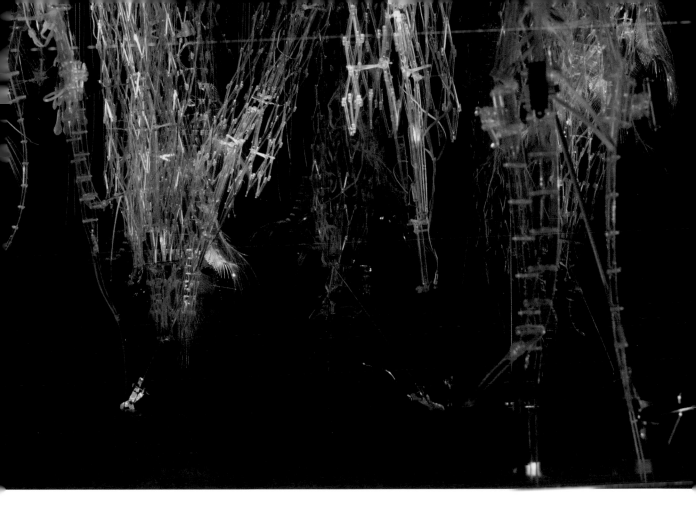

9 Sensor lash assemblies.
Hylozoic Soil, "e-art:
Communication Vessels,"
Montreal Museum of Fine Arts,
Montreal, 2007.

Dozens of sensors that detect the presence of visitors through changes in space, light, and touch are spread throughout the Hylozoic environment. They function like the space-reading sonar employed by dolphins and bats and feed impulses into an embedded network of microcontrollers, working in concert with and guiding device movements.

Interactive processing is based on the open-source Arduino microcontroller system. This palm-sized board can read sensors, make simple decisions, and control devices. The boards used in Hylozoic Ground carry extensions that provide communication, power outputs, and mode switches, together supporting the emergence of different behaviours. Levels of behaviour organized by local clusters, neighbourhood groups, and global systems are programmed into the sculpture in order to encourage coordinated spatial

behaviour. Each processor produces its own response to local sensor activity and listens for messages from neighbours. Background behaviours akin to pre-conscious muscular reflexes are produced in the environment using these encoded responses. Controllers hold information about sensor activity from individual boards and catalyze 'global' behaviour with this information.

Alongside mechanized component systems, a wet system has been introduced into the environment, with bladder clusters surrounded by thickened vapours. The system supports simple chemical exchanges that share some of the properties of life-giving blood in living organisms. Thousands of primitive glands containing synthetic digestive liquids and salts are clustered throughout the system, located at the base of each breathing pore and within suspended colonies of whiskers and trapping burrs. The salt derivatives serve a hygroscopic function, pulling fluids out of the surrounding environment.

The adaptive chemistries within the wet system capture traces of carbon from the vaporous surroundings and build delicate structural scaffolds. Engineered *protocells* and *chells*—liquid-supported artificial cells that share some of the characteristics of natural living cells—are arranged in a series of embedded incubator flasks. Bursts of light and vibration, created by the responses of visitors standing within the work, influence the growth of the protocells, catalyzing the formation of vesicles and inducing secondary deposits of benign materials. Sensors monitor the health of the growing flasks and give feedback that governs the behaviour of the interactive system surrounding the viewer. The flux of viscous, humid atmospheres creates a hybrid expanded protoplasm with constantly changing boundaries.

soil and protoplasm

Can soil be constructed? Work in previous decades began in this pursuit of the chthonian, the deep underground. The recent geotextile forms that prevail in Hylozoic Ground extend this pursuit, making synthetic earth.

Design paradigms for shelter built upon the solid, eternal ground of a Canadian wilderness render the task for architecture relatively simple.[10] Springing from foundations secured by the cardinal powers of the earth, one of the primary tasks of a building envelope might be rendering the outer world as vividly as possible, consuming the environment and serving my outward-seeking gaze in acute encounter. A functional definition of this architecture could describe

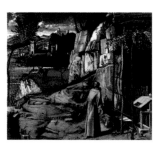

10 A compelling example is the
lattice-work shelter that supports
St. Francis in Giovanni Bellini's 1480–
85 St. Francis in Ecstasy, amongst
countless other 'primitive huts' that
speak to the origins of architecture in
cultural history.

11 "Global Biodiversity Outlook 3," published by the United Nations Secretariat of the Convention on Biodiversity (2010), is a recent report identifying logarithmic acceleration of biodiversity erosion in the twentieth century, marking a third phase within the Holocene or Sixth great extinction.

12 Haystack Veil, Philip Beesley, Warren Seelig, and Haystack Mountain School for Craft students, Deer Isle, Maine, 1997. Erratics Net, Philip Beesley and Dalhousie University students with Caroline Munk, Peggy's Cove, Nova Scotia, 1998.

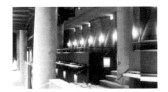

13 York University Student Centre, A. J. Diamond, Donald Schmitt & Co., Toronto, 1989.

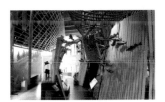

14 Interior French River Visitor Centre Gallery, Philip Beesley Architect Inc. and Baird Sampson Neuert Architects, French River, 2004.

15 Responsive Envelope Prototype System, North House, Team North, Washington, 2009.

building envelopes as filters that enclose human bodies and draw the environment inward and outward, sheltering the interior and amplifying the experience of the surrounding world.

The great extinction that occupies current human culture has swept away celebration of such transcendent, eternal qualities.[11] If I stand on the floating piers of the Venice lagoon, amidst a withering biosphere, my posture shifts. The ground is yawning, viscous, inducing queasy vertigo. My legs unconsciously tense themselves, reptile brain–inflected posture tensed by the elastic meniscus underfoot. The shift of my own posture inverts a confident gaze, sending it outward. The enclosing function of architecture shifts from consuming the surroundings. A renewed task appears: constructing synthetic ground.

Geotextile systems seen in installations such as *Haystack Veil* at Deer Isle, 1997, and *Erratics Net*, Peggy's Cove, 1998, pursued methodical expansion of landscape surfaces, building hybrid layers of artificial soil.[12] Earlier built projects, such as contributions to A. J. Diamond and Donald Schmitt's York University Student Centre,[13] also speak of nascent versions of this synthesis, folding and layering relatively thin planes of material, constructing hybrid depth. Recent buildings such as the Niagara Credit Union in Virgil, Ontario, and interior layers at the French River Visitor Centre[14] show a movement towards increasingly porous open space. In those buildings, hovering latticeworks of interlinking timber vaulting and dense constellations of material components offer expanded boundaries. Most recently, contributions to the North House project[15] include design of filtering active shades which work in distributed arrays. These design systems provide an expanded physiology akin to the layered envelopes created by nightdresses and bedclothes surrounding a sleeping body.

What ground, what soil, might support involved dwelling? Within Hylozoic Ground in Venice there lies a diffuse matrix, riddled with the ground. If, quickened by the humid Venetian microclimate and organic atmospheres blooming around human occupation, the vesicles and primitive glands crowding the Hylozoic Ground surface spoke, they might call and lure, voicing abject hunger. This matrix offers a map of a dissociated body moving to and fro across junctures of conception, disarticulating. This soil is pulling. Its environment seeks human presence as elemental food.

LIMINAL RESPONSIVE ARCHITECTURE

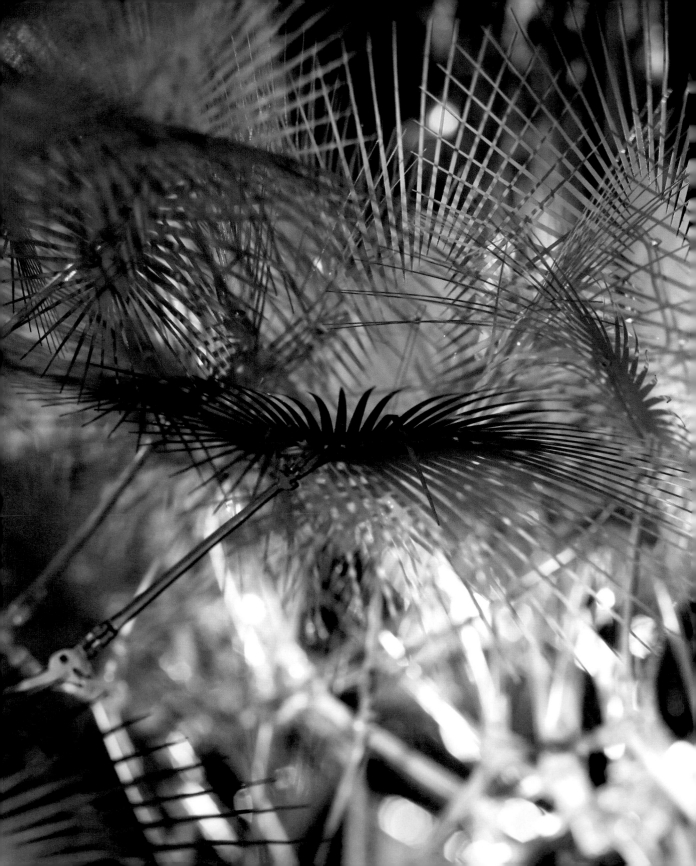

journal

The journal entries that follow correspond to various stages of development of the Hylozoic series. They loop in a series of wide aerial paths, tangent to Venice. The notes seek an orienting lexicon for the practical craft of working with protoplasmic space. These visualizations navigate weather-like formations of the atmosphere, layers of earth before condensation. The entries offer common threads that form a language rooted in generative formation and dissipation—a flux of dissemblance and figuration.[16]

The constructed fertility of the Hylozoic series claims material lying within the dark layers of soil that cloak the world, coming before the light-filled events of measured geography, and again before boundaries coalesced into smooth skinned spheres of bounded territory. Interlinking pools of vortices play within Pacific and Atlantic currents, forming surging necklaces that encircle the granite-bound landscape of the Canadian shield. The spiral pools are scored by glacial ice that cleared febrile soils, and even the salt-encrusted limestones that traced earlier lives in the Cambrian explosion. Barred, wrinkled hazes of cumulus and nimbus clouds hover in diffuse octaves that echo this liquid skin. Starved of metered focus, tinges of delirium blur these sightings. Pathways stretch through ripples, coalescing into bundled, gaseous rivers. I grasp faintly quivering traces, flame-licking tendrils projecting within the diffuse, slipping currents. What patterns am I printing within this field?

melt

Homogenous silence, marked by blurs and flecks. The dimension so vast as to measure time: an aeon of girth. Elephant-skin wrinkles, emerging from the smoothly ruffled surface of the massive depth of ice. At the edge, soaking in a million pits, the mass opening, revealing pitted subcutane, and then felted, porous liquid tendrils. At the edge, catastrophes: frozen tumbling fragments, continuous collapse. A minor sea collects in a shallow; accordioned shards of the sheet above, intermixing anew. Then failing: the phase yields into river. Cascade: infinitesimally slow torrent, rime of shards above the fresh water discharging to the ocean.

This is a landmass in reverse: not the fundament eroded by the shore, but a proto-ocean above as an upper land, turning like a sun into the open

16 Scholar Sarah Bonnemaison led me to George Didi-Huberman's Fra Angelico: Dissemblance & Figuration (Chicago 1995), which offers a nuanced bridge between materiality and transubstantiation.

facing page

17 Filter layer detail. Hylozoic Soil, "(in)posición dinámica," Festival de Mexico, Mexico City, 2010

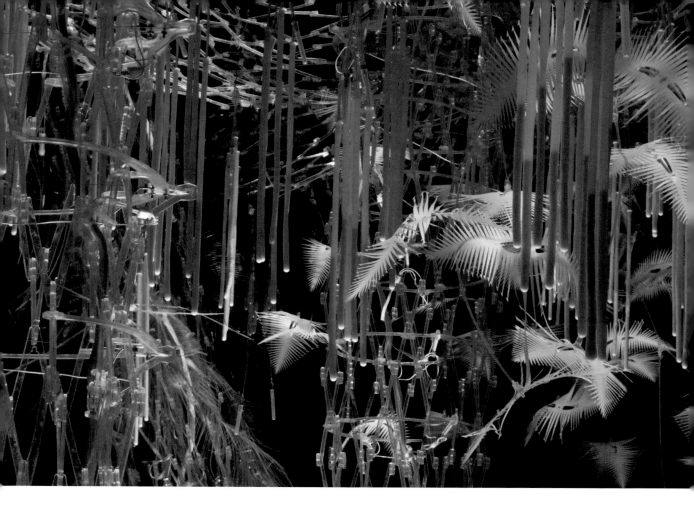

water outside. The land here seems like residue, effluent incident of the
melt. Ocean salt receives the freshwater: bright fissures of current, over-
lapping arcs of wrinkled pressures from the tide slowly pulsing toward the
land in counter-current to the melting. Then the sea begins, homogenous:
a miasma of swells, fissured by the transverse wind and second transverse
of rebounding coastal current. Cumulus drifts hover above, clustering into a
stratum that stands offshore, making a counter-coast, long dissolved fingers
casting shadow on the rippled water.

A new shore: a vast floating edge ends, revealing the preceding world as a
tableau. Trailing carcasses of thinning haze stream downward and stretch
off into entrails. A plunging gorge, edged by lapping swells that converge,
and marrow to heal the foot, bleeding into lower depths. This catastrophe is

PHILIP BEESLEY

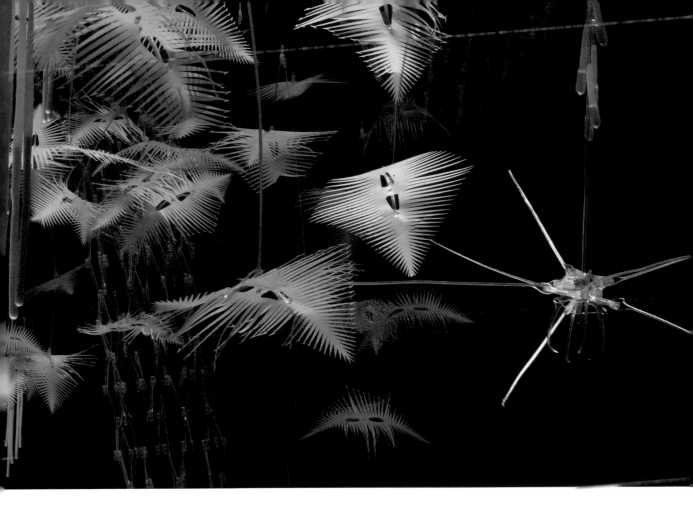

quickly cloaked by upper haze, engulfing me. Except for a string of plumes that orient me wide to my left, the field shifts to a single, hovering sphere reaching the pure horizon, sky against stratosphere, pronouncing the lensing flux of light at its furthest spherical tangent. Almost nothing, a suspension that plays me by deflection. That parsimony is stretched toward primal vagueness. Not lost, but delayed past recognition. Corrosion cloaked as leavened temperance: the quietest death.

Like finger-print wrinkles, clumping in repeated rolls, barrel-vault wrinkle oriented in a single meandering spread that shifts every few diameters, then reasserts itself. Cutting across, a twill chevron of cross-wrinkles searing across the whole, a ridge that grows in height, reverse fissures, becoming more turbulent as it merges, then collapsing upward into cumulus bursts

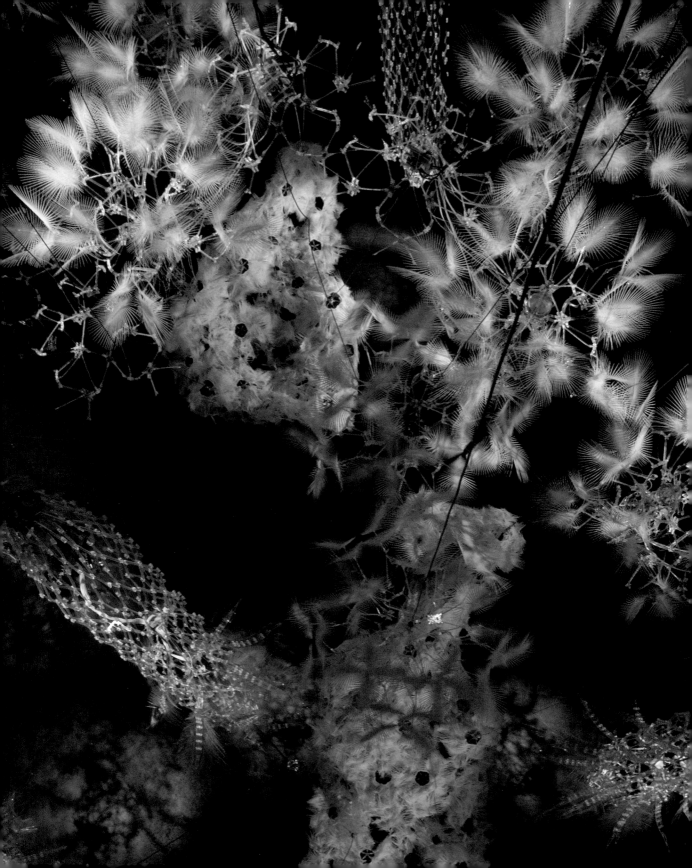

with entrail-quilted spicules and hydra-vortices shedding beside and behind. This thermal plumage is tiny, not the thunderhead I already know but instead tufts, follicles. Where is the *next*? Just ahead, one valley's length and then another. And another—skipping-stones' lengths, decelerating.

landfall

Similar wrinkles, but sharper and with tighter folds—like tulle or gauze, compared to the canvas lower down. Tufts here only singular, but marked by great outward swaths of rebound and counter-current that furrow the surface. Nipple and navel arrays, but then the reverse—ahead, a pitted skin with sinks and gentle whirlpool creases converging around, upholstered. Pigskin and orange peel alternating.

The drift coheres at landfall, resolving to corrugated cover and sheltered base. The fabric nap covers, approximately—gradient stretched between flickering surface of sea and quilted shore. Free-soldier trenchant barges plough up the middle of the strait. Tended cells arrayed along tight-lipped seams, tidied by the tightening cluster of attention at water's edge. Reaching inward, the cloud cover tightens its grain, first shifting to a dense stranded screen punctuated by fissures, then to wide banded rivers moving southeast, thrown into relief by the dawn light.

As the spread thickens further, the distinction of the warp-oriented main vectors blurs, fusing into broad ribbons interspersed with valleys. Slight shivers appear in the perpendicular axis, an oscillation recapitulating the chop of the dispersed veil that preceded it, now two hundred miles passed. Fusing again, toward an evenly spread, delicately wrinkled miasma of swells. One hundred miles more, and strains shadow the surface, reaching south and then south-west, arcing across the bias in a shuddering series of braided cross-currents. The seams reach deeper and suddenly cleave the surface, sending wide fjord-furrows out in repeating chatters of cross and parry. The breaks extend, each arcing back toward itself in a lagoon form, broken by its opposite arcing course reaching out and slowly dying in intensity, a string of vortices shed from the first cleavage.

Tidal river delta cut and banked, saturated with industry: mineral salts, ores, graded systems, riddled with access and irrigation and inventory controls.

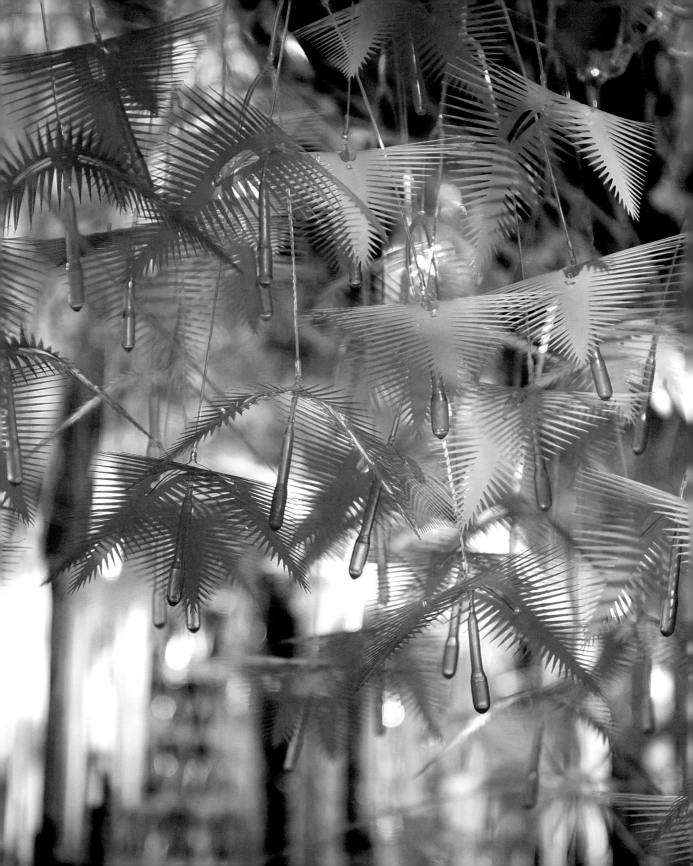

Beside the transport, a tidal marsh, racing outward fissure-like and then bounded again, beachheads running striated arms out into the ocean, long shallow subsidence fissured below by undersea valleys, and above by streaking sooty contrails. Dust layers above, rising into miasma at midlevel, rising to peacock blue in the atmosphere—a distinct, luminous lens, before I raise up again and lose myself in the lapis void above. The lighter blue, though—it gathers, thickened by light fluctuations in the mist that coalesce into the stuttering grain of cumuli, before hardening into the crystalline dewy grain of field and soil. Is this how gelatines are made? The colour is faint, gathering from hazy tan and gray-green field-webs. Gradually, shifting from soil to air: there is a middle zone that I pass over at first, racing into the brilliant blue in long horizon's reach. The furthest reach of all holds peacock blue glistening with clouded veils. Behind it again: only the 'further' of parallax, of beyond, of my birth. It whispers emerald green, more potent for its restraint, basest tincture amidst horizon blue.

tracking

Somewhat like this, I looked into the woods, standing on snow-crusted tracks that lead a mile in from washed-out bridge abutments. Alder saplings rising all around made a dense thicket, saturating the middle ground. Dotted in between are pines and cedar bushes, planted by the family a decade ago. In the snow just in front of mine, I saw rabbit and deer tracks clustered into a dense path, crossing and winding through the alder deep into the thicket on my right. I turned and looked, following the staccato clumps of rabbit paw racing, and deer hoof at measured pace. Folding out deeper, I saw the path lengthen and run past one alder clump, then another and another, overlapping tangles layering. Like tripping arpeggios, flittering in dashing ribbons threading down and in. It is that lengthening, darting further and further in a staccato rush, that I now wonder on: is it my skill in seeing the diminishing tracks, darting and reaching deeper? I see a tightly focused set of dashing stripes within a densely embroidered field: this mask includes, and excludes. The photograph of that scene shows only a clotted morass, path buried after only the immediate foreground, but I see; I am disposed to see. The springy trill of magnetic meniscus clumps lensing my named field: Track. Track. Track-track-track-track. Marionette, of my own ingrained rigging.

"Anima here is not a projection, but the projector. And our consciousness is the result of its prior psychic life. Anima thus becomes the primordial carrier of psyche, or the archetype of psyche itself." James Hillman, Anima: An Anatomy of a Personified Notion, Spring Publications (Dallas, 1985) p. 69.

facing page

20 Hylozoic Soil filter layer. Hylozoic Soil, "(in)posición dinámica," Festival de Mexico, Mexico City, 2010

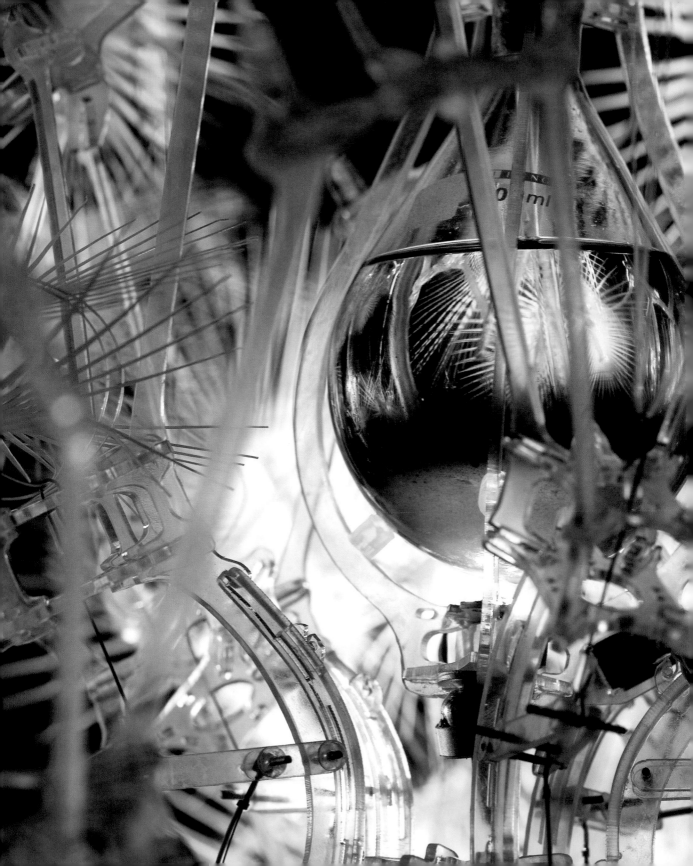

Reprogramming animal, limbic feeling-fountains with construction and optimism, the quickening of spring leavening the death embedded in present feelings. The lee housed the material that would carry the charge. Reprogrammable matrix, lemming-infants acting unhesitatingly. The habit of thinking positively, not as a leaden mask but as a buffered encapsulating sheath for the surging core. More directly, an interpretation gate: this means that we can make something of this, and that this thing is possible, and that the path that leads through there and there will not cause extinction, but salved opening. With emotional compass, seeking solution. With growth medium, where the pattern can hold.

Interrupted by upper-layer haze, thickening into the next skin. A circular rainbow accompanies my view. Centre: warm gold-pink, then blushing into rose, and cooling to violet and fading to pure blue indistinguishable from the surrounding bright sky above. Yet I see it as a shadow, marking the cloud field outward to green emerald, moving into yellow hue, and then into pink-orange in the centre. Again to red, and to violet, and outward into sky-blue. Yet again, elusively—the faint glow of green tinting the orb, moving toward yellow. When I see it, the arc asserts, streaming around. I turn around the whole and survey, answered by hints of hue—yellow, red-orange, violet outward in its condensing zone—outward again, octave-wise, measured from the cadence, and breath-whisper signal of hue in one zone, there at upper left, rippling outward with its accompanying inner tinges and echoed at sixty degrees to the right; four, five, six rings.

lagoon

Toward the Adriatic, I sweep over the field of clouds, furrowed in local and regional and national octaves, ocean swells enfolding molecular ripples and soviet clusters, sheared and torn by the strain of cross-current into shatters, gore hanging in thread. Shifting ahead into frozen crystal breaks whose cracking pattern marches for half the horizon and then softens into elastic rolls again, white meringue alternating. Drifting down my own membranes, darkened fragments of microorganisms float. My glasses fog slightly as the vessel turns into the light, carving the field with relief and searing through with prism shards, radian. Seeing the meniscus, blinded in pink and white, turning inward. Slow-shifting caustics and acids corroding soft-tissue wells; muscle sheath, cleavage-fissure working into cores running alongside bones,

" The construction of the painting is replaced by construction of the preconditions for the act of painting in the determinant of the action-field (of the space around the actor—the real objects present in his surroundings). The actual act of painting is freed from the compulsion of needing and having relics." Rudolf Schwarzkogler, Panorama Manifesto (1965), in Brus, Muehl, Nitsch, and Schwarzkogler, Writings of the Vienna Actionists, trans. Green, (London, 1999), p. 432.

facing page

21 Protocell detail. Hylozoic Soil, "(in)posición dinámica," Festival de Mexico, Mexico City, 2010

LIMINAL RESPONSIVE ARCHITECTURE

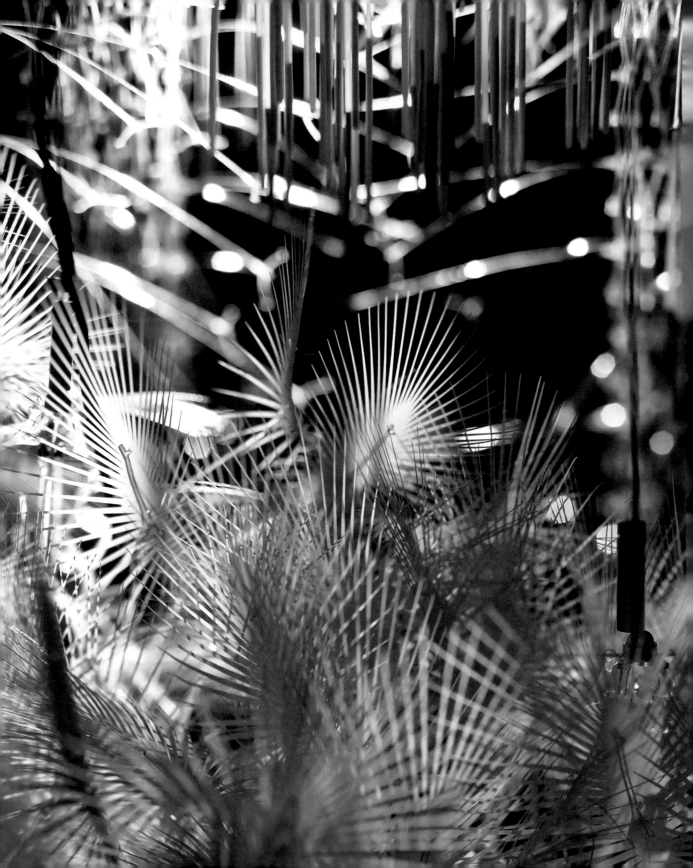

the relaxed eddies created by spaces in between sinews just before they intersect and plan—pools, cruelly, where collagen and might otherwise relax, recovering. In the lee of the joint. Not resolved for work like the resilient inner and outer pad layers between my vertebrae. Not resolved for birth, like the enriched ready-to-boil plasma of stem cell marrow. Taken unawares, dewy-saucer-eyed-cuddling-infant-throng-jelly-bubble matrix first irrigated with a tease of delight, then pulled void. Not resolved, but waiting interregnum.

The space that lies in the sheltered lee quietly rebounding just short of the pinching joint of two converging vectors, hollows where I might have paused to rest had I been a soldier. What am I seeing, and what am I projecting? Where do I look, and what is found? Pre-history tracks await in limbic brains, fissured to receive my gaze. Cutting and lurching to the front, in proud social *cognitium*: freezing, holding the view firm. Mine.

In those places lie dark pools. Out from the Lido, away from the sinking island. Reaching toward fertility.

LIMINAL RESPONSIVE ARCHITECTURE

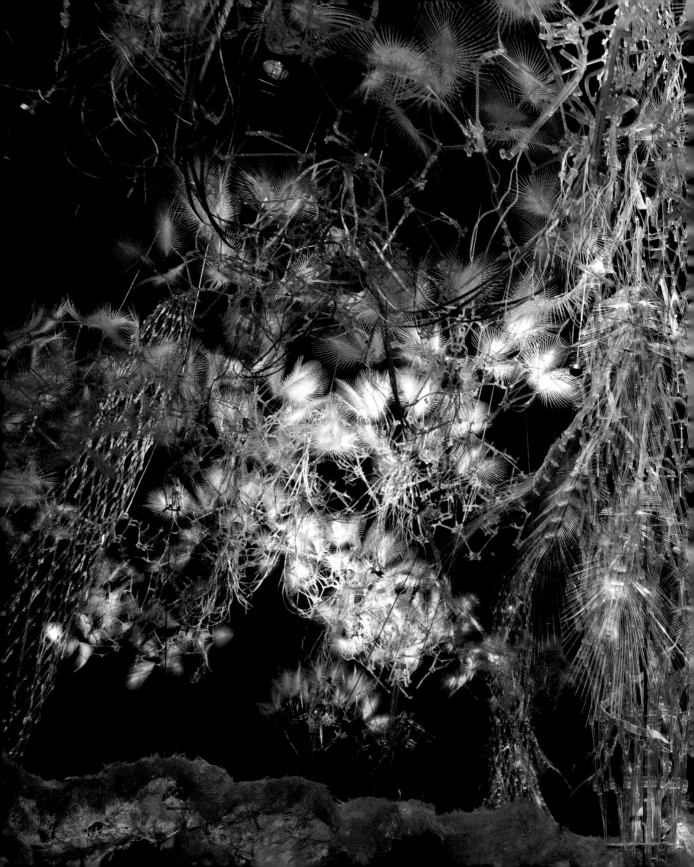

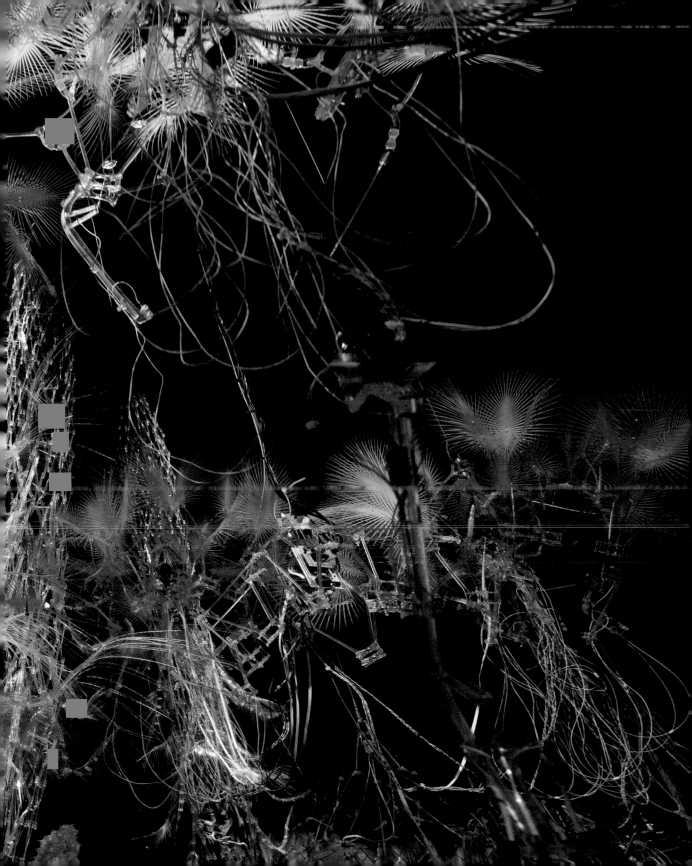

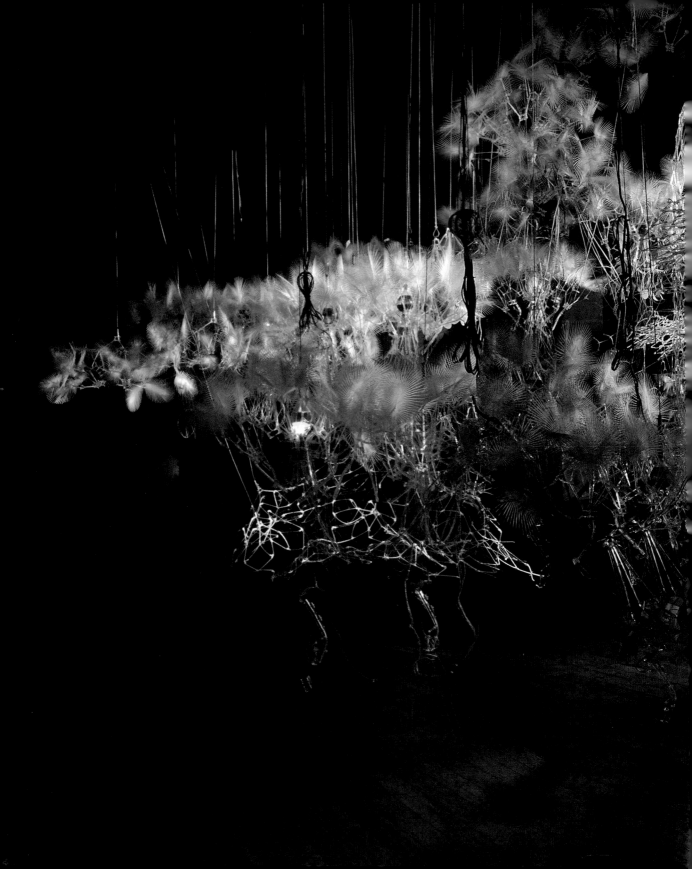

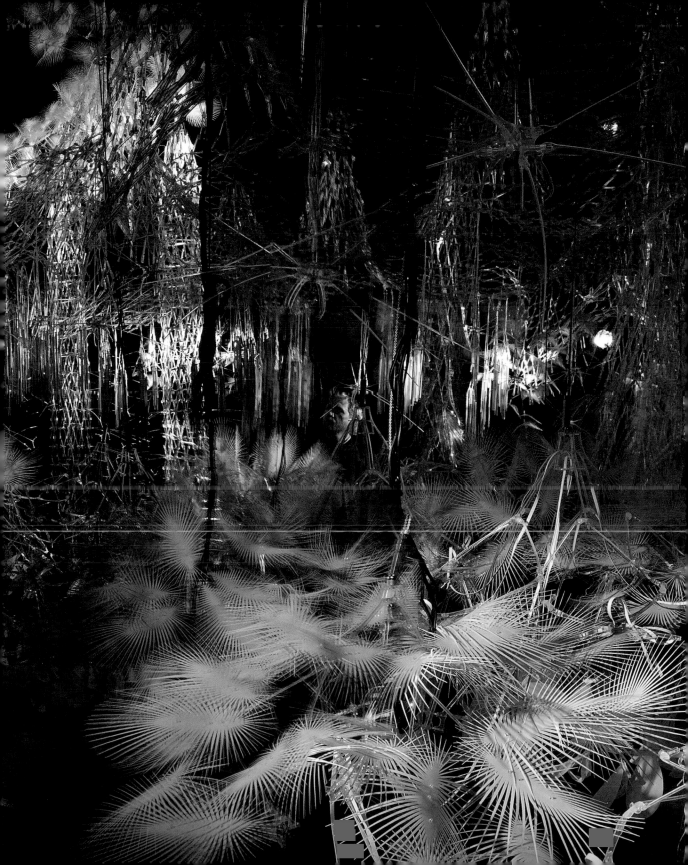

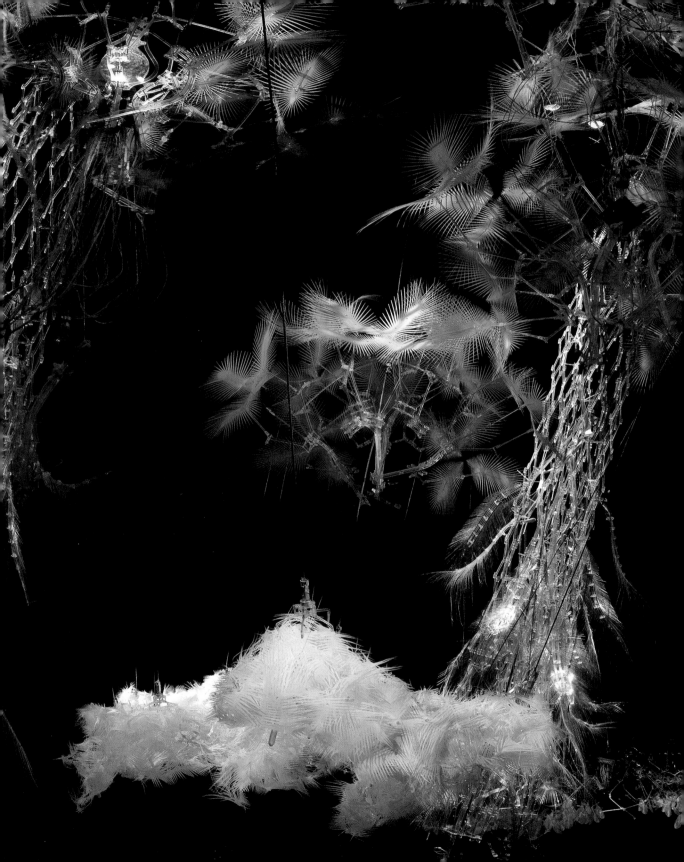

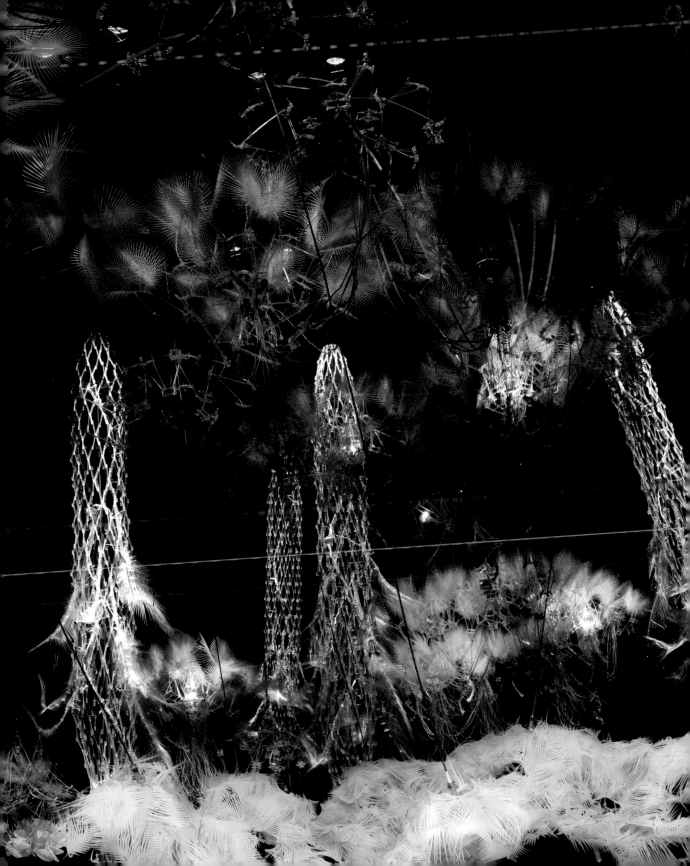

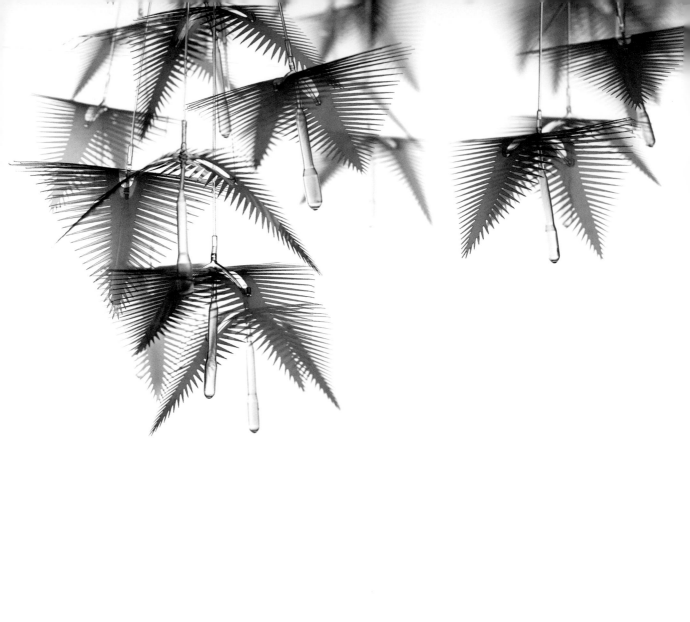

"The Tiber's shallow waters uncover the deposits of its turbulence. The sandbanks are stilled whirlpools, slightly stuck in a longer time. The hourglass, as if viscous, halts the flowing time. Rivers and turbulences, liquids and sand. Watch laminar layer of water brings a grain, an atom of sand with it. Time flows, water flows, sand flows, atoms fall...See the water scatter in drops, dissolve in thin air, evaporate, rush, in the clouds, the waves, the spindrift—there is not an atom missing since the world has been a world; liquid is not liquid, it is the most solid, most resistant, most permanent of beings in the world."

Michel Serres, Rome: The Book of Foundations

Synthetic Geology
Landscape Remediation in an Age of Benign Geotextiles

GEOFF MANAUGH

resurfacing the earth

Fresh Kills, located on Staten Island in the New York City archipelago, was once the world's largest landfill. Now, however, it is being ambitiously transformed into a public park (and subtly rebranded as Freshkills). In the process, Freshkills will be the most financially substantial park project in New York City in generations—and, when construction finishes in approximately 2028, it will be two and a half times the size of Central Park.

But Freshkills is also something of a geotechnical wonder. Creating healthy parkland from the ruins of buried household and municipal waste involves a complicated, layered intervention. Designed ecosystems, environmentally protective geotextiles, and soil remediation strategies are all being deployed, forming a thickly imbricated artificial stratigraphy that will take on the appearance of *nature*. "The mountain [at the center of this future park] was once a garbage pile," James Barron writes in the *New York Times*, describing this landscape to-come in a January 2010 article. "Now it has been sealed off with a plastic membrane and covered with a special kind of grass."[1]

1 James Barron, "Turning Trash Piles Into a Bird-Watcher's Paradise," The New York Times, January 25, 2010.

The local resurfacing of the Earth for the purpose of long-term environmental remediation at Freshkills has also been performed on two other landfills nearby. Turning to another article in the *New York Times*, we learn that two abandoned landfills in Brooklyn have become unlikely foundations for new, engineered ecosystems:

> In a $200 million project, the city's Department of Environmental Protection covered the Fountain Avenue Landfill and the neighboring Pennsylvania Avenue Landfill with a layer of plastic, then put down clean soil and planted 33,000 trees and shrubs at the two sites. The result is 400 acres of nature preserve, restoring native habitats that disappeared from New York City long ago.

"Once the plants take hold," the author adds, "nature will be allowed to take its course, evolving the land into microclimates."[2] Put another way, these terrestrial interventions—introducing acres of woven plastic textiles into the region's geology and cultivating specially chosen plant species—will even have effects on local climate.

2 Kenneth Chang, "A Wooded Prairie Springs From a Site Once Piled High With Garbage," The New York Times, September 6, 2009.

In all three cases, soil detoxification strategies are being layered on top of one another in a kind of geotechnical quarantine, keeping harmful substances at bay. But these new layers are also intended to act as an ecological

niche that will stimulate future flora and fauna that have yet to arrive in the landscape. Migratory birds, wildflowers, insects: these creatures will be welcomed as new residents of an almost entirely manufactured ecosystem whose very existence is predicated on its ability to process the harmful strata below. It is a beneficial artificiality.

In many ways, I'm reminded here of Philip Beesley's work—specifically, Beesley and collaborator Warren Seelig's early installation *Haystack Veil*,[3] a deep surface built from alder twigs, moss, and lichen. That sprawling matrix of wooden tripods gradually evolved into a labyrinth of warrens for wild animals. It became both ecosystem and maze, in other words, rotting back into the soil it once stood above, adding complex nutrients to the earth and becoming humus even as it was colonized by nonhuman species. The remains, still gathering moss as the installation falls apart in the coastal forests of Deer Isle, Maine, could be thought of as a synthetic soil: clumping, falling to the terrain below, and awaiting future germination by seeds. Interestingly, the decayed ruins of their project also have the potential to be excavated by archaeologists in one hundred, five hundred, or a thousand years' time, a designed artifact perfectly disguised as natural soil.

3 *Haystack Veil*, Philip Beesley, Warren Seelig, and Haystack Mountain School for Craft students, Deer Isle, Maine, 1997.

4 *Erratics Net*, Philip Beesley and Dalhousie University students with Caroline Munk, Peggy's Cove, Nova Scotia, 1998.

In an essay about Beesley's work, Christine Macy writes that "rather than stabilizing the earth beneath them as would a conventional geotextile," works like *Haystack Veil* and *Erratics Net*[4] actually helped to generate that very earth: that is, they "hovered just above the surface of the ground, catching airborne matter and creating a still zone at the surface of the earth in which fragile plant life might take root."[5] Beesley has compared this approach to the multi-layered surgical technologies of skin grafts—only in his work, carefully organized modules of organic matter are laminated on top of each other and structured into ecologically self-sufficient worlds.

5 Christine Macy, "Disintegrating Matter, Animating Fields," in **Kinetic Architectures & Geotextile Installations**, ed. Philip Beesley. Riverside Architectural Press (Cambridge, 2010).

Indeed, the biological potential of constructed surfaces is something we find throughout Beesley's oeuvre. He has been producing "benign geotextiles," he suggests, systems that can "shelter and accelerate plant growth. Captured large-scale organic matter fertilizes the system."[6] These "benign geotextiles" are like preparatory acts for a new layer of the planet—expanding the Earth with immersive surfaces as appropriate for installation in an art gallery as they would be at a site like Freshkills. (On the other hand, I am left wondering what exactly a 'malign geotextile' might be, how an architect

6 Philip Beesley, "Hungry Soil," in **Kinetic Architectures & Geotextile Installations**, Riverside Architectural Press (Cambridge, 2010).

could design one, and what would happen if a malign landscape installation were somehow to expand out of its creator's control—but that is a discussion for another forum.)

7 Philip Beesley, "Introduction," *Kinetic Architectures & Geotextile Installations*, Riverside Architectural Press (Cambridge, 2007).

8 Beesley 2010.

9 *Hungry Soil*, Philip Beesley. "ROMA XX," BCE Place Galleria, Toronto, 2000.

10 Beesley 2010.

In his introduction to the recent monograph *Kinetic Architectures & Geotextile Installations*, Beesley writes of how he and his collaborators are exploring "a transitional stage between non-living and living substance," a realm of self-organizing processes "constantly forming in nature by a process of disintegration of inorganic and organic matter."[7] This is more than just an abstract, theoretical concern; recounting a hike across the waterlogged soils north of Lake Superior, "where [the] humidity-thickened atmosphere was shot through with hanging moss and butterflies and where the ground was a succulent sponge, layer upon living layer,"[8] Beesley hypothesizes the existence of a "hybrid turf," something between landscape architecture and long-term terrestrial maturation. In this formulation, the designer becomes a participant in the climax of a local soil ecosystem—and Beesley's work, with titles like *Hylozoic Soil* and *Hungry Soil*,[9] acknowledges this openly.

The earth itself can even be thought of as a "thickened blanket,"[10] he adds, calling attention to the manufactured, textile-like qualities of finely-rooted, succulent Earth formations. Here, it is worth remembering that what we call 'soil' consists for the most part of finely broken-down fragments of loose rock, metabolized and processed through the digestive tracts of earthworms. Even Charles Darwin touched on this, focusing on the geological origins of soil in his 1881 book *The Formation of Vegetable Mould through the Action of Worms*.

It does not take much of a leap, however, to imagine some strange future version of this process, in which it is not worms creating our most verdant topsoil but monumental landscape installations by Philip Beesley.

soil machine

Beesley's work creates soil, then; his textile networks produce new earthly layers through decidedly unearthly means.

But the production of artificial terrain is not something new to human experience. It is not much of an exaggeration to say that any resurfacing of the planet—whether through agriculture, the extraction industries, or

urbanization—is coextensive with human activity. Anthropological stratigraphy surrounds us, from ancient sites being uncovered in the American southwest, to subway excavation work in London bumping into Roman ruins several metres below ground—let alone the politically controversial layering of the planet as seen in various contested cities in the Middle East.

In 1995–1996, Beesley himself spent time excavating an artificial terrestrial form, the Palatine Hill in Rome, helping to uncover the extent to which that structure is not a hill at all but something more like a massive building. It is an amorphous earthwork that would be comparable to the pyramids at Giza, were it not covered by two thousand years of human encrustation: buildings, basements, roads, and paths, a woven textile of human activity draped over the existing bedrock of a now-artificial mountain.

Beesley's experience with the manufactured landscape of Rome, its soil full of ruins, is a fascinating origin story for his interest in geotextiles and constructed strata. The idea that someday, excavators might uncover not just the arched ceiling of a forgotten temple or the foundations of a street lined with houses, but a massive geotechnical mat constructed several hundred years ago—still actively producing soil—is an astonishing scenario to consider.

Expanding on this idea of an archaeologically active, mechanical soil that operates *within* the surface of the Earth, Beesley describes one of his pieces:

> At first a bare latticework controlled by the geometry of its elements then increasingly formless and growing darker as it ingested decomposed matter. Thicker, and fertile, enveloping the wire implants and making a complete turf. This cover was finally dense, redolent with growth. And within that vital new earth, a convulsion glimmered—a poise telegraphing through from the sprung armature deep within.[11]

11 Philip Beesley, "Orgone Reef," Architectural Design 75 (4) July-August 2005.

This twitching soil brings to mind a peristaltic Earth prosthesis—something like the skin replacement therapies mentioned earlier: a convulsive xenograft, vivid and increasingly knit into the terrain it sits on, burrowing its matrix of root-devices into the planet below. Or perhaps it is a case of subterranean organ rejection, the planet attempting to push out these alien strata.

Either way, Beesley's work is less *art*, in any real sense, than a rogue branch of the planetary sciences.

GEOFF MANAUGH

peristaltic sex assembly

In a fascinating profile for *Mark* magazine, Terri Peters describes Beesley's recent work. Peters portrays the sculpture as a "lightweight landscape of moving, licking, breathing and swallowing geotextile mesh"[12]—a lattice of micro-mechanical nerve endings, "licking" and "swallowing" their immediate environs. To use the artist's own terms, this is "hungry soil," indeed. Beesley himself expands on this idea of ornamental eroticism, describing his *Implant Matrix* as an array of elements that interact with nearby humans through "subtle grasping and sucking motions...The interactive elements operate in chained, rolling swells, producing a billowing motion." This orgasmic pulse results in what Beesley calls "a diffuse peristaltic pumping that pulls air and organic matter through the occupied space."[13] Beesley's sculpture-spaces are "immersive theatre environments," Peters adds, in which "wheezing air pumps create an environment with no clear beginning or end."[14]

They are like new organs without bodies, throbbing in and out of rhythm in a serrated temporality of events without definable end or beginning. There are actors, plots, developments, and twists present in even the smallest piece of land, provided we learn how to see them. This is a planetary-scale theatre of soils, an endlessly thickening play of well-fertilized self-transformation.

Peters' descriptions of the *Endothelium*[15] are worth quoting at length:

> [The structure consists of] a field of organic 'bladders' that are self-powered and that move very slowly, self-burrowing, self-fertilizing and are linked by 3D printed joints and thin bamboo scaffolding. The bladders are powered using mobile phone vibrators and have LED lights. It works by using tiny gel packs of yeast which burst and fertilize the geotextile.[16]

This last detail—"using tiny gel packs of yeast which burst and fertilize the geotextile"—brings to mind something at the intersection of an improvised explosive device and a green roof. Perhaps a deployable landscape machine could someday be designed for installation atop a new building downtown; over the course of many decades, it vibrates, bursts with yeast, rotates, crawls, and grows through extraordinary cycles of grotesque architectural fertility, a solar-powered landscape of mould and micro-roots, generating its own soil. Within a few years, the original sculpture it all came from has

12 Terri Peters, "Philip Beesley Envisions an Architecture that Breathes and Grows," in **Mark** 21, September 2009.

13 Philip Beesley, "Hylozoic Soil," in e-art: Communication Vessels, Montreal Museum of Fine Arts, (Montreal, 2007).

14 Peters 2009.

15 **Endothelium**, Philip Beesley and Hayley Isaacs. "Body Art and Disease Symposium," UCLA CNSI/Broad Art Centre, Los Angeles, California, November 2009.

16 Peters 2009.

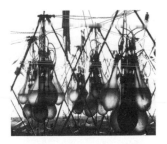

disappeared, made archaeologically undetectable beneath the vitality of the forms that have consumed it. Or perhaps a Beesley sculpture could be buried in the woods of rural England, where it will articulate new ecosystems slowly, over the cyclic course of generations—a kind of living geo-statuary, buried beneath the surface of the Earth in an act of extreme implanted agriculture.

Elsewhere in Peters's article, she writes:

> Endothelium is an automated geotextile, a lightweight and sculptural field housing arrays of organic batteries within a lattice system that might reinforce new growth. It uses a dense series of thin 'whiskers' and burrowing leg mechanisms to support low-power miniature lights, pulsing and shifting in slight increments. Within this distributed matrix, microbial growth is fostered by enriched seed-patches housed within nest-like forms, sheltered beneath the main lattice units.[17]

17 Terri Peters, "Philip Beesley Envisions an Architecture that Breathes and Grows," in **Mark** 21, September 2009.

What would happen, then, if we could install *Endothelium* above Fresh Kills—the landfill—to accelerate its transformation into Freshkills—the public park? Can large-scale landscape remediation occur without the use of subterranean barriers—like plastic sheeting and impermeable geotextiles—but rather through spatially immersive, organically active deep surfaces?

Seen this way, Beesley's artificial soils offer one possible direction for the future of park design: the auto-fertilizing presence of peristaltic bladders and organic batteries, throbbing inside the Earth's surface, with strategically sown seed patches and gel packs of yeast working to prepare any contaminated terrain for human use, advancing the planet into new ecologies.

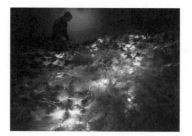

18 Orgone Reef, Philip Beesley, University of Manitoba School of Architecture Gallery, Manitoba, 2003.

In other words, rather than relying on the historical precedent of Frederick Law Olmsted, if we could scale *Endothelium* or *Orgone Reef*[18] up to the size of Central Park, what genuinely new public landscape experiences might we finally be able to foster?

hylozoic ground on mars

Following on this speculative note, it is worth looking a bit further afield into other possible future applications of Philip Beesley's work and its ability to generate new layers of the Earth, new soil deposits, new agricultural fields,

and new landscapes. We've looked at landfill remediation; we've looked at archaeological excavation; we've even looked at art galleries.

But what if we were to seek a truly extraordinary venue, within which the true potential of this work could come to light?

Risking hyperbole, it does not seem entirely out of the question to suggest that Beesley could find quite a role for himself on a research team at NASA or the European Space Agency (ESA). Everything we have seen so far—from *Haystack Veil* to *Endothelium*—would lend itself extraordinarily well to more ambitious off-planet experimentation: the terraforming of Mars, for instance, or the organic colonization of Jupiter's rocky moons. Using methods for the biological generation of soil and atmosphere, it might be possible to transplant—or xenograft—something like a terrestrial microcosm onto alien worlds.

It seems most appropriate, then, to end with a proposal: that a modular, self-unfolding Philip Beesley sculpture, backed by tens of millions of dollars of research funding, be launched into the depths of space. NASA—or the ESA, or the Chinese Space Program, or a private-sector entrepreneur—will then land it on a planet such as Mars, and we earthbound masses will watch in awe as whiskered vibrators and yeast-packs begin to shiver with signs of piezoelectric life. Small crystals surrounded by radio transmitters and genetically engineered space-seed patches will tremble imperceptibly, as acres of hypnotically pulsing virus-like bladders, arranged in blurred carousels, begin to evolve: mutation prone organic batteries, unprotected beneath starlight.

Give it a thousand years, and vast infected forests, full of unprecedented fungi the width of continents, take hold.

It is a distant planet, colonized through architecture and yeast: inhospitable terrain remediated from afar using works that, back in the dark ages of the year 2010, were merely installed inside art galleries and cultural pavilions before their true, geo-productive uses were found.

Liberating the Infinite Architectural Substance

NEIL SPILLER

A new breed of architect is emerging. Such architects cut across the nonsensical disciplinary boundaries that have often hampered their predecessors. This new breed has no truck with concepts that have defined architecture for millennia—such as inertia, stasis, and muteness. They explore notions of reflexivity, dynamism, and the cybernetics of personal perception. This new architecture grapples with the smartness and not-so-smartness of contemporary materials. Such architects become demiurges. I like to call these designers 'alchemic' architects. Currently their number is few, but more and more architects are donning the wizard's cloak of many skins, breathing life into their craft.

The 'hylozoic' in this project's title does not imply the creation of the imagined mythology of tree sprites, gods in the mountains, and water nymphs, so familiar to the ancient animists. Rather, it implies a belief in enlivening the vital force within materials, liberating the attributes of the material world, both man-made and natural; seeing these attributes as a kind of infinite substance, and then deploying these forces architecturally. This is the life-blood and the intellectual point of departure for Hylozoic Ground.

This idea is not new. The old alchemists perceived the world as infinitely transmutable and cyclically distillable. Alchemy is the art of metamorphosis of material, both spiritual and actual. Alchemists see their transformations as a way of refining the basest of materials into progressively purified forms. The aim is to attain the 'Philosophers' Stone,' or the mineral gold, but such stone and gold are merely physical manifestations of a spiritual quest. The alchemist works on himself as well as his external materials. Alchemy involves processes of solution, distillation, and condensation; heating and cooling; and a whole host of other cyclical processes. Alchemists were often persecuted as heretics and their art was almost always secret. A complex poetic literature evolved to cryptically describe their processes. Thus alchemical texts are a mixture of word and image, a world of birds and eggs, kings and queens, birth and death, moons and suns.

Alchemy almost disappeared nearly three centuries ago, but there has always been an interest in its literature and art. More recently, the

Surrealists used alchemical and other occult literature to inspire some of their most memorable works. We are reminded of, amongst others, Max Ernst's *Of This Man Shall Know Nothing* and *The Robing of the Bride*, and Marcel Duchamp's *The Bride Stripped Bare by Her Bachelors, Even (The Large Glass)*. It is perhaps interesting to reflect on the general principles of alchemical thought that so excited the Surrealists:

1 The universe is a single, live entity.
2 The universe is comprised of powerful opposites.
3 The microcosm of these opposites is the sexes.
4 Imagination is the real motivating force of the universe and it can act on matter.
5 Mind and matter are the same.
6 Self-realization that yields an understanding of the cosmos comes through intuitive thought, chance, self-induced derangement, or experimentation.

The great alchemical magnum opus begins with attempting to define and capture the elusive *prima materia*, or as it is sometimes called 'The Slough of Despond': the scum and filth of the world. Many clues about the identity of the *prima materia* are to be found in alchemical texts, but the secret has never been known outside the world of the adepts. Indeed, the adepts experimented with numerous substances deemed to be the elusive material. It is said the *prima materia* is overlooked and almost invisible to humanity. This inspired many medieval alchemists to investigate an assortment of base substances. This propensity was immortalized by Geoffrey Chaucer in "The Canon's Yeoman's Tale" as he describes the alchemists working with "poudres diverse, asshes, donge, pisse and cley."[1] Other substances thought to contain the prima materia were blood, hair, bones, spittle, semen, soil, worms, and dew. A typical paean to it is as follows:

> It is familiar to all men, both young and old, is found in the country, in the village, in the town, in all things created by God; yet it is despised by all. Rich and poor handle it every day.... No one prizes it, though, next to the human soul, it is the most precious thing upon the earth and has the power

1 Geoffrey Chaucer, The Canterbury Tales (London, 1968), p. 267.

NEIL SPILLER

2 Cherry Gilchrist, **Elements of Alchemy** (Rockport, 1991), p. 41.

to pull down kings and princes. Nevertheless it is esteemed the vilest and meanest of earthly things.[2]

Incidentally and appropriately an area of wetlands in Canada is named after this mythical notion. Slough of Despond is located on the Bruce Trail near Big Bay, Ontario, north of Owen Sound. To Philip Beesley, the *prima materia* is the Earth, the ground and the soil. He can often be heard lyrically waxing on about the soil and blood and the dense layers of history in Rome, or the feeling of sturdy stability standing on the base rock of the Canadian mantle.

Soil and ground are always formed by their context, above and below. Soil formation, or pedogenesis, is the combined effect of physical, chemical, biological, and anthropogenic processes. Soil genesis involves processes that develop layers or horizons in the soil profile. These processes involve additions, losses, transformations, and translocations of material that compose the soil. Minerals derived from weathered rocks undergo changes that cause the formation of secondary minerals and other compounds that are variably soluble in water; these constituents are translocated from one area of the soil to others by water and animal activity. The alteration and movement of materials within soil causes the formation of distinctive soil horizons. In the Hylozoic Ground project we can see such horizons, pre-histories, and archaeologies, and the results of previous iterations and cyclic distillations.

This is true of architecture itself; indeed, soil's architecture is conditioned by the same myriad of factors and morphologies that condition all structures and their related phenomena on Earth. Architecture can be typologically defined by the tactics and protocols that it uses to make itself watertight, or by how it turns a corner, or how it environmentally conditions itself, or by many hundreds of other distinctions. One of these typological distinctions is how architecture mediates the ground, and this is grist for Beesley's mill. The project is a microcosmic facsimile of this relationship. It expands on the idea of 'ground' and its penetration by and reconciliation with architecture and the materials of building.

LIBERATING THE INFINITE ARCHITECTURAL SUBSTANCE

Protocells form a recent inclusion within the reflexive loam of Hylozoic Ground. This is appropriate, because protocells are also alchemical; they are in a sense universal solvents. They can be used as agents, drivers, triggers, or food and can respond to any collection of ecologies. The operations, vectors, and machine-augmented processes of the city are seldom seen as belonging to ecologies. Such agglomerations of matter and events contribute to the palimpsest of the city. These palimpsests, human culture's largest artifacts, are the *prima materia* for architectures of reflexivity. The city is a series of fluid fields populated by multiple architectural objects, sensations, images, and chaotic strange attractors. There is little or no internal logic to the city; small perturbations in its current organization can tip it into a massive re-articulation of spatial emphasis. These perturbations may be economic, artistic, and paranoid, or may involve abrupt landscape metamorphosis and many other ratcheting triggers.

The palimpsest of the city is ascalar: that is, its complexity is revealed at any scale, from the city scale to the microscopic. This writhing mass of fleeting relationships is forever on the move, always dynamic, always being given new emphasis. Much has been written about new technologies collapsing, concertinaing, jump-cutting, and making space ubiquitous. Paradoxically, place becomes critically important. In relation to the palimpsest of existence, technology can contribute to a variety of invisible specifications becoming visible. Ecologies, microclimates, human use patterns, human idiosyncrasies, and all manner of non-human agencies acting on any site can generate highly dense, contextual architectures. These interactions and their space/time geometries can be made reflexive by utilizing virtual technologies that create highly sensitive surfaces that sense and trigger remotely.

When you look at Hylozoic Ground and feel its alchemical caress, you are experiencing a microcosm of the city's macrocosm. You are made aware of infinitely complex processes that are happening over time. Processes that have always comforted you in their vicissitudes, their movements, their imperatives—their life. One is also driven to admit a furtive sexual

interest, nascent but nonetheless present. The shuddering, stroking, and lingering ethereal fronds are redolent of an Eden, after the snake—where the snake has made no mistake: Arcadia, at the point of metamorphosis between unknowing and knowing. Hylozoic Ground is the opposite of the story of Apollo and Daphne. Where in the myth Daphne seeks to escape the amorous god's pursuit and predatory caress by changing herself into a tree, this project seduces, titillates, and beckons. It is shaking off the inertness of the architectural body in a search for the erotic encounter.

Queasy Posthumanism
Hylozoic Ground

CARY WOLFE

Hylozoic Ground, the remarkable work realized by Philip Beesley in collaboration with engineer Rob Gorbet, is visually arresting—a diaphonous testimony to the union of function and form; an uncanny melding of the biomorphic and the high tech. Viewers have described it variously as breathtaking, fragile, reverential, magical, and symphonic. 'Queasiness' is a sensation that Beesley has associated with the work; but as with the action painting that he cites as one of his influences, we might well ask what sorts of 'queasiness' lurk beneath Hylozoic Ground's stunning formal surface.[1]

1 Terri Peters, "Philip Beesley Envisions an Architecture that Breathes and Grows," Mark 21 (August September 2009), p. 201.

Part of this feeling, no doubt, is not just the experience of being in an enveloping space of extraordinary dimensional depth and texture, but in one that moves peristaltically, at once synchronous and asynchronous with the viewer's own actions. As Beesley puts it, "It's an immersive environment, it's about being inside something, not being on top of it and owning it, but being swallowed by it, with a sense of vertigo." "Once you enter the room," journalist Terri Peters observes, "you can only hope it's friendly." [2] What is intriguing to me here is the sense of exposure that seems to accompany our experience of Hylozoic Ground: a sense that, for artist and viewer alike, can border on a feeling of fascination and even empathy mixed with a vague atmosphere of menace. "It has a lot of hunger," Beesley observes; and in fact, one reviewer, Tim McKeough, characterizes the piece as a "predator." "It treats you much like any wild animal would treat a human," Beesley observes; "You're its food."[3]

2 Peters 2009. pp. 200–201

3 Tim McKeough, "This Art Bites," Wired (November 2007), p. 134.

Indexed here is a fact crucial to both the phenomenological and conceptual torque of Hylozoic Ground: the fact of our own embodiment, of being a living body in space and time, one for whom stakes are involved in location, movement, proximity, and proprioception. Following closely on the heels of this fact is a question that the work is bound to provoke: if we have and are a body, is it possible to say the same of the probing, swallowing, pulsing thing that surrounds us in Hylozoic Ground? Indeed, one might even say that in the case of the artwork, the gap between *having* a body and *being* a body is minimal; for that very reason this work is even more suggestively resonant with contemporary attempts, such as those in certain strains of cognitive science, to de-ontologize the question of subjectivity and instead think of it functionally and materially.[4] To raise such questions is simply to make the point that the issue of embodiment, which seems so natural, so straightforward, turns out to be more complicated than one might think at first blush.

4 See, for example, Daniel Dennett, Consciousness Explained (Boston, 1991).

But why would such a question ever arise about a meshwork of acrylic tiles, monofilaments, and microprocessors in the first place? What gives us the sense that we are not in the presence of a 'thing'—an object—but rather surrounded by something that's alive, something that fascinates and unsettles precisely because it seems to have its own animus, its own agenda? Here, it seems to me, Hylozoic Ground generates another kind of 'queasiness' or vertigo—the vertigo associated with what is now being called 'posthumanism': the need to move beyond the comforting philosophical categories and certitudes of the humanism we have inherited from the Renaissance and the Enlightenment, to a more nuanced and complex vocabulary that allows us to deftly process the imbrication and enfolding of bodies, machines, codes, discourses, and spaces that we increasingly encounter in our own historical moment—and in Hylozoic Ground.

Systems theory, one of the more powerful and ambitious theoretical approaches associated with posthumanism, appears to be of some help here, particularly because it deploys the same explanatory principles across what, in humanism, are considered ontologically discrete domains: subject versus object, culture versus nature, human versus animal, organic versus mechanical. From its very origins at the Macy Conferences in New York in 1942, systems theory (or cybernetics, as it was originally called) was interested in using the same theoretical model, centered on positive and negative feedback loops, to explain phenomena as diverse as governors on steam engines, thermoregulation in warm-blooded animals, neurophysiological changes in the human brain, and targeting systems in anti-aircraft weaponry.[5] Examples of the developing systems theory can be found in the work of figures such as Norbert Wiener, Warren McCulloch, Claude Shannon, Gregory Bateson, and others. "When we talk about the processes of civilization, or evaluate human behavior, human organization, or any biological system," Bateson writes in a seminal essay, "we are concerned with self-corrective systems. Basically these systems are always *conservative* of something" (emphasis added)—in the sense of conserving a homeostatic norm, baseline, or setpoint.[6]

In Bateson's view, there are four fundamental, minimal characteristics of any system, be it biological, mechanical, or social: First, that the system operates according to *differences*, deviations from a norm, baseline, or rule—say, the set point of a thermostat, or the optimal body temperature of a species

5 For an overview, see Steve Joshua Heims, Constructing a Social Science for Postwar America: The Cybernetics Group 1946–1953 (Cambridge, 1993).

6 Gregory Bateson, Steps to an Ecology of Mind (New York, 1972), p. 429.

7 Bateson 1972, p. 429.

8 Bateson 1972, p. 429.

9 Bateson 1972, p. 429.

of warm-blooded animal. Second, that a system is composed of "closed loops or networks of pathways along which differences and transforms of differences shall be transmitted"[7] so that they can be processed by the system as information. Third, that "many events in the system shall be energized by the respondent part rather than by impact from the triggering part";[8] a fact neatly demonstrated on the terrain of the visual system by the famous parallax effect, which demonstrates how the visual system doesn't simply process input such as wavelengths of light in a linear fashion, but actively and dynamically constructs the visual field in response to visual stimuli. Fourth, that systems "show self-correctiveness in the direction of homeostasis and/or in the direction of runaway"—that is to say, in the direction of either negative feedback or positive feedback.[9] (For the former, think of thermoregulation in warm-blooded animals, or cruise control in an automobile; for the latter, think of how coughing in response to an irritated throat only increases the irritation, or how drinking bottled water to avoid the contaminants caused by the very processes used to advertise, package, and ship bottled water only makes the problem worse.)

In the rudiments of systems theory, we have the basic conceptual tools to begin to explain how Hylozoic Ground uses some of the same principles and processes that constitute us as viewers to generate its uncanny effects: it processes differences generated by the location and move-ment of the viewer's body. That it does so via non-linear feedback loops creates the impression of something far more sensitive and nuanced than a crude stimulus-response mechanism. In systems theory, the tradi-tional distinctions between subject and object, culture and nature, spirit and matter, and so on are now replaced by system theory's fundamental distinction, between system and environment

This distinction is not fixed to a particular substance but is *analytical*—that is to say, it is not ontological but functional. We become part of the envi-ronment for the system that is Hylozoic Ground; the artwork is at the same time part of *our* environment, and we are coupled together in a loop of reciprocal exchange which need not be—indeed, *cannot* be—representa-tional. I think this is something close to what Beesley is driving at when he suggests that he wants to develop "a stance in an intertwined world that moves beyond closed systems.... In terms of figure-ground relationships the figures I compose are riddled with the ground."[10] To phrase

this in systems theory parlance, the system is riddled with the environment, and vice versa, since both are co-implicated and co-specified as part of the same loop of interactive exchange. Bateson suggests that the basic unit is not "organism versus environment" but "organism-in-its-environment." The relationship between system and environment, you might say, is hyphenated.[11]

However, we need to supplement and extend these 'first-order' systems theory models with important refinements from later, 'second-order' systems theorists such as Humberto Maturana, Francisco Varela, and Niklas Luhmann to make headway on an age old conundrum: are systems open or closed? If they are open, how do they maintain their integrity and reproduce themselves? If they are closed, how do they interact effectively and adaptively with their environment? The answer, according to Maturana and Varela, is that autopoietic systems—systems that are capable of reproducing the elements that constitute the system itself—are *both*. Autopoietic systems are open in terms of their *structure*—the material nature of their elements and how they are affected by the laws of physics and chemistry, energy flows, and the like; but they are closed in terms of their *organization*—the self-referential, highly selective logic that they use to filter and process environmental complexity.

As Maturana and Varela write of the nervous system:

> The operational closure of the nervous system tells us that it does not operate according to either of the two extremes: it is neither representational nor solipsistic. It is not solipsistic, because as part of the nervous system's organism, it participates in the interactions of the nervous system with its environment. These interactions continuously trigger in it the structural changes that modulate its dynamics of states.... Nor is it representational, for in each interaction it is the nervous system's structural state that specifies what perturbations are possible and what changes trigger them.[12]

What this means is that the environment, the 'outside,' is always already the outside *of* a particular inside, since what can be recognized as a perturbation or stimulus for a system depends (and this seems common-sensical enough) upon the system's own qualities and capacities, what Niklas Luhmann calls the "self-reference" of the system.[13] This is probably

10 Philip Beesley et al., **Kinetic Architectures & Geotextile Installations**, Riverside Architectural Press (Cambridge, 2010), p. 20.

11 Gregory Bateson, **Steps to an Ecology of Mind** (New York, 1972), p. 429.

12 Humberto Maturana and Francisco J. Varela, **The Tree of Knowledge: The Biological Roots of Human Understanding**, rev. ed., trans. Robert Paolucci (Boston, 1992), p. 169.

13 Niklas Luhmann, "The Cognitive Program of Constructivism and a Reality that Remains Unknown," in **Selforganization: Portrait of a Scientific Revolution**, ed. Wolfgang Krohn et al. (Dordrecht, 1990), p.76.

14 For Nagel's classic essay and an interesting commentary on some of its assumptions, see Douglas Hofstadter and Daniel Dennett, The Mind's I: Fantasies and Reflections on Self and Soul (New York, 2001).

15 Bateson 1972, p. 429.

16 Luhmann 1990, p. 76.

easiest to understand when we think of the neurophysiological differences between different forms of animal life and how they perceive the world—a fact that led to a famous set of reflections and ruminations by philosopher Thomas Nagel in his essay "What Is It Like to Be a Bat?" [14]

One of the more salient consequences that flow from this line of reasoning is that any observation of the world is *non-representational* because the observed phenomenon is not grasped but is rather generated—brought into intelligibility—by the particular biological and perceptual mechanisms of the observer, and also in the case of human beings, by the conceptual schemata and knowledge-making codes we use to describe what we experience. As Bateson is fond of saying, *"The map is not the territory."* [15] This means, in turn, that space is always already virtual; a space inhabited by different autopoietic observers, with different modes of embodiment and different organizing schemata, is by definition *virtual* space—not 'unreal,' but rather 'multi-dimensional,' and, for that very reason, all the *more* real because it is replete with multiple possibilities for different modes of perception, experience, and engagement. Just as crucially, this means by definition that since our knowledge and experience of the world is selective and contingent on our organization, the price we pay for our knowledge is a fundamental non-knowledge of whatever is excluded by our modes of perception and our conceptual coordinates. As Luhmann puts it in a Zen-like moment, "Reality is what one does not perceive when one perceives it." [16]

Such a vantage point helps us more robustly describe our experience of Hylozoic Ground as well as some of its fascinating conceptual fallout. From this vantage we can see that strictly speaking, the work doesn't respond to 'us' at all. Rather, its collector barbs, trapping burrs, and reservoirs for artificial organic materials gather information (differences) generated by our presence in the room, but do so discretely, not with a search image of 'us.' The 'us' reflects our way of being in the world, and so our feelings toward the work—of fear, of fascination, even of empathy—make perfect sense and are therefore not wrong.

Our experience of Hylozoic Ground and its apparent aliveness may feel uncanny; but what is *really* uncanny is not that it is almost like us in its aliveness, but rather that we are like *it* in our self-referential, non-representational

relationship to a world that we then *later* Platonize and naturalize through language, custom, ideology, and habit. The work of art certainly exists for us, in a human world. But what is dramatized here is that not all worlds are human—or, to put it in different terms, that the world is actively and very selectively constructed, and not simply given.

This bears directly on how Hylozoic Ground deploys a stunning visual surface and a compositional, formal harmony as a kind of lure to achieve something else altogether. The piece embeds visuality within the multi-dimensional space of embodiment, in which sight is no longer equated with the viewer's position of mastery, but is simply part of a larger animal sensorium which may not be all that reliable in helping us to read our situation in the instance at hand. And for that very reason unsettling: 'queasy'; Is it going to pet me? Is it going to eat me? Does it know the difference? If it knows I'm here, how and what does it 'know'?

The contrast here between Hylozoic Ground and your standard display of animatronics virtuosity is instructive. In the former, nothing is hidden, and yet, in an important sense, everything is. In the latter, everything is hidden and yet, in a sense, nothing is. To wit: in Hylozoic Ground, the engineering apparatus is more or less in full view. Yet, what is not visible—and, as Luhmann might say, not visible *in principle*—is what the piece is up to, what its agenda might be, what kinds of emergent behaviors its recursive relations with us might generate. In traditional animatronics, the engineering and the mechanics are meticulously hidden, but only to produce a visible mimesis of a reality—one might even say an ideology—that we already know all too well. A favorite example I recall from my childhood is a visit to the Hall of Presidents at Disney World, Florida. Once one gets the trick and has the "Aha!" moment, the world gets redoubled: "Wow, even *machines* think the way we do!"

On the other hand, Hylozoic Ground tempts us, even invites us, to encounter the piece within the frame of art imitating life; but when we do so, we find a rather uncanny twist on a familiar theme: the imitation does not follow the representational ratio and visibility of life; as we know it, but rather the *invisibility* of other ways of being in the world that are extracted as the price of our own ways of knowing and being: "Reality is what one does not perceive when one perceives it." This refers not just to the bat's sense

CARY WOLFE

of echolocation or the bloodhound's sense of smell, but also the exquisite sensitivity of a machine to our presence even before we know we've arrived. Those other ways of being might know us in ways that we cannot know and master. Might make us, in a word, 'queasy.'

To put it this way is to sharpen the difference between a certain spectatorial relation to art marked by an identifiably humanist rendering of visuality, and a more radical experience of 'spatialization' that is dependent on our own contingent embodiment—and on what that embodiment can and cannot see. Organizing the visual and perceptual field around the fixed point of the eye as sole agent of *logos* and *ratio* is a tradition with a genealogy that runs from the Renaissance theory of perspective, through Sigmund Freud's parsing of the sensorium in its evolution from animal and olfactory to human and visual, through Sartre's analysis of the Look, and finally to Foucault's work on the Panopticon. Instead, we find here what Jacques Derrida has called the "ruin" of vision.[17] What is unseen in Hylozoic Ground is unseen not because it is hidden from view but rather because as Derrida would say, it is heterogeneous to the visual as the philosophical tradition conceives it. As Derrida puts it in an interview, "It is within a certain experience of spacing, of space, that resistance to philosophical authority can be produced."[18] Space, for the very reasons we have been examining, is not "essentially mastered by the look." "Space isn't only the visible," Derrida argues; "the invisible, for me, is not simply the opposite of vision."[19]

However, we need to remember that for Derrida, "space" doesn't just refer to a multi-dimensional, virtual perceptual field shared by different observers; it also refers to the fundamental logic of 'spacing' by which any 'difference that makes a difference'—any information—may come into being. For Derrida, "space" refers to any and all *codes*.[20] In a sense, Derrida is simply radicalizing the realization of first-order systems theory announced in essays such as Bateson's "Form, Substance, and Difference." After noting that "The map is not the territory," and that "What gets onto the map, in fact, is "*difference*," Bateson asks,

> But what is a difference? A difference is a very peculiar and obscure concept. It is certainly not a thing or an event. This piece of paper is different from the wood of this lectern. There are many differences between them— of color, texture, shape, etc. But if we start to ask about the localization of

17 Jacques Derrida, **Memoirs of the Blind**, trans. Pascale-Anne Brault and Michael Naas (Chicago, 1993), pp. 65–70. For a broader discussion of the question of visuality in relation to posthumanism, see Cary Wolfe, **What Is Posthumanism?** (Minneapolis, 2010), in particular Chapters 5–8 and 11.

18 Jacques Derrida, with Peter Brunette and David Wills, "The Spatial Arts: An Interview with Jacques Derrida," in **Deconstruction and the Visual Arts**, eds. Peter Brunette and David Wills (Cambridge, 1994), p. 10.

19 Derrida 1994, p. 24.

20 For a cross-mapping of deconstruction and systems theory on precisely this point, see Cary Wolfe, **What Is Posthumanism?** (Minneapolis, 2010), Chapter 1.

those differences, we get into trouble. Obviously the difference between the paper and the wood is not in the paper; it is obviously not in the wood; it is obviously not in the space between them.... A difference, then is an abstract matter.[21]

21 Gregory Bateson, Steps to an Ecology of Mind (New York, 1972).

In other words, it is a matter of spacing—in this case, the spacing of two elements, which cannot occupy the same place at the same time, between which the abstract relation emerges. Most radically of all, and most directly to the point of how we think about Hylozoic Ground, that spacing doesn't just apply to human language, or human codes. It is the fundamental structuring principle of the 'programs' that traverse the difference between human and non-human life forms, but further—and more radically—the difference between the organic and the mechanical.[22] "Instead of having recourse to the concepts that habitually serve to distinguish man from other living beings," Derrida writes, "the notion of *program*" denotes a movement of "difference" and "spacing" that "goes far beyond the possibilities of the 'intentional consciousness.'" [23]

22 Jacques Derrida and Elisabeth Roudinesco, For What Tomorrow: A Dialogue, trans. Jeff Fort (Stanford, 2004), p. 63.

23 Jacques Derrida, Of Grammatology, trans. Gayatri Chakravorty Spivak (Baltimore, 1976), p. 84.

What this means is that the concept of 'life' is radically denaturalized—not in the sense that it is divorced from its material substrate, but that it returns us to a broader examination of what forms of embodiment can give rise to the recursive relations of structural coupling on which emergent interactions depend. The conceptual momentum thus pushes in two opposite but intimately related directions: On the one hand, expanding the definition of 'subjectivity' outward, toward new forms of embodiment—that may or may not be carbon based life forms. On the other, pushing the notions of code, system, and program from the technical to the domain of the living, but more pointedly to the domain of the human.

In this context, the goal (if not quite yet the reality) of Hylozoic Ground appears to be that it might not just seem alive but in some sense *be* alive. As Beesley suggests, "It is safe in the known territory of robotics, but the liquids add an element that is both nurturing and rather creepy." The metabolic liquids that fill the work's bladders and its hydroscopic islands absorb, digest, and release information and matter within the system. "These material exchanges," Beesley continues, "are conceived as the first stages of dependent interactions where living functions might take root within the matrix".[24] On the other hand, we don't need to wait for

24 Terri Peters, "Philip Beesley Envisions an Architecture that Breathes and Grows," Mark 21 (August-September 2009), p. 201.

Hylozoic Ground to come alive to understand the full force of the post-humanist reframing of the question of life that this work brings to the fore: whatever we are, we come to be that way by submitting to a fundamentally prosthetic relation between us and the external. Paradoxically, these radically inhuman and nonorganic programs, codes, and archives are the medium through which we can fully realize who we are—but only by becoming something we are not. In this light, the uncanny effect of Hylozoic Ground is that rather than confronting us with the question, "Is it alive?", it confronts instead with the dawning realization, "Are we?"

Architecture of Contingency

MICHELLE ADDINGTON

Architecture privileges the two-dimensional surface. Regardless of whether the surface representation originated from the classical method of orthographic drawing or from the contemporary method of three-dimensional modeling, the result is the same: buildings that can only be processed through the qualities of the surfaces in view. The privilege afforded to the surface emanates from an *a priori* belief that perception is rooted in and determined by geometry. Geometry relentlessly tethers the built environment to static artifacts.

Geometry is, however, a subordinate player in perception. Perception is driven by local, discrete, and transient energy exchanges between the human body and its immediate surroundings. Building surfaces might provide an armature or a context for these exchanges, but they do not generate them. The architecture of a perceptual environment is instead an architecture of contingency: Not geometry and surface, but heat and light. Not form and materials, but sensuality and tactility. A contingent architecture emerges through interactions with the body, and responds to each body with behaviors that are specific to that moment in time and that individual. When the contingencies are designed, the objective totality of a geometrically-derived architecture gives way to subjective discretion.

surface and boundary

An oft-repeated cliché is that architects do not design buildings, they design 'space.' Architects may draw surfaces and objects, but their ability to knowingly imbue those surfaces with concepts of 'territory' and 'effect' supposedly differentiates architecture from quotidian construction. The more gifted the architect, the more cerebral the effects of the designed space. The historian and theoretician Robin Evans described this quality of extension as a "projective cast" that operates in the "intervals between things."[1] Evans describes a set of ten transitive spaces that form the reading of object by observer; seven are constructed geometrically from the surfaces of the objects, while three fall into the realm of the imagination: "Projection—or rather quasi projection—breaches the boundary between world and self, the objective and the subjective."[2] The imagined space escapes precise and specific characterization of the geometrically constructed surfaces of the object, and yet the implication is that its very existence is determined by those surfaces. Even insofar as one cannot trace a line of causality from

1 Robin Evans, **The Projective Cast** (Cambridge, MA, 1995), p. 366. Published posthumously.

2 Evans 1995, pp. 368–369.

objective surface to subjective perception, we unconditionally accept that the surface is the progenitor of the effects that determine perception.

The hegemony of the surface reinforces a lexicon for architectural materials that categorizes materials as aesthetic artifacts. Typical materials such as wood, stone, aluminum, concrete, and glass are visually identifiable and functionally predictable. Most basic design requirements are satisfied by selection of a particular material. For example, the choice of a particular type of wood defines possible functions, properties, and appearance. If a material is not in the field of view, as in the case of materials intended for structural systems, selection is predicated on its *instrumentality*—how economical, efficient, and effective the material is for achieving the desired architectural form. A material in view, however, is no longer *instrumental* in creating an image—it *is* the image. The architect only has to name the material to define the resultant appearance. Wood connotes warmth and domesticity; aluminum, a lightweight universality.

If surfaces are the carriers of effects, then they are also the delimiters of the architectural object; as such, they define the extents of its property. Evans' "projective cast" may pose space as projecting from the object, operating between objects, even penetrating the object, but it is the object which is the relevant datum. The delimiting surface unambiguously defines the datum thus differentiating *inside*—within the extents of property; from *outside*— beyond the extents. The surface-as-datum thereby takes on an additional, and perhaps more problematic role as 'boundary.' The architectural boundary inherently marks difference and ownership through a prescribed discon- tinuity. The physicality of the surface manifests this boundary as a barrier, container, or edge, producing a very real discontinuity that is perceptually impenetrable if the surface is opaque, and that remains physically impen- etrable even if the surface is transparent.

The building envelope represents the ultimate manifestation of the omni- functional surface boundary. Not only does it demarcate ownership and limits, and determine form and image; it also protects the occupant from the myriad trespasses of a hostile world—intrusion by the public, assault from the environment. While traditional architecture was capable of providing shelter from the environment, the advent of HVAC (Heating, Ventilating and Air Conditioning) systems at the beginning of the twentieth century

3 Le Corbusier, **Precisions on the Present State of Architecture and City Planning**, trans. E. Aujame (Cambridge, MA, 1991), p. 66. The volume is an English translation of a series of lectures that Le Corbusier delivered in Brazil in 1929. The original compilation was published in French in 1933. Degrees are in Celcius.

4 James Marston Fitch, **American Building 2: The Environmental Forces That Shape It** (Boston, 1972), p. 46.

5 The classic James Marston Fitch image depicting the building envelope as the primary determinant of human well-being. External physical phenomena: thermal, atmospheric, aqueous, luminous, sonic, world of objects, spatio-gravitional. Internal perceptual responses: metabolic mechanism, perceptual systems, skeletal-muscular system.From **American Building 2: The Environmental Forces That Shape It** (Boston, 1972)

6 Built in the late 1980s, Biosphere 2 is a large glass enclosed complex located between Tucson and Phoenix, Arizona. Two teams of 'biosphereans' were sealed inside the artificial environment during the 1990s to test survivability, but severe problems with sustaining the interior environment resulted in the high-profile cancellation of the missions. The Passivhaus stems from a concept developed by Wolfgang Feist in the 1980s which was premised on the reduction of heating load by using super-insulated walls in a tightly sealed envelope. All fresh air enters the building through means of a mechanical heat recovery system.

established the building envelope as a cocoon in which an alternative universe was maintained.

In a lecture delivered in 1929, Le Corbusier described the envelope as a "hermetic" seal that enabled the nascent HVAC system to provide ideal interior conditions: "The Russian house, the Parisian, at Suez or in Buenos Aires…will be hermetically sealed. In winter it is warm inside, in summer cool, which means at all times there is clean air at exactly 18°."[3] Half a century later, James Marston Fitch essentially equated 'architecture' with 'envelope' in describing its thermal determinism:

> The task of architecture is not merely to abolish gross thermal extremes (freezing to death, dying of heat prostration) but to provide the optimal thermal environments for the whole spectrum of modern life…. To achieve a thermal steady state and a thermal equilibrium across space.[4]

The image that illustrates this equivalence appeared on the cover of Fitch's seminal *American Building 2: The Environmental Forces That Shape It*.[5] The building is entirely represented by an envelope that isolates a static, homogeneous interior from a dynamic, heterogeneous exterior. As if the image were not didactic enough in stating the authority of the envelope as determinant of man's condition, the accompanying notes list what was then considered to be the full range of perceptual responses in the interior with the associated physical phenomena on the exterior, showing the envelope in a role as the intervening litigator. From the ill-fated Biosphere 2 project in Arizona, in which microcosms of the Earth's major biomes were housed in a completely sealed complex, to the German Passivhaus with its massive, highly-insulated walls, there continues to be a profound faith in the envelope as not only the definitive boundary for architecture, but also as the only boundary of consequence.[6]

boundary conditions

The static surfaces of the envelope may demarcate the ownership of property or the territory of a domain, and they certainly establish the visual extents of the picture plane; but these are boundaries of discontinuity. When speaking about phenomena rather than objects, the boundaries of consequence are all continuous. In physics, a boundary is a region in which change occurs: heat is exchanged, pressure is equalized, molecules are

ARCHITECTURE OF CONTINGENCY

combined. A boundary is a zone of action, where the laws of physics are manifest at their most fundamental and potent level. A cold front colliding with a warm front produces a line of thunderstorms at the boundary where the two storms' different thermal conditions are negotiated;[7] an airplane fights gravity through manipulation of pressures in the boundary layer that forms between its air foil and the surrounding atmosphere. Unlike the static boundary of the building envelope, the energy boundary does not exist to create discontinuities; rather, it emerges to resolve them.

Many architects would argue that the building envelope is an active zone of energy exchange, even pointing to Fitch's image as evidence of just how embedded the idea of exchange is in the accepted concept of the building boundary. Indeed, there continues to be a great deal of interest in the 'performative' envelope. The performative envelope is a highly engineered façade construction that, at its most basic level, is optimized for a variety of performance criteria relating to heat and light transmission. At the envelope's most advanced level, it may contain active components that allow for adjustment of its performance as exterior conditions change: automated shades may drop to prevent glare as the sun angle shifts; fans may be activated to relieve accumulated solar heat gain inside the wall layers.

The quest for an envelope that performs all of these functions seamlessly while maintaining a slim profile has been the holy grail of façade design for decades, beginning with Mike Davies' 1981 proposal for the 'polyvalent' wall,[8] and including the Smartwrap skin exhibited by the firm Kieren Timberlake in 2003.[9] While this approach might seem to be a shift away from the concept of 'wall' as a static artifact, it instead reinforces the hegemony of the wall as the overarching (and permanent) determinant of the interior conditions.

The polyvalent wall may seem to possess the characteristics to negotiate energy exchanges, but it falls short in three ways. First, it is predicated on maintenance of the homogeneous interior; as such, its primary role is to protect and preserve an autonomous, unchanging environment. Second, the site of the envelope is presumed to be the definitive site of the phenomena. And third, it is assumed that decisions at the architectural scale govern phenomenological behaviour. All three of these unquestioned beliefs tether phenomena to the wall, and in so doing, treat phenomenological characteristics as geometric entities rather than transient behaviors. In privileging

7 The boundary in a collision between a cold front and a warm front is clearly demarcated by the cloud layers. Image courtesy of the National Oceanic and Atmospheric Administration.

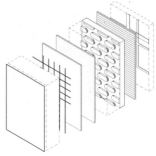

8 Schematic representation of Mike Davies' polyvalent wall. Davies proposed that the exterior wall could be a thin system with layers of weather skin, sensors actuators, and 'photoelectrics.'

9 Mike Davies, when he was an associate of Richard Rogers, proposed that the exterior wall could be a thin envelope comprised of layers of weather skin, sensors and actuators, and "photo-electrics." See Mike Davies and Richard Rogers, "A Wall for All Seasons," RIBA Journal 88 (1981). The architects Steven Kieren and James Timberlake realized Davies' vision for a polyvalent wall in their Smartwrap product, which combines weather proofing, a layer of OLED lighting, insulation, and photovoltaics into a thin skin suitable for wrapping buildings. Although the material has been demonstrated in numerous art installations, it is not commercially available.

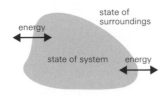

10 A thermodynamic system is any identifiable collection of matter that can be described by a single temperature, pressure, density, or internal energy. A boundary arises whenever there is a change in one of the conditions—energy crosses the boundary to bring the conditions to equilibrium.

11 Schlieren thermal image depicting the convective boundary layer rising from the human body. Image courtesy of Gary Settles, Pennsylvania State University.

12 This phrase is a slogan of the United States Department of Energy's Energy Star program. The underlying premise is that the building envelope must be extremely tight to prevent any outside air from leaking in, so as to reduce the amount of energy consumed by the mechanical system for heating. But, as human occupants require fresh air, the mechanical system is then made responsible for conditioning and delivering that air, which ironically must come from the outside.

architectural scale and surfaces, the performative envelope is no more 'active' than a common concrete wall.

Active energy exchange occurs at the boundary between a thermodynamic system and its surroundings. The classic diagram of a thermodynamic system depicts its boundary as soft, deformable, and malleable.[10] The boundary emerges whenever the conditions of the environment develop a minute difference in temperature, pressure, density, internal energy, or composition. A human body walking through a room will create numerous shifts in conditions: the temperature difference between the human skin and the surrounding air will produce an exchange of heat between the body and the air; this exchange of heat will create a density difference; the density difference will produce convective movement of air; moving air will affect the humidity immediately adjacent to the body, thereby setting up a mass transfer of moisture from the body to its surroundings.[11] As long as the human body is alive and present, the various energy exchanges will occur, with their intensity and duration dependent upon the magnitude of a given difference at any moment. Of course, one energy exchange has rippling effects upon many others, with the result that boundaries are constantly emerging, mutating, and dissolving. Some of these boundaries might emerge along the walls, but most will not. The architecture of the building—as determined by surface and geometry—is but a subordinate player.

heat, light, sound

The building systems responsible for creating the interior environment are tautologically intertwined with the concept of the envelope as boundary, as container, as hermetic seal. A homeostatic interior with steady-state, unchanging conditions is only possible if it tightly sealed. A hermetic seal can only function if what it contains is unchanging. The United States Department of Energy's current slogan "Build Tight, Ventilate Right"[12] is a demonstration of this circular reasoning: buildings are to be made as tight as possible to prevent air from leaking in, but then a ventilation system must be designed to provide the fresh air needed by occupants. Essentially, the human body is treated as a problematic perturbation that disrupts the optimum functioning of systems whose only purpose is to maintain an environment for the human body.

ARCHITECTURE OF CONTINGENCY

The dynamic phenomena of heat, light, and sound determine human perceptual responses, yet our building systems are predicated on creating an unchanging field of neutrality. The accepted goal of HVAC design is to produce an environment in which "eighty percent of the occupants do not express dissatisfaction," or, essentially, an environment that is not noticed.[13] An empirical index known as the PMV, or Predicted Mean Vote, is one of the most commonly used assessment tools for determining degree of satisfaction. Use of this index results in a bulk temperature and humidity that is acceptable for a statistical majority of occupants. Lighting standards mandate a uniform delivery of illumination to a horizontal plane across the entire floor plan, regardless of the field of view of the occupant, and irrespective of whether the source is daylight or electric light. With the exception of buildings designed for their aural qualities, such as performing arts venues, sound is treated as noise to be dampened, so that it too is unnoticed. The very phenomena that define the human experience are precisely the ones that the building environment is designed to nullify.

The human senses respond only to change. Thermo-receptors in the skin are only activated when the difference between skin temperature and core temperature changes; environmental temperature is one of many factors, but not the direct cause of thermal sensation. Photoreceptors in the eye only respond when specific clusters in the retina encounter a change in the rate of photon strikes (a difference in luminance); otherwise, the eye is incapable of distinguishing between white and black.[14]

Indeed, for all of the attention given to constructing the ideal environment for the human body, the designed environment is incidental in the determination of perception (as are the static surfaces that enclose it). As an example, consider the perceptual characteristic that is most often attributed to the architecture of a building: image. We presume that formal decisions regarding massing, geometry, proportions, materials, and ornamentation made during the design of a building are the fundamental determinants of its ultimate visual reading. Whether considering the highly articulated façade of the Rococo period or the taut façade of early Modernism, the presumption is that the form determines the image.

This is not, however, how the eye perceives image. The modernist building could easily by visually read as Rococo, and the Rococo as modernist, by

13 ASHRAE (The American Society of Heating, Refrigeration, and Air-Conditioning Engineers) defined thermal comfort in this manner for decades. Their most recent guidelines are published in ANSI/ASHRAE Standard 55-2004, which defines comfort as "that condition of mind which expresses satisfaction with the thermal environment and is assessed by subjective evaluation."

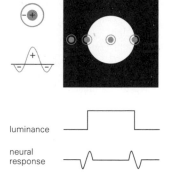

luminance

neural response

14 Schematic of the eye's receptor field and how it responds to changes in luminance. Photons that strike the center of the field 'zero out' photons that strike in the periphery; constant luminance levels, whether completely dark or completely light, produce the same neural response. Only when the receptor field encounters a difference in luminance is there any change in response.

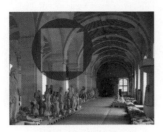

15 The installation Disque sans carré / carré sans disque demonstrates that luminance is a greater determinant of depth and perspective than form itself. The 'circle minus square' appears to be on a transparent picture plane, but is actually painted bright red onto the columns and vaults along the colonnade. Image courtesy of Felice Varini.

quite simple shifts in luminance. Removing differences in luminance flattens surfaces; adding differences can articulate a three-dimensional form. One only has to experience the light installations of James Turrell or the anamorphic projections of Felice Varini[15] to see how directly luminance determines the reading of form. Image is contingent upon the fleeting energy transactions between photons and the retina, and not constituent of the formal object. The surfaces we make are not the authors of their own appearance.

the interactive boundary

Achieving more direct engagement of the body with its surroundings is at the heart of a burgeoning movement in the design of interactive environments. Urban screens, media walls, and responsive surfaces are pro forma components of every hip young architect's portfolio. Digital images may appear on a mute surface as a human body nears; the color of a wall may change when touched by a hand. Many of these installations are less about rethinking the body in its environment and more about demonstrating the technological tour de force of new materials. Thermo-chromics, which change color in the presence of heat; piezo-electrics, which generate electricity when deformed; and shape-memory alloys, which change form after an input of energy, have now joined the lexicon of architectural materials and technologies.

These materials can be classified as thermodynamic materials in that they all involve some form of energy transfer in order for their transformations to take place. Architects who have lusted after the active façade have seemingly had their desires sated. If these active materials form the surfaces and walls, if these surfaces and walls are interactive and respond to the human body, do we now have the merging of architectural boundary with energy boundary? Unfortunately, not yet. The hegemony of the picture plane subjugates any active response by these surfaces into a series of stills: a hand touches a wall; the wall changes color where the hand touched it. The point of the interaction is didactic: to visibly demonstrate that an interaction has indeed taken place. The body itself is pushed to the background; the hand is nothing more than a proximate switch. Bodily sensation is irrelevant.

How can the body occupy the foreground? How does one directly design for perception? What and where are the determinant boundaries? These

questions are very much at the heart of Philip Beesley's investigations. His use of textiles, meshes and matrices challenges the impenetrable barrier of the normative architectural envelope, while explicitly demonstrating that the territory marked by man-made objects is an abstraction not bound by the laws of physics.

Haystack Veil, installed in Maine in 1997, covers a quarter acre of woodland with a triangulated grid of twigs.[16] There is a profound sense of humanity asserting ownership and claiming territory, while simultaneously, the forces of nature adhere to their own rules: animals penetrated and eroded the structure, layers of plant debris settled into and onto the grid, tangled overgrowth usurped its form. Dominion belongs to the dynamic flows of energy, and not to static structure.

Beesley's latest installations engage the human body in this push and pull between the objective constructed surface and the subjective energy interactions. His Hylozoic series of immersive environments fully decouples the phenomena from the architectural surface—each energy exchange is discrete and localized. The physical components for creating those exchanges are pragmatic, functional constructions, completely alien to the architectural lexicon. The textile mesh defines territory, but it is clearly not the generator or even a primary determinant of the various exchanges. Rather, the mesh serves as their armature. The site of architecture relinquishes the phenomenological behaviour to the site of the discretionary exchange, enabling direct engagement between body and phenomena. The constituent stasis of the mesh as armature yields to the transient contingency of the body's interactions with its environment.

Unlike the interactive installations of his contemporaries, Beesley's environments always question the idea of boundary, and in doing so, question the very nature of architecture. Not content to activate a surface or automate a building system, Beesley reconfigures the concept of interactivity through layers of sensors and actuators feeding forward from the body and back to the body. The body essentially sets off a localized chain of events that appears analogous to sensor pod system that agencies such as NASA are developing.[17]

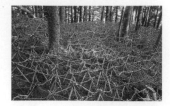

16 Haystack Veil, Philip Beesley, Warren Seelig, and Haystack Mountain School for Craft students, Deer Isle, Maine, 1997.

17 D. Michelle Addington and D.S. Schodek, **Smart Materials and New Technologies for the Architecture and Design Professions** (Oxford, 2004), Chapter 5.

The sensor pod system operates between the two extremes of an autonomous environment and an interactive network. Sensors and actuators are distributed throughout an environment, but they communicate and collaborate in small clusters known as pods. Each pod has a master node that carries a higher level of decision making capability than the local sensors and actuators in its cluster, and it is this node that has the freedom to engage and disengage. In Beesley's environments, the body operates as the master node around which a locus of activity hums. The body now forms the constituent architecture, whereas the surrounding physical objects—the field of mechanisms—are rendered contingent. Architecture emerges in the space of activity.

18 George Baird, The Space of
 Appearance (Cambridge, MA, 1995).

19 Hannah Arendt, The Human
 Condition (Chicago, 1958).

The architect and theoretician George Baird turned to political philosopher Hannah Arendt for inspiration when he wrote *The Space of Appearance* in 1995.[18] Arendt had posited that what constitutes the public was not the community at large, or even that which was not private, but rather the body politic in action.[19] As such, the public only appears through the processes of speech and action. Baird carried this concept further by defining the public realm as the physical place that creates a space for this appearance. Baird's concept, however, can be much broader than his description of urban public space. Architecture, whether as room, building, or urban setting, establishes the tangible armature that allows for the contingent appearance of phenomena. For Baird, the need for tangibility kept image and surfaces in the foreground of architecture, even as he conceded that the purpose of that tangibility is enabling action. For Philip Beesley, the purpose of tangibility is not to create the space of appearance, but to create appearance itself. Architecture is no longer object; the boundary is no longer surface. Architecture only appears through tangible action.

ARCHITECTURE OF CONTINGENCY

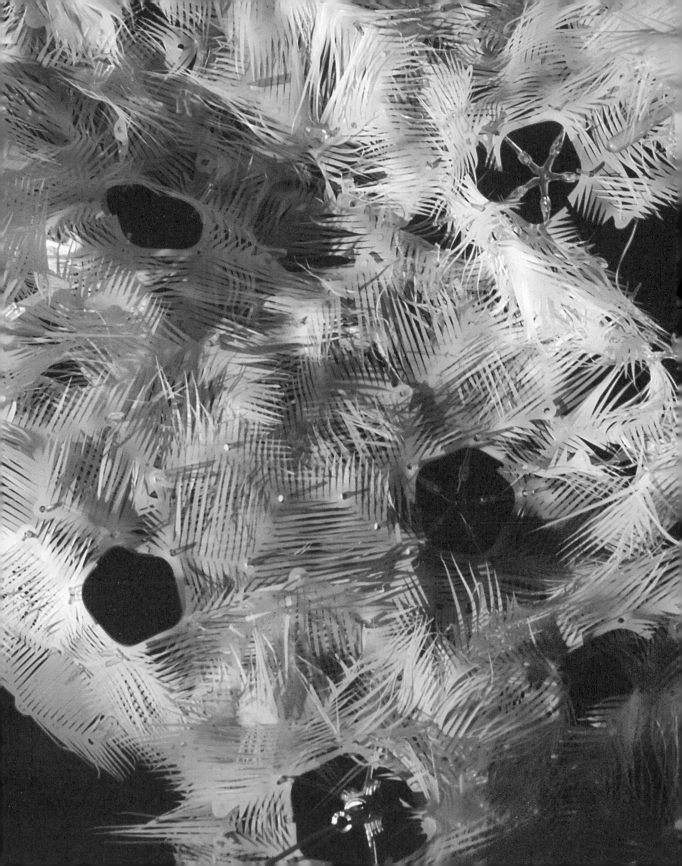

Hylozoic Ground

Canada Pavilion,
12th International Architecture Exhibition

LA BIENNALE DI VENEZIA, VENICE
August 29–November 21, 2010

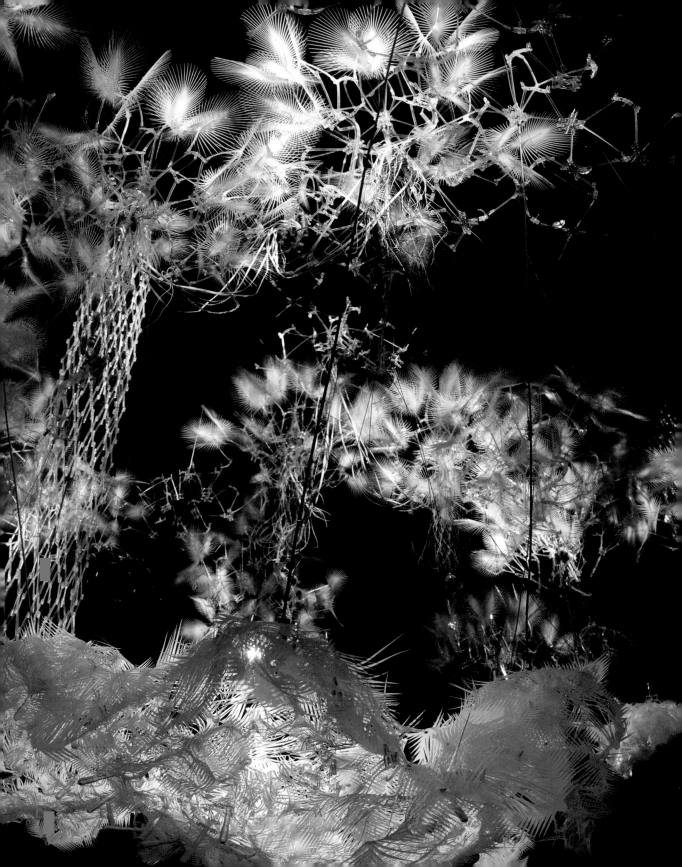

Integrated Systems
The Breathing Cycle

JONAH HUMPHREY

The Hylozoic series pursues living, breathing systems of architecture and landscape, organized in self-generating complexes. The immersive Hylozoic environment operates in a manner akin to a living organism, considering its multiple layers of moving assemblies, emulated metabolism, and responsive actions. These elements combine to form a distributed network of dynamic and cooperative structures and integrated systems spanning multiple scales. The coordinated movements of the system can be thought of as a *breathing cycle*, as the environment circulates air and filter particulate matter through its expanded meshwork membrane for self-sustenance. The underlying meshwork functions as a responsive fabric, forming the main canopy and columns of the Hylozoic environment. Fitted into this flexible membrane are hundreds of responsive kinetic devices. These devices function similarly to pores and hair follicles within the skin of an organism, and are organized in clusters or 'hives.' They act as both discrete colonies and integral organs necessary to the function of the system as a whole. Waves of kinetic

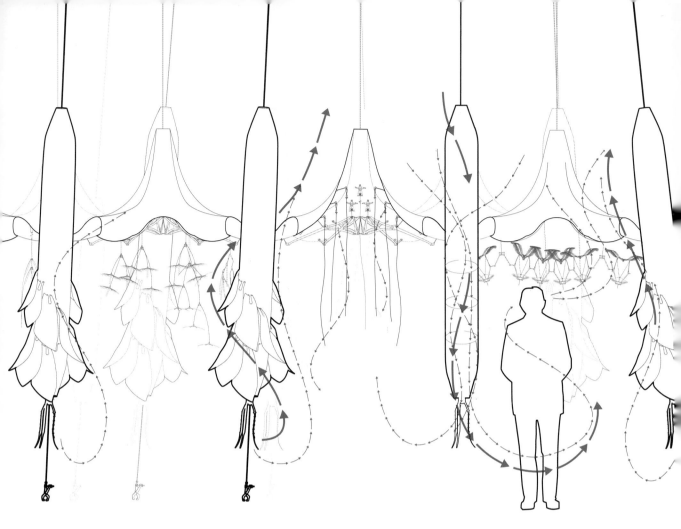

2 Breathing cycle flow diagram,
 Hylozoic Ground section.

JONAH HUMPHREY

reactions in the breathing cycle are activated by human occupants moving through the space. The environment supports an empathic, mutual relationship that initiates responsive motion, particle exchange, and air cycling between system and visitor.

breathing cycle

Choreographed airflow pushes particulate matter through the Hylozoic environment, where it is collected, filtered, and re-distributed in a continuous loop. Air passes down through the canopy to the zone of human occupation, before cycling back upward, following gentle spirals of thermal convection impelled by the combined peristaltic action of kinetic devices. This breathing cycle includes the operations of breathing, swallowing, filtering, and absorption, as well as the feedback between those processes and the visitors. *Breathing pores* and *sensor lashes* stir air while pulling air-borne organic material inward. *Swallowing actuators*, *whiskers*, *hygroscopic islands*, and stray *burr filters* further amplify the process of air movement and filtration.[2]

The responsiveness of the devices and processes in the breathing cycle allows the Hylozoic environment to expand its physiology to incorporate that of the visitor. In fact, the breathing cycle relies on the occupant in several ways. It is primarily the intruder that provides organic matter to the system. The presence of human occupants also affects the air flow, both passively due to general perturbation of air flow, and actively as their presence actuates the responsive devices in the system. This direct contribution of the visitor is an integral part of the breathing cycle and can be said to be desired by the system for sustenance.

Sensor lashes are catalysts in the Hylozoic environment. They activate at the beginning of the breathing cycle and provide direct reflex motion in response to approaching visitors. The lashes appear in clusters of three tongue-shaped devices, rooted into the base of meshwork columns. When actuated, fleshy silicone lashes attached to the tongues sweep air up from the floor with a delicate whipping motion, setting off a cascading upward airflow. These mechanisms are powered by shape-memory alloy 'muscle wire' attached to tendons that move the tongue in slow muscle contractions. Proximity sensors housed atop each tongue trigger impulses that guide subsequent reactions in the breathing cycle.

INTEGRATED SYSTEMS

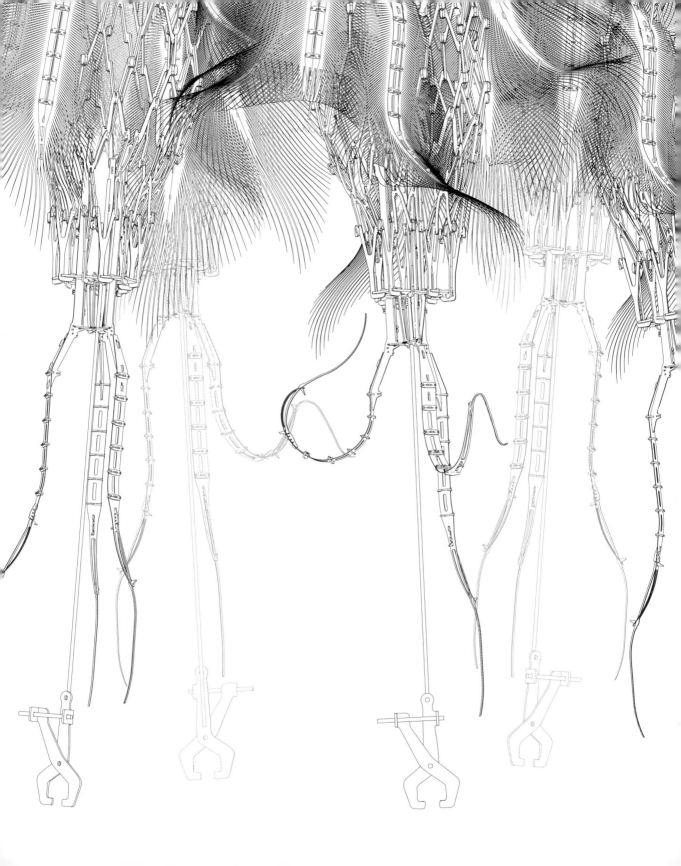

Breathing pores are inserted into the corrugated surfaces of the meshwork columns, reaching upward from the sensor lashes in helical chains. They are composed of thin mylar sheets shaped into serrated, outward-branching membranes. These pores act like dynamic fins displacing air, curved in order to minimize resistance in their counter-stroke movements. Like sensor lashes, breathing pores are powered by shape memory alloy–driven levers and tendons. The pores operate in sequences of upward-curling motions that amplify small amounts of energy, contributing to the overall spiralling airflow. Around the visible motions of these pores, invisible eddies are created in alternating, symmetrical vortex-shedding flow patterns. Secondary airborne particulate matter collects within the feathered tines of the fronds. Over time this particulate coalesces, thickening and clotting. A salt-charged gland, located at the base of each actuated frond, harvests materials from the diffuse bodies that form on these surfaces.

Swallowing actuators displace the column meshwork in a succession of expansion and contraction. Located within the columns, these employ chains of simple, ring-shaped air muscles, each composed of expandable latex bladders housed within polypropylene sheaths. The air muscles work in sequence to create a peristaltic motion, expanding and contracting the column meshwork in stages travelling from the cap to the base. In the next generation of wet circulation systems, downward movements within these segmented columns will perform a siphoning function.

Whiskers are wound wire pendants supported by acrylic outriggers with rotating bearings. Direct-current miniature motors spin the pendant wires, sending oscillating waves down the assembly. The whiskers are suspended from the meshwork canopy and arranged into dense, hovering colonies. Acting like flagella, the whiskers impel tiny spirals of air that break adjacent laminar flows, rousing dormant matter. Tensile mounts for the whisker colonies further amplify the cascades of rippling, spinning motion and transmit swelling wave motions into the supple mesh structure.

Primitive glands are clustered throughout the Hylozoic environment in weed-like thickets. *Hygroscopic islands*, *clamping needles*, and feathered *burr filters* crowd the mesh surfaces. This layer filters the air, treating it for human use while ingesting particulate matter for its own purposes. In this way it forms a kind of synthetic epithelium. Like the interstitial flora of the gut, the

3 Sensor lashes activate at the beginning of the breathing cycle. They produce direct reflex motion in response to visitors.

INTEGRATED SYSTEMS

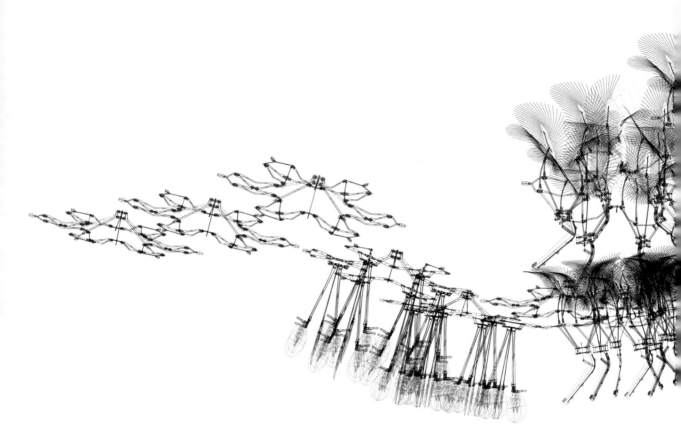

weed layer collects material as humidified air passes through its array of glands and bladders. Latex bladders containing digestive substances such as hygroscopic salts, brine, and soy, as well as next-generation protocells, are fitted with hollow needles for injecting and transferring materials within the system. These material exchanges are conceived as representing initial metabolic interactions from which living functions might arise in the matrix.

Suspended below the mesh-borne weed layer is the *filter layer*, a striated horizontal pumping system that directs a general downward flow of air and particulate matter. In early versions of the Hylozoic series, this layer was designed as a stationary pump, employing mouth-like valve forms arrayed within a continuous blanket filter, which operated by means of airflow pertur-bations. Recent iterations of the filter layer incorporate actuated arms, wired in groups that actively propel air and matter downward. Feathered acrylic

JONAH HUMPHREY

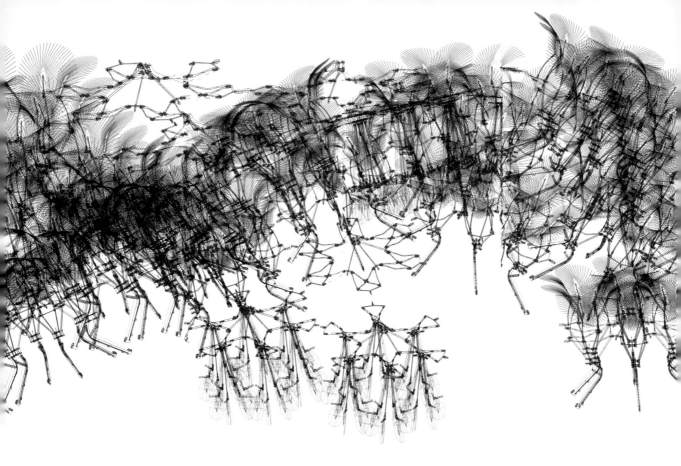

4　The filter layer is a striated horizontal pumping system that directs a general downward flow of air and particulate matter.

rhombic tiles are arranged in alternating radial pentagonal and hexagonal arrays. The edges of adjacent 'frond' tiles cluster together and make pore-like incurving valve forms, assisting air movement downward while collecting material in the fine layer of lacy leaves.

Clamping needles, embedded in the weed layer, are parasitic weed elements that act relatively independently. From within a grove-like cluster of bladders, a thin tube is fed through four acrylic teeth, designed to grasp in a slow centrifugal motion. The clamping needle is fitted with two sets of probes, curved in opposing directions. Stray vibration caused by human occupation produces small motions within the probes. The radial probes move in opposing clockwise and counter-clockwise directions, driving a ratcheted spring-loaded assembly that provides glacial propulsion. The bladders contain an injection medium, supporting the spread of future spore growth in the Hylozoic environment.

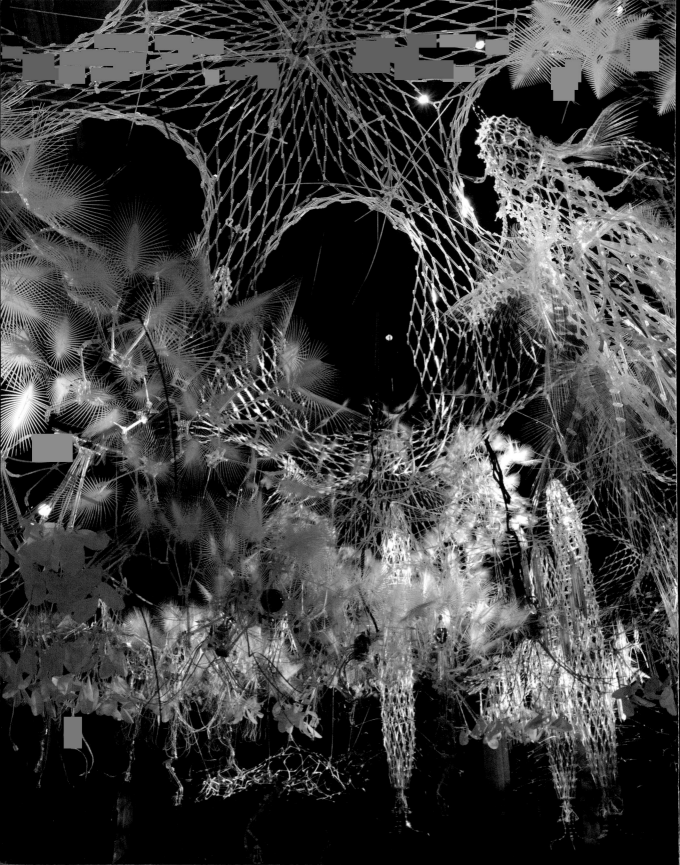

Topology and Geometry
The Hylozoic Mesh

CHRISTIAN JOAKIM

The scaffold that supports Hylozoic Ground is a resilient, self-bracing, diagonally organized space-truss that shapes and informs the system's geometric organization. Distributed responsive systems, colonies of assemblies, and actuated devices within the Hylozoic environment are rooted in this meshwork foundation.

Curving and expanding the mesh creates a flexible hyperbolic grid-shell that stretches and deforms to embrace visitors in the space. The meshwork is composed of flexible, lightweight chevron-shaped linking components. The chevrons interconnect using snap-fit fastening to create a pleated diagonal grid surface—a *diagrid*. Columnar elements extend out from the diagrid membrane, reaching upward and downward to create tapering suspension and mounting points. The recursive nature of the geometric involutions and evolutions of the mesh give rise to a fecund surface—a second skin of the Earth, rich in possibilities and thick in pleasures. The actuated surficial geotextile offers an extension of the Earth's living crust.

facing page

1 Hylozoic Soil, "(in)posición dinámica," Festival de Mexico, Laboratorio Arte Alameda/ Ars Electronica México, Mexico City, 2010

chevron

The core unit of this structural mesh is a bifurcated chevron link, an optimized laser cut form with an interlocking 'snap-fit' receiver at each of its junction points. The V-shaped chevron design contains thickened feet and head, strong shoulders, and slender arms that are capable of twisting slightly. The design of this element, intimately coupled to material characteristics of the acrylic, gives the Hylozoic mesh its substantial geometric flexibility.

The underlying chevron-shaped geometries of the Hylozoic mesh relate to herringbone patterns used in traditional fabrication systems such as masonry, woven textiles, and embroidery. Early explorations of the Hylozoic chevron unit were based on space-filling tessellated tile systems with components laid back-to-back, completely filling stock material sheets.[2] Shaping these components to achieve full tessellation involves an iterative design process where successive generations of components are refined in numerous cycles of testing.

When the Hylozoic chevrons are snapped together foot to foot, the two-dimensional herringbone pattern expands to form a structural diagrid. This corrugated chevron sheet offers a flexible structure, capable of acting in both tension and compression. This basic structural geometry was the catalyst for generous form-finding exploration during the initial development stages of the Hylozoic topology.

Columnar forms emerge by assembling loops of connecting diagrid strands in rows. Expanded sheets of assembled diagrid strands create flat panels that can warp into arched forms. By connecting progressively lengthening diagrid strands in rows, more complex fabric forms emerge, including conical caps for columnar elements, and double-curved hyperbolic arched sheets. The lily-like forms of the Hylozoic Ground canopy are created by combining sets of hyperbolic arched sheets and conical caps.

Individual chevron components and the assembled mesh topology have evolved in parallel. The physical geometry of the basic chevron has developed as demands on its flexibility and strength have increased. Alterations have been made to the profile thickness, the width of the arms, the dimension of the snap-fit, and the scale of the piece itself, in order to accommodate new formal and structural explorations of tiling patterns and component arrays.

2 While there are many systems of tessellation—regular, semi regular, symmetric, asymmetric, and fractal—the developmental focus of the Hylozoic project initially concentrated on periodic and aperiodic systems. The 'quasiperiodic' tessellation systems that have resulted are discussed further in this chapter.

facing page

3 Hylozoic chevron diagrid sheet.

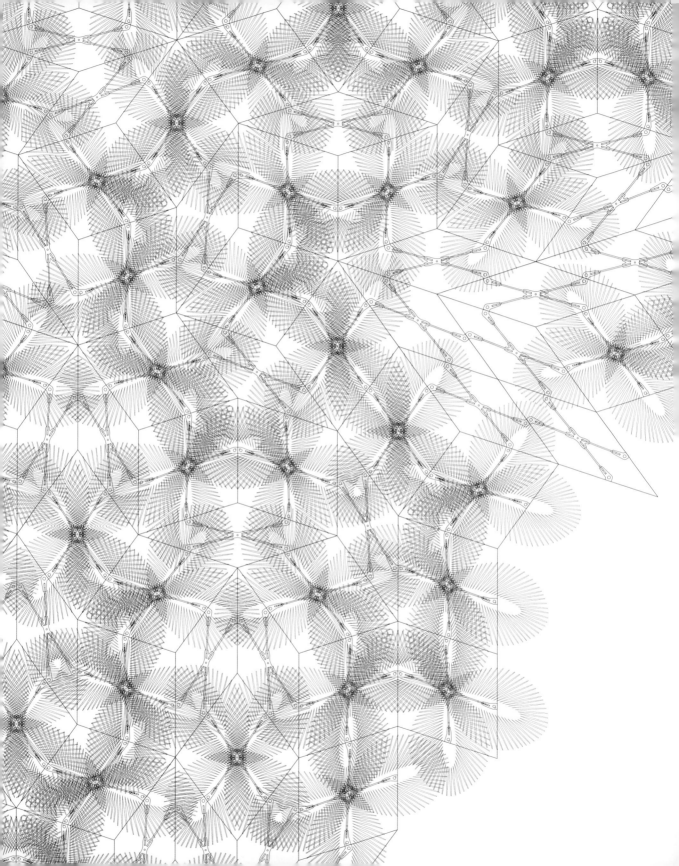

ordinance

The choice of a specific geometric system implies an ordinance, the authoritative geometric figure which grounds the possible arrangement of subsystems and components. Universal geometric ordinance systems have long cultural histories.[4] Multiplication of the ordering units of three, four, and higher multiple–sided units in regular arrays reveals efflorescent, crystalline fields of possible formations. However, while transcendent orders recur in the Hylozoic series, they are heavily modified by local circumstance. On the other hand, the ordering system of the Hylozoic series is far from a pure, chance-driven 'aperiodic' system that avoids repetition. The combined effect of local variation and generalized orders produces heterogeneous, reticulated 'quasiperiodic' fields of material.

The Hylozoic topology has pursued driving factors of variation, flexibility, and order in its evolution. Initial explorations into non-repeating two-dimensional systems employed Penrose tessellation derived from preceding projects including *Orgone Reef*, *Orpheus Filter* and *Implant Matrix*,[5] and more recently in the filter layers that appear within the Hylozoic series. Penrose tessellations, invented by British physicist Roger Penrose, are generated from sets of 'prototiles' that make up the particular tessellation patterns. These prototiles may possess rotational or reflection symmetry, but general translational symmetries do not appear. While local symmetries and repeating clusters of units appear throughout a Penrose tessellation, the fabric as a whole does not repeat its patterns.[6]

Alongside the quasiperiodic system of rhombic tiles, a regular tiling system of hexagons has been used which exploits the diagrid surface structure to become infinitely expandable, both horizontally and vertically. Variability and flexibility in the rigid geometric pattern is achieved by varying the introduced components and by inserting bifurcations within ordered arrays.

lily and treo

The hexagonal pattern is constructed by stitching together six identical flat meshwork 'petals.'[7] When joined, the petals erupt into a three-dimensional *lily* structure that can be multiplied vertically and horizontally to form hyperbolic canopy elements. In early generations each lily terminated in a

4 Western culture provides particular examples, such as the distilled crystal forms that appear in Plato's **Timaeus**, and the quadrilateral system for colonizing urban space latent in the Judeo-Christian Genesis texts.

5 Orgone Reef, University of Manitoba School of Architecture Gallery, Manitoba, 2003. **Orpheus Filter**, "Digital Fabricators," The Architecture Pavilion, RIBA, Interbuild, Birmingham; 2003; "Digital Fabricators," The Building Centre Trust, London UK, 2004. **Implant Matrix**, "scale," InterAccess Electronic Media Arts Centre, Toronto, Ontario, 2006.

facing page

6 Example of initial explorations into non-repeating two-dimensional Penrose tessellation.

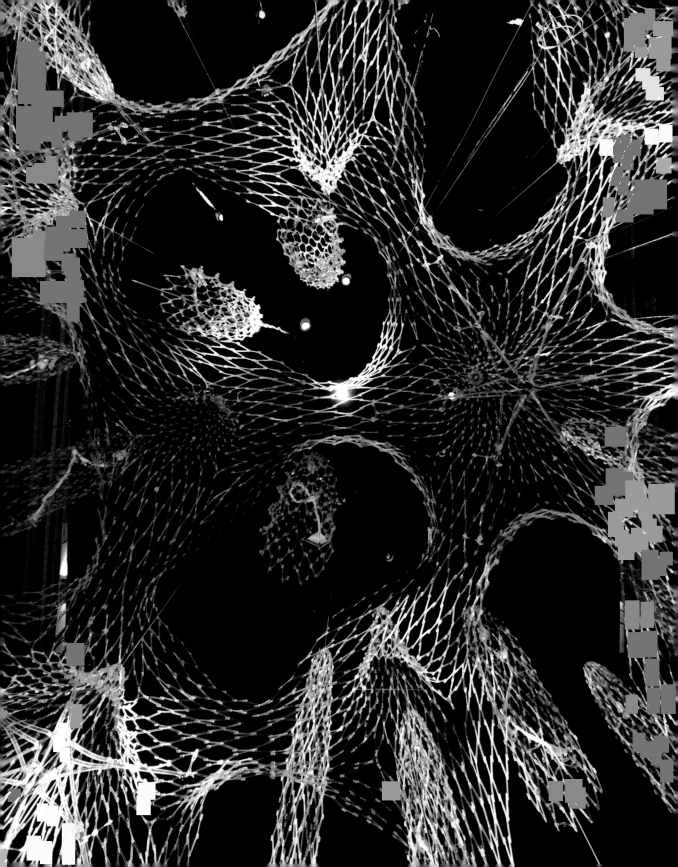

7 Hylozoic Soil lily petal.

columnar growth which, depending on the orientation of the lily, attached to either the floor or the ceiling. Triangular, vaulted structures, called treos, were introduced in the interstitial spaces among lilies to relieve the build-up of stress within the meshwork. These variations on the lily structure employed three panels compressed into arched volumes.

Recent iterations of the Hylozoic environment has replaced the treos with three way lilies and separated the columnar forms from the canopy, inviting those elements to develop freely as independent bodies placed in interstices of the continuous meshwork. By adopting this new tiling pattern of both three- and six-way lilies, circular apertures have been created within the hexagonal grid canopy. Through these apertures, angled stainless steel tension rods with toothed clamps bite into the ceiling and floor surfaces, supporting new freestanding columns. This revised geometry releases the canopy from the weight of the columns and pore mechanisms, and allows the columns to float dynamically in relation to one another.

Two basic petal tiles, both following a three-dimensional herringbone pattern, are preassembled before installation. Overlapping arched sections of petals remain uncoupled, releasing the arch forms and permitting flat packing. Due to their modular form, these petals can then be stacked and transported in small containers. The process going from chevron to mesh is quite beautiful: one begins with a flat material and a geometric shape that arrays to fill the two-dimensional plane. It lifts out of the surface, snaps together, and expands into a three-dimensional diagrid that is subsequently recompressed into a stackable, repeatable tile. Finally, it is expanded again to its fullest extent when the tiles are stitched together into the final Hylozoic mesh topology.

topology evolution

The original Hylozoic mesh used relatively few chevron types. Particular geometries were achieved by introducing bifurcations and complex patterning in the row-by-row assembly of the tiled units. In order to increase stability at points of weakness, the chevron was adapted by substituting the regular snap-fit joint with hook connections to suit the amplified tensile forces required by these areas. In transitional areas of the mesh, many

facing page

8 Mesh canopy lily and treo elements.

TOPOLOGY AND GEOMETRY

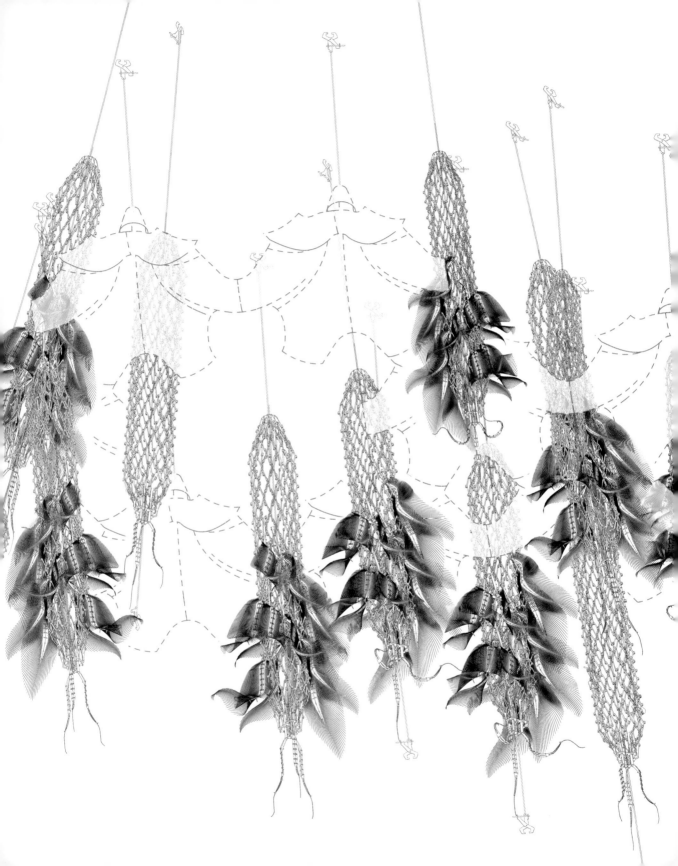

chevrons possess both snap-fit and hook connections to equip them for varying levels of force.

In high-stress regions of the mesh where the geometries generate intense torsion, the acrylic chevron was initially replaced with a vinyl chevron capable of adjusting to this twist. Later, specialized acrylic chevrons were introduced in these locations. The chevron's snap-fit joints were replaced by barbed feet designed to connect via resilient silicon tube details.

Chevrons have also been developed to taper, widen, and lengthen in order to increase the flexibility of the mesh geometry. Another category of chevrons encompasses those designed for specific roles such as device and mechanism connections, collar connections, and hanging connections. In the Hylozoic Ground installation at the Venice Architecture Biennale, approximately thirty different chevron types make up the mesh canopy and column system. After many successive generations, and out of relatively simple components, a topology of increasing complexity and diversity is emerging.

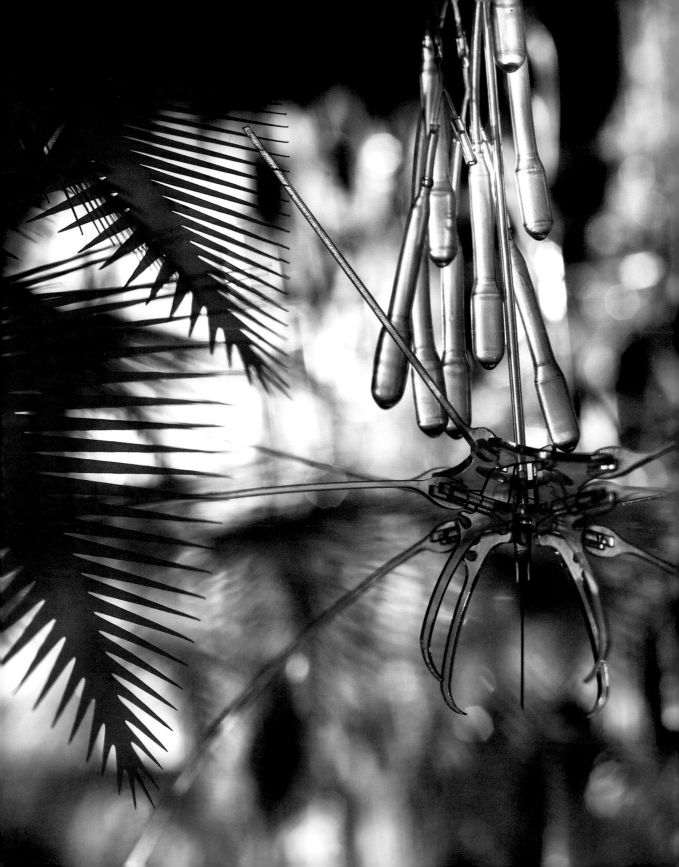

Component Design
An Evolutionary Process

WILLIAM ELSWORTHY

The design of the components, assemblies, and actuated devices of the Hylozoic series is an evolutionary process. Each specific device and each constituent component is developed incrementally, refined and specialized. Components develop in response to constraints that push their design towards strength, lightness, simplicity and expression. This iterative process improves the structure in specific ways—strengthening a local weakness, preventing a joint from cracking, or increasing range of motion. Initial production tends to focus on the component itself, clarifying and refining its individual qualities. The interface between an individual component and other devices is addressed in further cycles. Understanding how a component functions in its larger context—at the level of the assembled devices, or integrated system of which it is member, and within the environment as a whole—is fundamental to the component design. For example, comprehensive physical stresses involving torsion and strain tend to appear only after complete assembly, as the weight of the entire environment is

facing page

1 Filter layer detail. Hylozoic Soil, "(in)posición dinámica," Festival de Mexico, Mexico City, 2010

31/05/2010 2:30:25 PM

HylozoicGround_C68_18x24.dwg

balanced and distributed. Similarly, long term mechanical movement and cycling of integrated systems reveal unanticipated stresses on specific components.

The cycles of analysis, hypothesis, testing, and evaluation tends to produce a surplus, a plethora of offspring that remain as incomplete sketches, half-built joints, and preliminary test assemblies. As with biological evolution, general families of parts evolve in parallel, and are differentiated by incremental changes in geometry, connection, and utility. Changes in one component often affect changes in others and may speed up development, as lessons learned while working on one component can be applied to another in its family, like a kind of heredity. On the other hand, this process may cause a development lineage to be aborted because it has become obsolete.

component design

Acrylic, copolyester, and silicone—resilient, flexible, and self-supporting materials—are used to manufacture the bulk of components in the Hylozoic environments. The most commonly used material is sign-grade impact resistant (IR) acrylic. Resistant to distributed bending stress, IR acrylic is free of 'grain' or directionally-biased stiffness. IR acrylic is used for the chevrons that make up the Hylozoic diagrid meshwork and the skeletons of most Hylozoic assemblies and devices. The transparency of the hard IR acrylic is preserved by the particular laser-cutting process used in the studio, which polishes the edges of the plastic.

Localized or point stress can cause cracking and failure in the acrylic. To take advantage of its strengths and prevent weaknesses from manifesting, a number of features have been developed including snap-fit joints, crack-stop corners, and gussets. Copolyester is more flexible than IR acrylic, with increased resistance to cracking and corner stresses, but at the cost of a somewhat cloudy appearance. These qualities make copolyester suitable for hinges and flexible ribbons seen in the 'tongue' cores of the sensor lashes and breathing pores.

Cartilage-like layers of silicone appear throughout the Hylozoic environment. Silicone is extremely flexible and elastic, and is employed in pre-manu-factured tubes cut by mechanical means. Silicone's increased flexibility

COMPONENT DESIGN

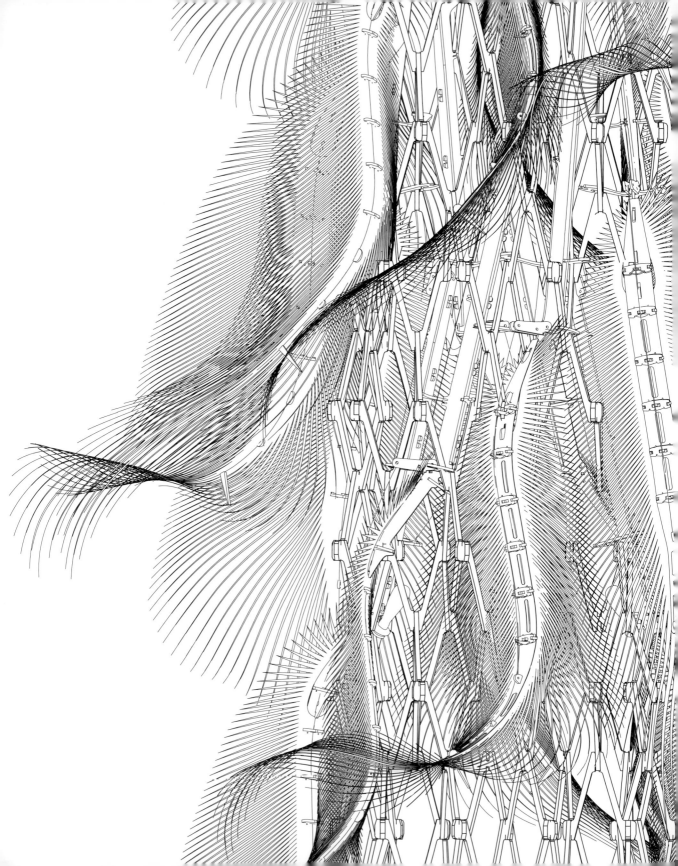

3 Snap-fit acrylic joints used in the C6B chevron diagrid arrangement.

4 Crack-stop detailing used in a Hylozoic component.

facing page

5 Breathing column prototype model.

makes it ideal for use in flexible joints and vibration dampeners for motors. In combination with snap-fit junctions, these layers are employed in areas receiving additional stress, including densely-massed systems of interlinking joints in the filter layers, demountable access vents within meshwork columns, and force-relieving gussets for the meshwork canopies.

Specialized snap-fit acrylic joints are predominantly used for joining mechanisms required by the Hylozoic meshwork, assemblies, and devices. Snap-fit joints are common in industrial and product design where they appear in such forms as the lip of a felt tip pen, or the snaps on vacuum-formed retail packaging. A standardized joint recurs within the system. This joint, which has undergone many iterations and stages of refinement, is used to connect two laser-cut acrylic components axially, tangentially, or in parallel.[3] IR acrylic has proven to be effective and reliable for manufacturing the snap-fit joints, and requires no other mechanical fasteners or adhesives. The length and thickness of the jaws and size of the ridges can be varied to produce loose, temporary connections or tougher, more permanent joints. While the flexibility and hardness of IR acrylic make it an excellent choice for snap-fit joints and bendable hinges, the flexural stresses on the material tend to concentrate at sharp corners, leading to cracking and failure. Crack-stop detailing involves filleting or rounding off the interior angles to distribute the stress over a greater area.[4] The amount of filleting or easing that is required is often fairly small relative to the size of the component. In some cases, the easing can be pushed into an internal cavity in the component. This approach is often used when the U-shaped crotch of a part needs to provide a positive stop to secure and limit the movement of another part. Crack-stop corner detailing is employed in a variety of components, including latching clips employed to secure air muscles in swallowing columns, tightly-fitted voids for modular jacks in actuated devices, and buckle fasteners for securing whisker sensors.

Joints, corners, and nodes can be strengthened by thickening as a way to re-direct stress to adjacent areas. Conversely, removing material from the edges of a part will weaken it or make it more flexible. In combination, these strategies can be used to focus bending to a particular area of a part and create a hinge. Creating smooth transitions between thinned and thickened sections prevents stress build-up and subsequent cracking. Creating a void in the interior of a component is a way to reduce the weight of a part while

COMPONENT DESIGN

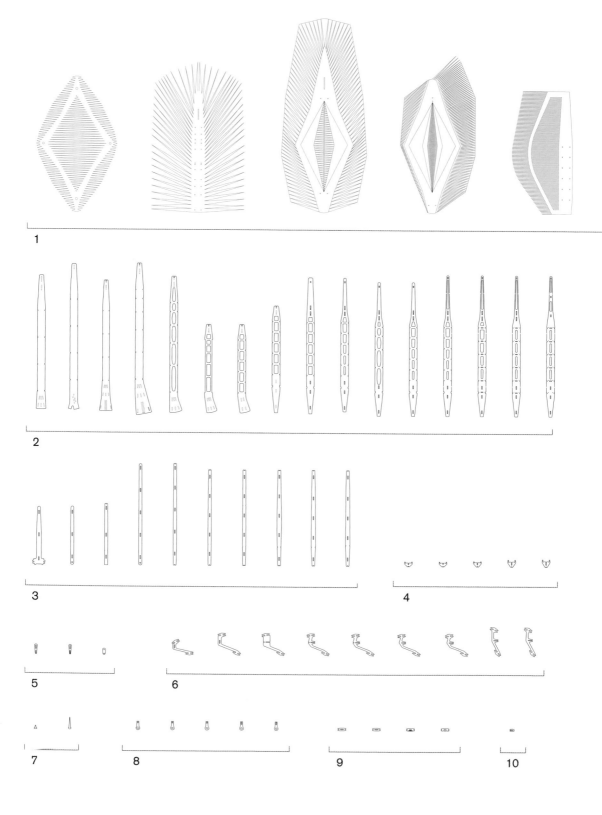

1

2

3 4

5 6

7 8 9 10

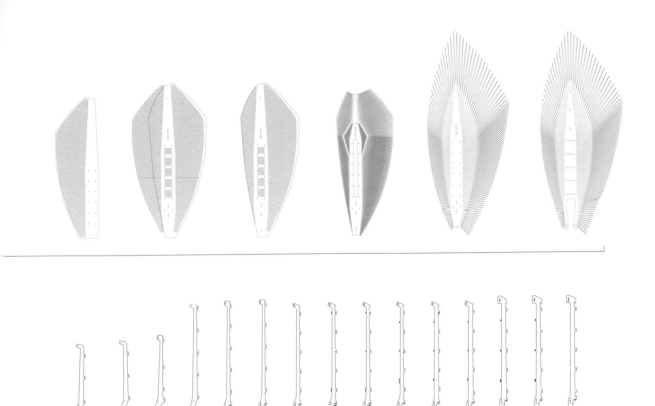

11

12 13 14

15

breathing pore evolution

1 Breathing pore feather 2 Tongue 3 Strengthening gusset for main spine 4 Tongue stabilizer 5 Shape memory alloy fin
6 Arm unit 7 Tongue lash 8 Gland clip 9 Strut clips 10 Lever stop 11 Main spine 12 Lever 13 Tongue strut
14 Tongue end strut 15 Attachment to mesh

maintaining strength. Refinement based on particular strategies of thickening and voiding has been applied to the chevron family of components, permitting these elements to handle substantial torsion forces.

While a combination of thickening and voiding can be used to add strength without increasing weight, these strategies are limited to two-dimensional orientations.[6] Third-dimension stiffness is often achieved with flanges, which are added locally for reinforcement. These are also attached along the entire length of a part to create T-shaped beams, as in the example of the breathing pore spine.[7]

The manufacturing stage is fundamental to the advancement of component design. Arrayed components are reconciled with the rectangular dimensions of a sheet of IR acrylic scaled to fit in the cutting bed of a CNC (Computer Numerical Control) laser cutter. The organization of the array prior to cutting can add another variable to component design, especially for components that will be produced in greater numbers. In order to use materials efficiently and reduce waste, the shape of the component is refined so that it fits a tightly as possible with duplicates and other components on the same sheet. In the case of the chevrons that make up the expansive mesh lattice, the tessellation of the component has been refined to the point where they are fully nested and share edges. Sharing edges makes it possible to remove overlapping lines, greatly reducing cutting time and reducing material waste to nearly zero.[2]

IR acrylic responds well to laser cutting, which produces smooth, clear edges. The heat of the laser tends to vaporize the upper surface to a greater degree than the lower, creating V-shaped cuts and bevelled edges. The greater the thickness of acrylic, the more power is required to cut through the material, resulting in more pronounced sloping of the cut edges. Tuning both snap-fit and simpler, slotted joints becomes increasingly difficult in components cut from the thickest acrylic, since the diameter of a slot at the upper edge may be significantly wider than at the lower edge. Given this eccentricity of laser cut pieces, thinner IR acrylic stock material is selected wherever possible; this has the added benefit of also reducing weight and cutting time.

6 Voiding in this component creates flexibility and reduces weight.

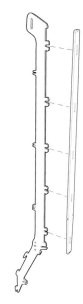

7 Flanges are designed to add rigidity and strength to components.

kinetics and actuated devices

Hylozoic Ground includes a large number of actuated, kinetic components including the filter layer, swallowing actuators, sensor lashes, and breathing pores. The iterative refinement process has proven critical to the development of the actuated devices in achieving both efficiency and physical and conceptual integration into the Hylozoic environment.

Several actuation mechanisms have been explored at various points during the design development. Of the many different solutions available, the silent, subtle motions produced by shape memory alloy (SMA) wire support its primacy among materials used in Hylozoic Ground. Flexinol (a trade name for the nickel-titanium alloy material) has a crystalline structure that can be stretched mechanically when cool, and can then be reset to its original, shorter length by applying heat via electrical current. The high strength of the wire in its hot state means that it can exert a sizeable amount of force when it contracts. The amount of force exerted and current required are proportional to the thickness of the wire. Initial development in the Hylozoic series employed thin (0.004") wire, keeping power consumption to a minimum. More recently, thicker-diameter (0.012") wire has been used for its increased strength and durability. To balance the increased power demands of the thicker wire, behaviour patterns to organize and limit the number of SMA wires that are activated at any time have been explored.

Flexinol's response to electrical current is silent. The contraction of the wire is characterized by a logarithmic envelope response pattern, similar to the natural movements of muscle fibres in living organisms. An individual wire will only contract by about five percent, inviting the use of amplifying levers layered with tendon and pulley systems to create visible motion.[8] Mechanical linkage systems have proven to be an effective way to balance degree of movement with strength.

The Hylozoic filter layer employs clusters of devices that contain rigid structural skeletons, containing long, extended arms that have been thinned to create a hinge point. SMA wire is installed just above this hinge point to effect the greatest motion at the top of the tapering arms where the filters are attached. Successive generations of these devices have pursued increased motion, focusing on hinge and arm profiles. The hinge design

8 Delicate 0.004" diameter muscle wire can exert 150 grams of pull force per foot, while 0.012" wire can exert a formidable 1,250 grams of force per foot.

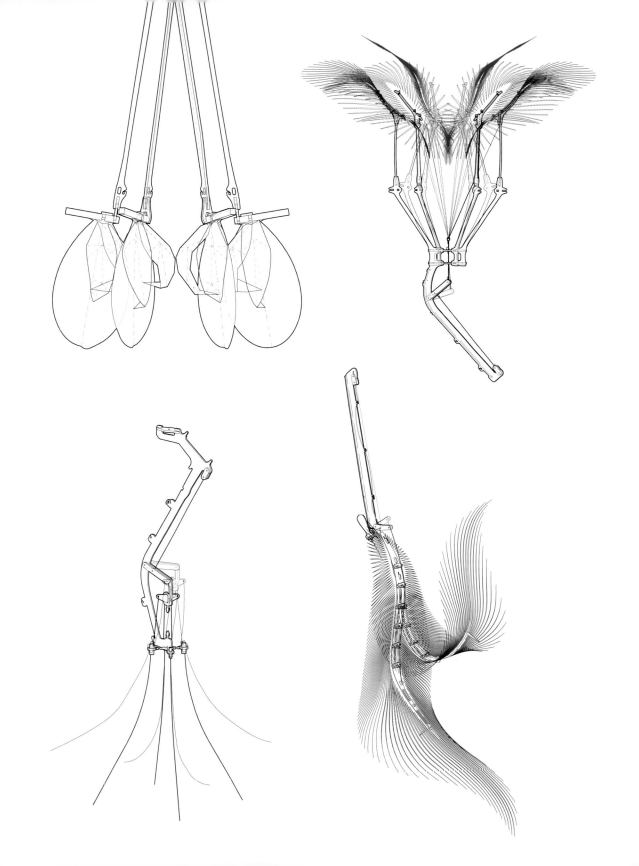

attempts to strike a balance: being supple enough to allow the SMA to express its potential, while stiff enough to fully stretch out the SMA in its cooling phase. Laser cut mylar fronds are mounted at the top of the long arms. Folds created by laser-scoring the mylar were designed to give stiffness, and to accent and focus the movement.

The actuated devices referred to as breathing pores and sensor lashes achieve dynamic motion in a more complex way than the actuated devices in the filter layer. The core assembly of these devices is a flexible acrylic and copolyester tongue. A long tendon of high-strength nylon filament is used to pull on the tip of the tongue. The tendon is then attached to the tongue at specific intervals to compound the relative movement of the tendon. Design iterations have lead to a tighter spacing of filament guides, calibrated to the material's tendency to form a local hinge point. With tighter spacing, the interior of the tongue could be voided to reduce the pull force required. This was instrumental, as it allowed the tendon to be placed closer to the tongue, thereby creating a dramatic increase in movement with less total tendon pull, but with the pull force still kept in check. The relationship that formed, whereby more pull force and movement could be achieved with reduced energy input, made for an effective marriage of these components with SMA wire actuators.

Designing the swallowing actuators presented a different sort of challenge. Generating enough force to move the strong structural grid over a large distance had to be balanced against maximizing the effect of the motion. To address this, the swallowing columns have undergone three major changes within the Hylozoic series.

The first series of swallowing actuators employed a paired linking mechanism in the form of a scissor-type jack.[9] When the initial triangle of the jack can be turned to reach wide, obtuse angles, contraction along its hypotenuse will produce the greatest increase in the distance between this vertex and the hypotenuse, and thereby create the greatest effect. Predictably, this effect comes at the expense of additional required pull force. This also requires a long apparatus compared to the effective length of the device. To increase pull force to the levels necessary to distort the three-dimensional structural grid, three SMA wires were used in tandem to operate a rigid tri-axial linkage reaching out to points around the perimeter of the inner column

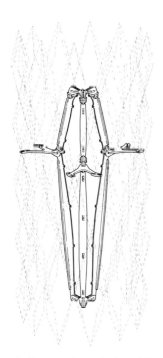

9 First generation swallowing actuator incorporated a scissor-type jack.

facing page

10 Actuated devices using SMA.

Clockwise; cricket assembly, filter assembly, breathing pore, capacitance whisker.

COMPONENT DESIGN

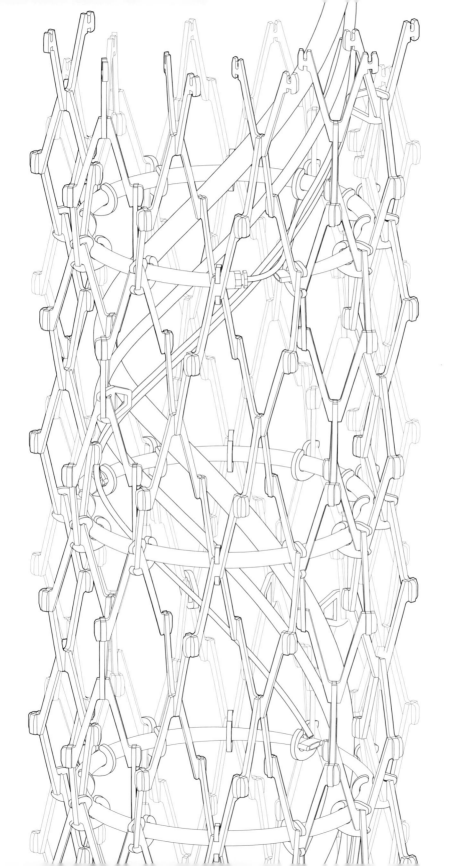

walls. To increase their reach and strength, the segments of the linkage were thickened through their middle sections, and gusseted. Threaded fasteners were used to connect the segments, creating hinge points at the vertices of the linkage. Relatively complex, time-consuming part assemblies resulted from this approach.

A second version of the swallowing actuator was grafted onto the inside surface of the column, operating in isolation to locally deform sections of the column grid.[11] A mechanism similar to the first version was used, though the way in which its elements were distributed and operated was inverted: The SMA moved from the hypotenuse to replace the two formerly rigid segments' triangular linkage, while the hypotenuse transformed into the structural backbone of the device. This structural rib was doubled up, stiffened, and shaped to follow the curvature of the column and provide clearance for the rod assembly. The SMA is housed between the two ribs and rolls around wire pulleys at the vertices of the linkage, allowing many fasteners and pivot points required in the earlier version to be eliminated entirely. These pulleys also allow the SMA actuator to be lengthened and folded back on itself to increase the total amount of contraction.

Using obtuse-angle geometry to maximize the SMA contraction as before, the force is in turn directed to the column walls by a wire rod guided by a plate spanning the ribs. To allow the wire rod to withstand the heat of the SMA actuator, a part was digitally modelled and manufactured in ABS plastic using 3D printing technology. This part fits onto the end of the wire rod and accepts a small metal ferrule that can handle the heat given off by the SMA as it contracts under current. Digitally modelled and printed elements like this allow for complex connections and relationships to be greatly simplified.

In the current iteration of the swallowing column, miniature banks of SMA-powered pneumatic valves are used to control air pressure in rows of ring-shaped custom air muscles, coordinating their action to produce a peristaltic motion in the surrounding meshwork. Fixed-length interwoven polypropylene jackets restrain the inflated dimensions of the muscles' latex core. Increased diameter forced by the distended latex results in shortening of the muscle. The silent action of these SMA valves offers a subtle envelope of response, similar to the organic movement implied by muscle wire-actuated kinetic devices within the environment.

facing page

12 Third generation swallowing column
incorporates miniature banks of
SMA-powered pneumatic valves,
used to control air pressure in rows
of ring-shaped custom air muscles.

COMPONENT DESIGN

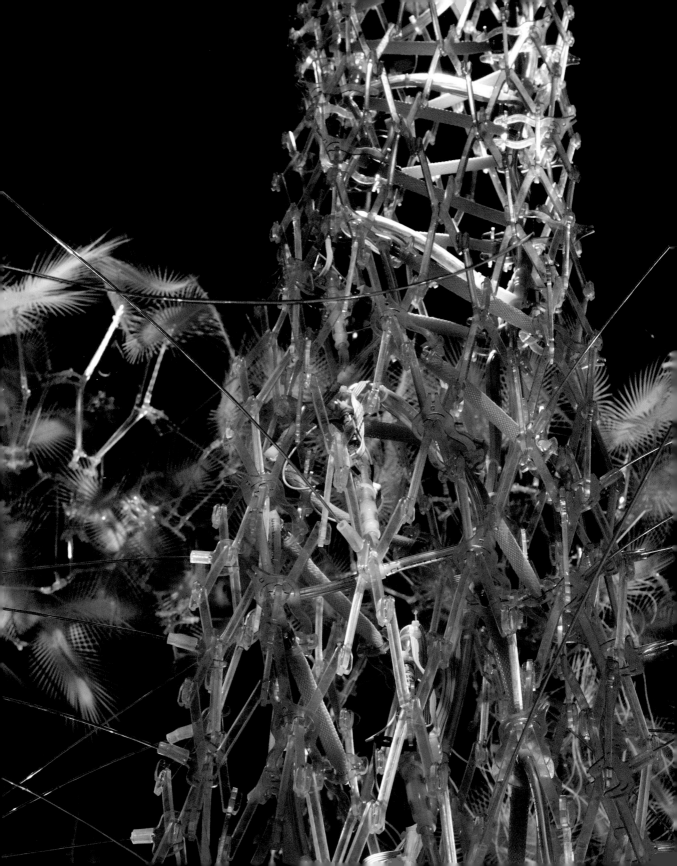

Refinements in the swallowing actuator have prompted parallel experiments aimed at creating flexible axes within the diagrid mesh structure without undermining its integrity. Variants in the design of the chevron components, and the use of silicone tubing to create flexible connections at particular points within the matrix, have increased the performance of the diagrid meshwork. These changes have also reduced the pressures on devices and the actuators, increasing the integration of kinetic devices within the fabric of the Hylozoic environment while still permitting wide deformations and a highly varied topology.

facing page

13 Swallowing columns.
 Hylozoic Soil, "(in)posición
 dinámica," Festival de Mexico,
 Mexico City, 2010.

COMPONENT DESIGN

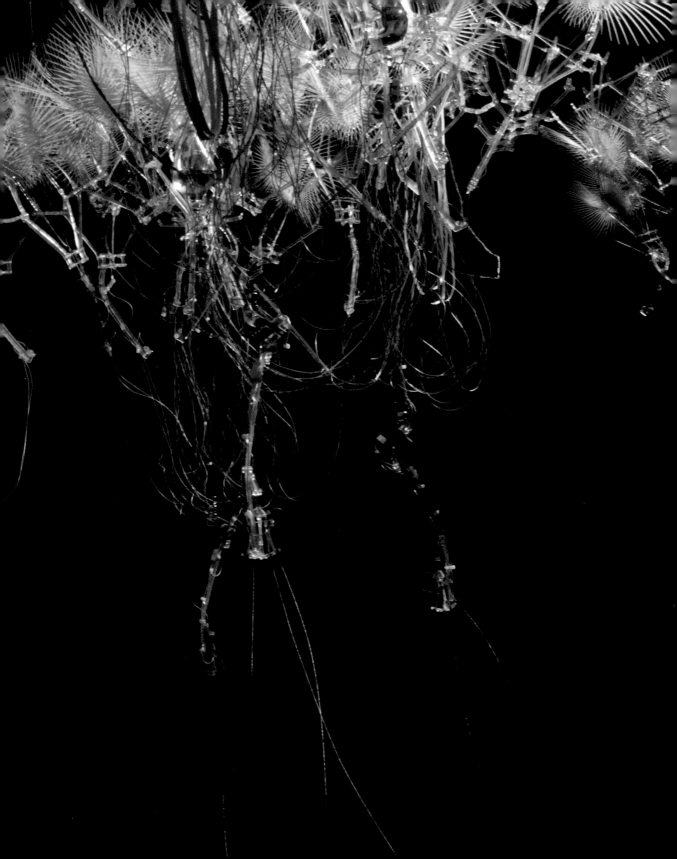

Revealing the Hylozoic Ground Interaction Layer

ROB GORBET

The immersive, interactive environments of the Hylozoic series are prototypes of responsive architectural spaces that in the future will offer empathic, sympathetic environments for occupants. This chapter exposes the systems—electronics, sensors, actuators, and communications—that facilitate the Hylozoic system's interactions between environment and occupant.

One of the questions frequently asked by artists and non-artists alike is whether it is possible to make 'good' technology art. Like any artistic medium, one can find examples of varying quality, and since evaluation is often subjective, the easy answer is "yes." It can be difficult, however, to apply the traditional tests of quality—particularly recognition in gallery exhibitions and museum collections—to technology-mediated works, because rapid obsolescence and difficult documentation pathways make them expensive or impossible to maintain in exhibition environments.

facing page

1 Filter layer detail, **Hylozoic Soil: Meduse Field**, "Mois-Multi Festival," Meduse, Quebec City, 2010.

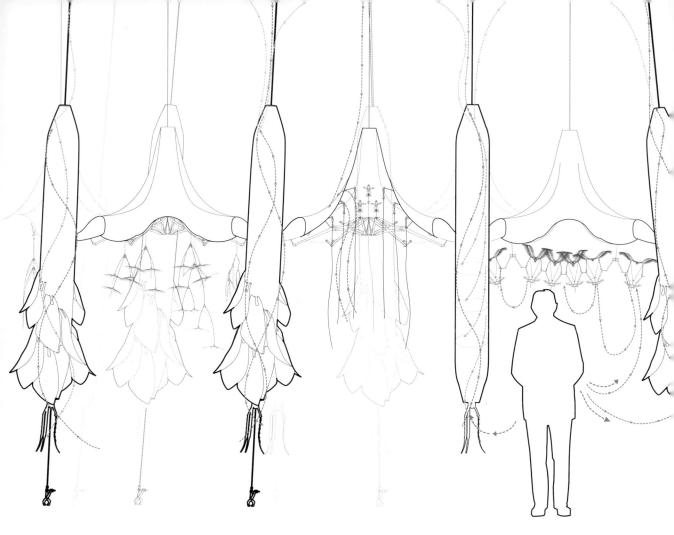

2 Visualization of programmed series of
 motions initiated by occupants within
 Hylozoic Ground.

This is the case for screen-based works, which rely on computer hardware and electronic storage. But it is even more true of kinetic and interactive non-screen-based works, like the Hylozoic environments, because of their reliance on numerous physical components as well as distributed and embedded systems. New paradigms are being developed for curating and documenting these works, often termed 'variable media,' or 'new media.' Examples include Richard Rinehart's *Media Art Notation System* (MANS), or Jon Ippolito's *Variable Media Questionnaire*, which spawned the Variable Media Network (www.variablemedia.net) in partnership with the Daniel Langlois Foundation. Enriching discussions are taking place in forums like CRUMB (Curatorial Resource for Upstart Media Bliss; www.crumbweb.org).

A central parameter in the assessment of 'good' interactive art is the extent to which the interaction allows access to the experience of the artist's intent. The *potential* for interaction, particularly computer-mediated interaction, is so great that the designer can be tempted to pursue something just because it is possible. The creation then becomes slave to the technology, rather than the technology service the concept, and the experience of 'using the interface' obscures the work. This is not to say the technology must be transparent, or that the experience of the interface cannot itself be a part of the artist's intent. But the 'interaction layer' should not be so thick that it becomes impossible to penetrate beyond to the 'conceptual layer.' In such cases, even if the user leaves feeling satisfied with their experience, the work has failed to effectively convey the artist's intent.

the arduino project

Within the Hylozoic environment, the thin interaction layer is implemented using low-level embedded electronics and distributed sensing and actuation systems, powered by the Arduino platform. Arduino is an open-source physical computing platform that was created to make tools for software-controlled interactivity accessible to non-specialists. The Arduino microcontroller board can read sensors, make simple decisions, and control devices. This palm-sized computing platform is the product of an open-source community project that began with a small group of hardware developers giving work-shops, and that now numbers many tens of thousands of international users that co-operate in developing specialized applications. The first developers of Arduino—Massimo Banzi, David Cuartielles, Tom Igoe, Gianluca Martino,

REVEALING THE HYLOZOIC GROUND INTERACTION LAYER

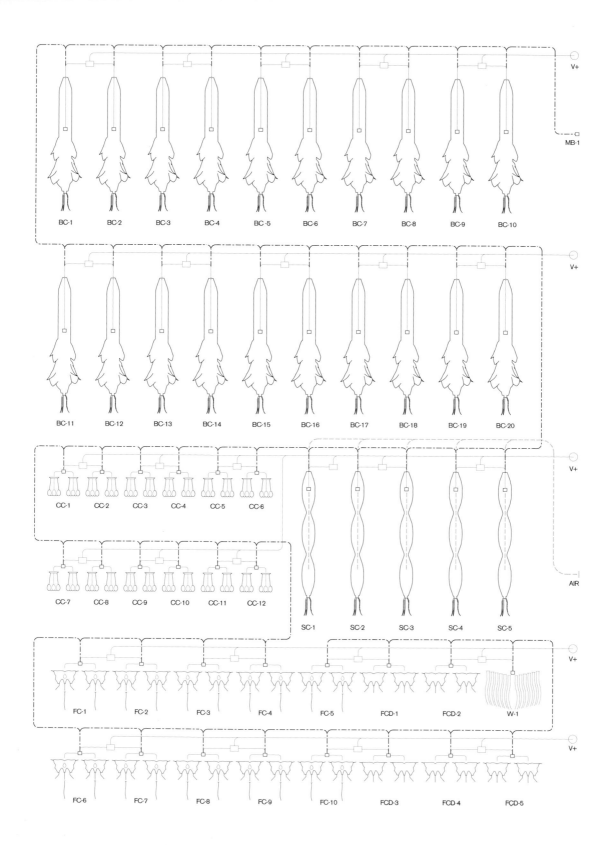

David Mellis, and Nicholas Zambetti—ran workshops demonstrating assembly of the devices, and gave copies of the board away to stimulate development. A community of developers and users now provides co-operative support, and the programming environment and documentation is written with the neophyte in mind. To date, the Arduino community has created myriad documents describing how to extend and interface Arduino with different systems. Examples include MaxStream's inexpensive and compact XBee RF wireless transceivers; Bluetooth-enabled mobile phones, using the Arduino BT extended board; LCD displays; and Cycling 74's Max/MSP/Jitter graphical scripting environment.

The distributed nature of the interactive environments in the Hylozoic series and the group behaviour that emerges relate strongly to the open-source ethos of the Arduino project. Individual occupants move within the Hylozoic environment as they would through a dense forest thicket. Local sensors embedded throughout the environment signal the presence of occupants to controlling microprocessors, and motion ripples through the system in response.

Dozens of microprocessors, each controlling a series of sensors and actuators, collaborate indirectly to create emergent reactions akin to the composite motion of a crowd. Visitors move freely amidst hundreds of actuated kinetic devices within this interactive environment, tracked by many dozens of sensors organized in 'neighbourhoods' that exchange signals in chains of reflexive responses. The installation is designed as a flexible, accretive kit of interlinking components, organized by basic geometries and connection systems. Like the open source Arduino project itself, variations are produced by numerous individuals during the assembly of the piece. At all levels—assembly, function, and experience—the result expresses the turbulent chorus of a collective accretion.

the hylozoic control system

The control system that was developed for active functions within the Hylozoic environment deserves mention. The micro-controller used in this Arduino platform is the Atmel ATmega168, a tiny computer-on-a-chip that contains specialized hardware to process digital signals, read analog inputs, and communicate over a serial connection. Software is custom written in

facing page

3 Global Systems Diagram showing all actuated elements, communications routing, power distribution and air supply routing, Hylozoic Ground.

BC	Breathing Column
SC	Swallowing Column
CC	Cricket Cluster
FC	Filter Cluster
FCD	Filter Cluster Drone
W	Whisker Cluster
MB	Masterboard
AIR	Main Air Supply
V+	Main Power Supply

REVEALING THE HYLOZOIC GROUND INTERACTION LAYER

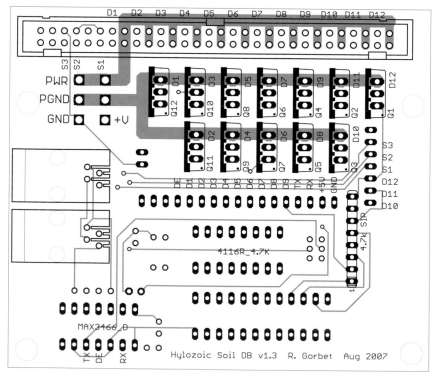

a high-level language on a personal computer and programmed into the microcontroller by connecting the Arduino board to the computer's standard USB port.

The version of the Arduino hardware used for the Hylozoic series is the Bare-Bones Board, developed by Paul Badger.[4] This inexpensive implementation of the platform has a small forty-by-sixty-millimetre footprint, and is provided either fully assembled or in kit form. The board includes components for power regulation, timing, and external digital inputs and outputs that can control a range of interactive devices. A custom 'daughterboard' (or 'shield') was developed by the author to provide three key additional elements to extend the function of the main board: a high-current output stage, configuration switches, and a communication interface.

Twelve high-current output channels permit digital control of devices at currents of up to one amp per circuit and voltages of up to fifty volts. Twelve switches are read by the software during initialization of the boards, and can be used for functions such as configuring individual board addresses and specifying software modes to control board behaviour. The communication interface converts serial communication signals from the Arduino and supports high-speed distribution to a network of boards using the RS485 standard. The daughterboard also provides a sixty-pin ribbon cable interface for connecting actuators and sensing devices. There is a two-channel power connector to distribute high currents to actuators as well as a lower current 'electronics' supply.

actuation

The Hylozoic environment includes several kinds of actuated elements: breathing pores, sensor lashes, filters, crickets, and swallowing actuated by shape-memory alloy (SMA) muscle wires; whisker elements driven by small direct-current motors; and a range of lights including high-powered LED clusters and miniature signalling lights. The devices are designed to operate at five volts and are interchangeable in the control harness, allowing flexibility in their spatial distribution throughout the meshwork.

Under software control, the output drive channels switch current from the high current five-volt supply to each of the individual actuator elements

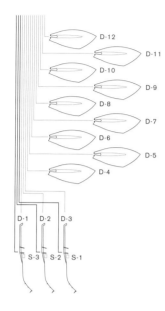

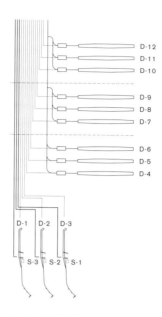

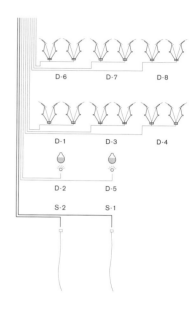

6 Breathing Column

 Output: 9 Breathing Pores,
 3 Sensor Lash Actuators
 Input: 3 Proximity Sensors

7 Swallowing Column

 Output: 9 SMA Valves (Air Muscles),
 3 Sensor Lash Actuators
 Input: 3 Proximity Sensors

8 Filter Cluster

 Output: 6 Filter Pairs,
 2 Burst LED Triggers (PWM)
 Input: 2 Whisker Capacitance Sensors

using a transistor switch. The SMA-actuated pores and lashes are driven by ten-inch lengths of 300-micron-diameter Flexinol wire that contract when an electrical current runs through them. Mechanical leverage amplifies the half-inch contraction that occurs in each wire and translates this into a curling motion. Filters and crickets use several shorter lengths of Flexinol wire in series to maintain the same electrical characteristic as pores and lashes but provide more subtle kinetic response. Several proximally-located swallowing actuators use SMA-powered pneumatic valves to control air pressure in custom air muscles, coordinating their action to produce a peristaltic motion in the surrounding meshwork. The whisker elements are composed of flexible wound wire strings extending from the shaft of a small three-pole motor. In combination with 150-ohm current-limiting resistors, yellow LED lights are configured for the five-volt power supply to create visual feedback. These LED lights add a signalling layer to the Hylozoic ground environment, offering a visual map of the system response.

ROB GORBET

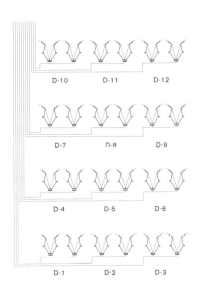

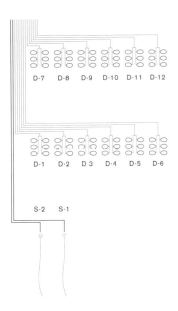

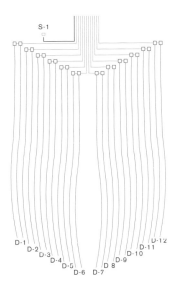

9 Filter Cluster Drone

 Output: 12 Filter Pairs
 Input: Neighbouring Behavior

10 Cricket Cluster

 Output: 12 Cricket Sets
 Input: 2 Whisker Capacitance Sensors

11 Whisker Cluster

 Output: 12 Motor Driven Whisker Pairs
 Input: 1 Proximity Sensor

6 - 11 Power and communications
between actuated clusters of
mechanisms on each Arduino
microprocessor.

sensing

Each daughterboard accommodates up to three analog sensors. Infrared proximity sensors with varying detection ranges provide feedback that allows the sculpture to respond to occupant motion. Powered by the five-volt electronics supply, the sensors emit an infrared signal and receive reflections of the signal from nearby objects, registering the distance of the reflecting surface and feeding that information back to an input on the Arduino board. A second type of capacitance-based sensor signals the approach and touch of an occupant through perturbations in electric fields generated by the occupants' bodies themselves, much like the sensory nerve endings of the epidermis.

REVEALING THE HYLOZOIC GROUND INTERACTION LAYER

communication and programming

The daughterboard also contains a communication layer which translates raw serial data from the Arduino to the RS485 communication standard. Jacks connect the boards to a 'full-duplex, differential multi-drop' bus. A full-duplex implementation uses two pairs of wires: one pair for incoming information and the other for outgoing data, allowing for simultaneous communication in both directions along the bus. Each board constitutes one 'drop' of the multi-drop system, and communicates with the others via a single board, which assumes the role of 'bus controller.'

RS485 is a differential standard, wherein information is transferred on pairs of wires that carry differing voltages. Bit values are detected by measuring the difference in voltage on the paired wires. Together with the use of twisted-pair cabling, this scheme makes the system less prone to communication errors induced by electrical noise. The Maxim MAX3466 transceiver chip used in the daughterboard allows up to one hundred and twenty-eight boards to communicate. Since there is the potential for multiple devices to 'drive' the shared bus lines, bus conflicts can occur; this typically results in garbled information transmission at best, and can pose a serious threat to the hardware. Therefore, the MAX3466 chip includes a pin, controlled by one of the Arduino's digital outputs, which allows the microcontroller to effectively turn off the driver circuitry.

In addition to the bus transceivers, the daughterboard contains hardware which permits simultaneous 'batch' programming of all the devices connected to the bus. Normally, a device is programmed by connecting it to a computer's USB port, then resetting it before running a software tool on the computer to download code to the Arduino. When the Arduino is reset, a special program called a 'bootloader' executes for a few seconds, listening for incoming information on the serial port. By setting a switch on the bus controller board to 'program' mode, any board connected to the bus will see messages sent by the computer to the bus controller. If the boards are all reset just prior to downloading new code from the computer, the bus controller will act as a proxy in the exchange, and every board will receive the new code. The bus controller switch is then reset to normal mode and it resumes control of the bus.

ROB GORBET

multiple layers of responsiveness

Combined with the bus architecture described above, the Arduino system provides an inexpensive platform for experimentation with distributed intelligence and emergent behaviour in a physical environment. For example, each local board in the Hylozoic environment can produce several layers of response to a visitor's presence within the mesh.

As a local response, any board which registers change in its sensor status immediately activates a reflex device, reinforcing the connection between the actions of the visitor and the sculpture. Reflex responses are followed by slightly delayed and more coordinated chains of reactions by devices connected to the triggered board. Additionally, the board informs the rest of the environment, via the bus controller, that it has detected a visitor. Boards are programmed to respond to messages from their spatial neighbours, setting up larger but more muted chains of reaction. A third layer of behavioural control is orchestrated by the bus controller: Since it relays all messages, it is aware of the general level of activity within the mesh. It can therefore exercise some control over system-wide behaviour by asking the mesh to set up a general low-level behaviour if things are too quiet, or to quiet down if activity is excessive.

The Hylozoic series is a body of work that has been gradually transitioning from individual figures, composed of complex hybrid sculptural assemblies, towards immersive architectural environments that behave like highly mobile crowds of interlinked individuals acting in chorus. The most recent generations of this work employ active sensing and actuator mechanisms in pursuit of reflexive, kinetic architectural environments. Hylozoic Ground, as exhibited in Venice, builds upon previous generations by developing a decentralized structure where much of the system is distributed and extensible, based on localized intelligence.

The electronics in the Hylozoic environments—the sensors, controllers, actuators, power, and communication systems—are expressly revealed, a visible reminder of the sentient nature of the environment. But the interactions are specifically designed to be subtle, reflexive, and natural. They require no cognitive overhead and leave the visitor to the environment, free to wonder at the possibilities for the future.

REVEALING THE HYLOZOIC GROUND INTERACTION LAYER

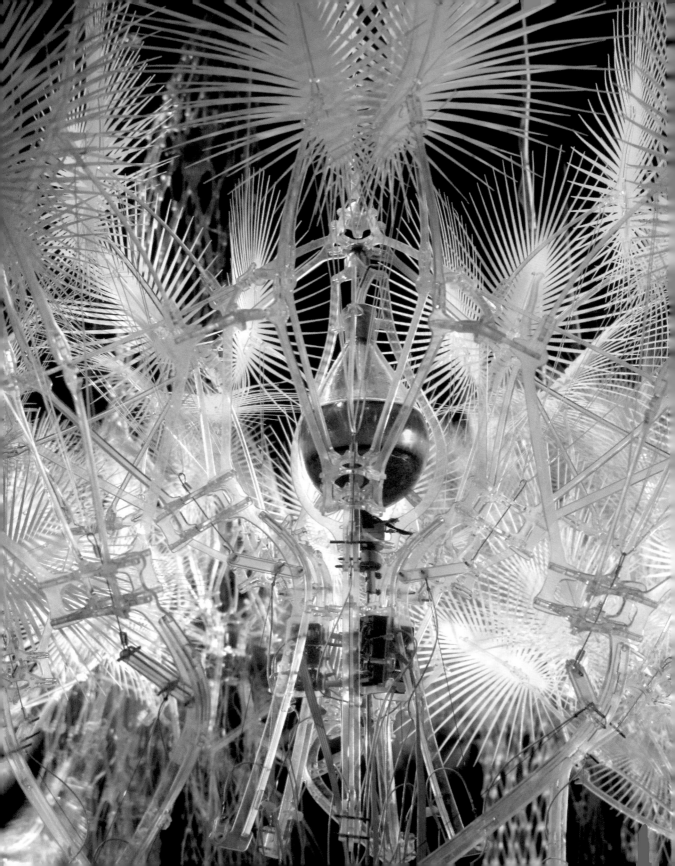

Hylozoic Ground Chemistries & Unanswered Questions in the Origins of Life

RACHEL ARMSTRONG

hylozoic succession

1 The Future Venice project sets out to explore how self-assembling chemical technologies such as programmable protocells could be used creatively in the built environment of Venice in order to tackle apparently the intractable environmental challenges it faces. These challenges include the potential impact of rising sea levels, widespread rising damp, lagoon bed erosion, and subsidence of the city itself (www.futurevenice.org).

facing page

2 Filter layer from above. **Hylozoic Soil: Meduse Field**, "Mois-Multi Festival," Meduse, Quebec City, 2010.

The historic city of Venice exists in an unlikely geographic and environmental location, made possible only through technological intervention. The evolution of Venice from mud flat settlements to a prosperous and iconic city has been a difficult one and throughout its history, the city's existence has remained precarious.[1]

Venice can be described as a synthetic ecology, shaped by human intervention and the application of technology, which together have transformed the uninhabited terrain into a substrate for human settlement. Like all ecologies, Venice's own character is dynamic and continually shaped by the ongoing interactions between its inhabitants and their surroundings. In biological terms, today's Venice is the result of *succession*, an evolutionary process caused by the actions of successive generations of organisms that changes an environment. In the particular case of Venice, the greatest impact on the

3 John Julius Norwich, The City
 Rises Up, A History of Venice
 (New York, 1982), pp. 26–38.

environment has been due to the actions of technology-wielding humans who used their tools to drain the soft, marshy delta soil, incapable of sustaining human settlement, in order to support the city's foundations. Through persistent modifications and development, the Venetians created an environment suitable for human habitation; the city even became the centre of European trade with the East between the ninth and twelfth century CE.[3]

Conditions quite similar to this hybrid urban growth can be discovered in Philip Beesley's Hylozoic environments. The installation's cybernetic framework becomes a substrate that supports colonization and transformation through an ecology of tools and technologies. The short time frame in which these environments are created and disassembled is a miniscule fragment of evolutionary time. The site-specific Hylozoic Ground installation takes place during the three-month Venice Architecture Biennale. Like the original soil on which Venice was founded, the condition in which the 'soil matrix' of this environment is discovered is sub-optimally suited to support advanced living systems, gradually revealing the extent of its complex constituency. Hylozoic Ground offers an environment that is not only kinetically responsive but also capable of transformation through physical and chemical processes. The soil matrix of Hylozoic Ground incorporates 'living' technology that embodies some of the properties of living systems. Its characteristics and native identity are more in keeping with the practice of alchemy than with mechanics.

the hylozoic soil matrix

The Hylozoic environment is a model system of a synthetic ecology undergoing an evolutionary process. Visitors can observe the initial state of the environment's constituent materials, influence dynamic processes that respond to external presence, and review these ongoing modifications over time. On closer inspection of the environment, it is possible to observe the constituent processes that connect physical and chemical elements in various stages of transformation within the cybernetic framework of the Hylozoic 'soil matrix.'

Organic soil is made of structurally repetitive organic and inorganic materials that possess heterogeneous properties. Similar to the complex assemblies of tissues and organs in living systems, soil contains functions that are

supported by an orchestrated variety of cells. The various elements of a soil matrix are spatially arranged in a way that provides suitable surfaces for self-organizing and evolving biochemical exchanges. These interactions are complex. The chemistries self-regulate and interact and they confer the various molecular species with complex behaviours of living systems, such as growth and sensitivity to their surroundings.

Similar to these properties of organic soil, the soil matrix of the Hylozoic environment is composed of a responsive cybernetic framework made of inert materials and a 'living' technology layer made of the various species of adaptive chemistries—specifically organic 'protocell' technology and inorganic 'chell' (chemical cell) membranes. Protocells and chells are chemical models of primitive artificial cells working together to form the tissues and organs of the soil matrix. The self-assembling chemistries of the protocells and chells have evolved to the point where at least one of the 'minimal cell' criteria—container, metabolism, information—are met.[5] These cells therefore exhibit some of the properties of living systems, even if not considered by researchers to be truly alive.

5 Steen Rasmussen et al., "Bridging Nonliving and Living Matter," Artificial Life 9 (2003), pp. 267–316.

protocells and chells

A protocell is a model of a cell that is formed by the innate, complex chemistry of molecules that exist at the interface between oil and water. Protocells are able to move around, sense their environment, and undergo complex behaviours that are observable to viewers. Protocells are generated through a 'bottom-up' approach to living systems, in that they are created directly from their constituent chemicals rather than from an arrangement of pre-existing biological parts. The protocell metabolism can be precisely designed through considered selection of the chemicals involved. This chemical programming enables protocells to exhibit unique properties not present in natural cells.

6 Lee Cronin et al., "The Imitation Game—A Computational Chemical Approach to Recognizing Life," Nature Biotechnology 24 (2006), pp. 1203–1206.

Chells are chemical cells that are artificially created in the laboratory since, like protocells, they are not fully alive but exhibit some of the properties normally attributed to living systems.[6] Chells have inorganic membranes with dynamic properties that can encapsulate an interior environment. While inorganic compounds are not usually considered primary building blocks of living systems, the chemical constituents of chells possess dynamic qualities,

facing page

7 Self-generating and self-healing Traube cell membranes; Rachel Armstrong and Philip Beesley, University of Southern Denmark, 2010.

such as growth and self-assembly, and physical properties, such as semi-permeability establishing gradients for kinetic or chemical exchange. Chells exhibit the characteristics of both container and metabolism during their self-assembly. They become the vehicle through which a desired internal milieu, a 'physiology,' can be designed and introduced. Interactions of this internal milieu with the environment imbue the systems with additional living properties.

Initially only a small number of artificial chemical cell species form habitats within the Hylozoic soil matrix, capable of thriving under the initial conditions. Given enough time to evolve, new species take hold, as spontaneous physical and chemical changes take place within the living technology. The new species further modify the habitat by altering physical variables such as the amount of carbon dioxide in the atmosphere or the mineral composition of the synthetic tissues and organs of the Hylozoic soil.

The complex exchanges between adaptive chemistries, responsive materials, and environmental fluxes within the Hylozoic soil matrix oscillate and respond not only to each other but also, crucially, to people passing through the environment and reshuffling the soil matrix. Together, these processes result in a series of transformations within the soil matrix that manifest over time as a 'synthetic succession.' This 'living' succession of protocell and chell technology forms the tissues and organs of the Hylozoic soil matrix. Key ingredients include incubators (protocells), carbon-capture 'protopearls' (protocells), and traube membranes (chells).

incubators

The *incubators* nest in the responsive Hylozoic filter layer and function as a tissue system—an aggregation of similarly-specialized cells that collectively perform a special function. Their cellular units are not biological but are created by protocells. The incubator protocells are generated from an arrangement of water molecules in an oil-based environment that undergo a dynamic interaction with iron and copper based minerals. The timing of these changes is phased by using oil layers of different densities—in this case extra virgin olive oil and diethyl phenyl phthalate. As the water-based minerals travel through the oil layers, they come in contact with the water-based protocell agents and the chemistry intermingles at the

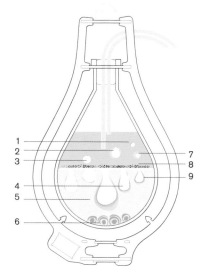

8 Liesegang ring-like reactions.

1 Copper sulphate
2 Ferrofluid solution
3 Attenuated sodium hydroxide solution
4 Magnetite crystal 'seeds'
5 Diethyl pheryl phthalate (DEPP)
6 Complex of various precipitate
 forming metal ions
7 Calcium chloride
8 Olive oil
9 Protocell

surface of the protocell. This reaction generates complex precipitates of iron and copper that influence each other's formation as they compete in their microenvironments under conditions that dictate their precipitation and redissolution. This complex growth process resembles how bone matrix is first laid and then reshaped through resorption.

As crystal development occurs over time, a gradual transition from an organic matrix to a mineralized structure takes place—similar to the process of petrification, an example of which occurs during fossilization. The interactions between the iron and copper salts in the incubators through precipitation, diffusion, super-saturation, and re-precipitation is reminiscent of the complex physical and chemical phenomenon of Liesegang ring formations, described by Raphael Liesegang in 1896, which produces geometrically stratified, concentric precipitates.[9] The fossilized protocells undergo a similar transformation and dynamic restructuring within the incubators, and in their turn inform the synthetic soil matrix of new interactions with adaptive chemistries. The incubator process represents a life pathway within a system rather than a complete life cycle in itself.

protopearl flasks

Carbon-capturing *protopearls* are also located within the responsive Hylozoic filter layer, alternating with incubator systems. These function as carbon-fixing organs for the Hylozoic soil matrix. Like biological organs, protopearl flasks house autonomous material systems with tissues that perform a special function. The tissue is formed by protocells made by oil droplets in the medium of water. These protocells adopt a chemical phase arrangement that works in reverse to the water-in-oil-based system of incubator protocells.[10]

Protopearl flasks derive their nutrients from Venice canal water, which contains dissolved carbon dioxide and dissolved metal ions such as calcium and magnesium. These chemicals are introduced into the vessel through a filter (to remove organic matter from the Venice canal water) and a simple gravity-fed circulation system. The flasks reveal the presence of carbon dioxide and minerals in the solution by creating material building blocks when their specifically designed metabolism comes into contact with carbon dioxide. This occurs via a physical process called the *Marangoni effect*, described by Carlo Marangoni in 1865, which refers to a dynamic internal movement of oil

9 Raphael Liesegang, "Ueber einige Eigenschaften von Gallerten," Naturwissenschaftliche Wochenschrift 11(1896), pp. 353–362.

10 Otto Bütschli invented the reverse phase protocell system of oil and water. See Otto Bütschli, Untersuchungen über Structuren (Leipzig, 1898).

HYLOZOIC GROUND CHEMISTRIES

molecules within a droplet. In the protocell system, the effect creates internal flow and movement of the oil molecules that give rise to the dynamic behaviour of the droplet.[11] As the active chemicals circulate, they come to the surface of the oil droplet where they interact with dissolved carbon dioxide, precipitating an insoluble form of the gas carbonate to produce a layer of crystals.

The 'designer' metabolism can be engineered to produce a variety of different carbonates with varying properties and appearances, depending on the selection of particular metal ions used to interact with the dissolved carbon dioxide. In this particular system, the metal ions barium, magnesium, and calcium will make a white precipitate if they are dissolved in the Venice water. Copper ions are introduced into the environment through the protopearl system and diffuse out from the oil to produce a green solid on contact with dissolved carbon dioxide. The carbonate crystals gather within the organ flasks to form pearl-like structures. The protopearls are not self-replications, so they require a 'birthing' technology that consists of a primordial oil-based droplet system primed with a chemical compound to bind with dissolved carbon dioxide. As the protopearls become inactive from the precipitation of carbonate on their surface, an LED light sensor detects the change occurring in the opacity of the fluid, stimulating the syringe driver to produce more protocells, which are primed to precipitate more carbonate from the circulating Venice water. In contrast to the incubators, whose material systems are closed to the environment, the carbon-capturing protopearl flasks exist within an open system of material flow and their pearl-like structures become an intrinsic part of the Hylozoic soil matrix.

Since the equilibrium of the organ system requires a continuous and rich supply of carbon dioxide, the container itself is open to the gallery air and functions as a sink for additional carbon dioxide produced by gallery visitors as a waste product of respiration. As an open system this organ exhibits connectivity to both the visitor and the technologized Venetian environment.

traube membranes

In the next phase of development following the Venice installation, *traube membrane* chell systems will be included within the Hylozoic soil matrix, located within the filter layers. Traube membranes perform the work of an

11 L. E. Scriven and C. V. Sternling, "The Marangoni Effects," **Nature** 187 (1960), pp. 186–188.

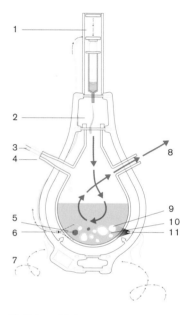

12 Protopearl flask.

1 Syringe driver with protopearl formulation
2 Air: nitrogen, oxygen, carbon dioxide
3 Venice canal water
4 Filtration unit
5 Copper ions, metal ions in solution from Venice canal water
6 Sensor
7 Agitation
8 The airflow outlet will act as overflow
9 From Venice water: magnesium, barium and calcium ions
10 Protopearls
11 Emitter

13 Traube presented a paper on his experiments to the forty-seventh Congress of German Naturalists and Physicians in Breslau on September 23, 1874. Karl Marx also made reference to Traube's work in Marx's letter to Pyotr Lavrov, June 18, 1875, and to Wilhelm Alexander Freund, January 21, 1877. Karl Marx and Frederick Engels, Collected Works 46 (New York, 1992).

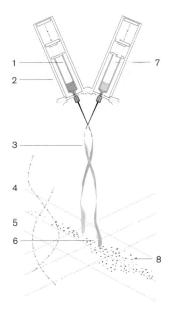

14 Extended Traube membranes.

1 Copper sulphate + gelatine
2 Timed release syringe drivers
3 Metal scaffolding to collect and direct traube cell reagents
4 Absorbent matrix to support Traube cell grow
5 Agitation from hylozoic matrix, vibrational forces further extend membranes
6 Traube cell extension (Copper hexacyanoferrate with complex polymer scaffolding alginate/gelatine)
7 Copper hexacyanoferrate + alginate + gelatin
8 Hygroscopic attractant permeates absorbent matrix

organ system made from inorganic chells that provide a contrasting physiology to the organic, oil-based protocell systems. The growing membranes that characterize traube cells were first described by Mortiz Traube in 1874.[13] A traube cell is an artificial, inorganic model of a cell that consists of a semipermeable membrane surrounding a vesicle that allows water to pass into it, but not back out again. The version of this chemical cell model used within Hylozoic Ground contains additional complexity including water-seeking biopolymers in the form of alginate and gelatin. These ingredients help extend cell membranes by providing additional structural integrity and by conferring an osmotic physiology that amplifies the growth of the chell and causes it to exhibit water-seeking hydrophilic tendencies.

The main membrane is a semipermeable skin made of brown copper hexacyanoferrate, formed through a reaction between pale yellow dilute potassium hexacyanoferrate and violet blue concentrated crystalline copper sulphate. During the formation of the traube cell wall, the copper hexacyanoferrate membrane expands to a much greater volume than that of the original crystal, owing to a dramatic osmotic influx of water.

The growing, seaweed-like membranes use this hydraulic imperative in the system to create an expanding series of inorganic cells. A continuous supply of raw materials provided through a syringe driver ensures continuous mingling of the traube salts. The membrane produced by the copper hexacyanoferrate is initially soft but hardens on drying. A continual feed of traube salts creates a sequentially layered structure that adds thickness to the membrane, forming partially dried layers that transform from a single-layer membrane into a many-layered, temporally maturing (hardening) integument, trapping water for growth and adding structural integrity to the developing chemistry. Since these compounds extend, expand, and contract with the changing hydration state, the choreographed airflow of the breathing cycle within Hylozoic Ground has a significant impact on the formation of this inorganic cell tissue.

extended membranes

Within the Hylozoic environment, traube membranes are provided an opportunity to leave their fluid-based existence and extend their chemical scaffolding into open air. The self-organizing chemistry of the traube cell allows it to move beyond its original habitat and colonize other available spaces within

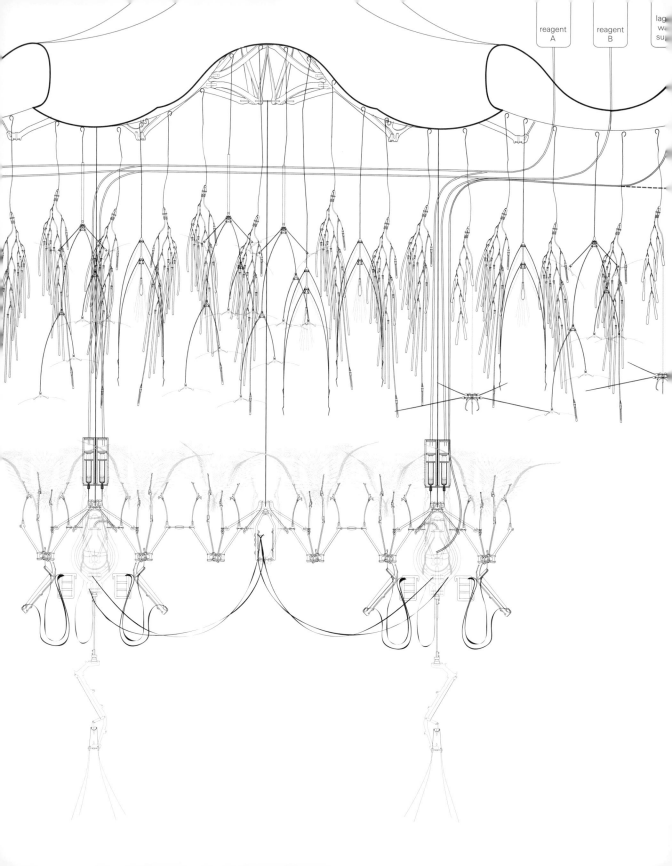

reagent
A

reagent
B

lag
wa
su

the soil matrix. Drivers of this process include gravity, airflow, oscillations of the cybernetic framework, and the presence of oases of moisture in hygroscopic materials dispersed throughout the soil matrix. These factors are triggered by a variety of direct and subtle interactions—the passage of bodies through the space, the sensory reflexes of the cybernetic matrix responding to direct actions of visitors, and changes that occur in the hydration state of the hygroscopic islands, which act as a lure for the desiccating chemicals of the Hylozoic environment. All of these factors are intricately connected to the behaviour of visitors within the environment, whose presence is vital in shaping and improving the conditions for growth of these extended membranes.

hygroscopic islands

Hygroscopic islands are integrated into the weed-like layers of glands and traps that line the upper meshwork surfaces of Hylozoic Ground. They are composed of alternating organic (glycerin and latex vials), inorganic (sea salt) and natural materials (dried lavender). While these substances interact dynamically, their relatively simple behaviour is distinct from the 'living' func tions demonstrated by protocells. Their affinity for water enables them to draw circulating moisture from the gallery space into their substance.

In the Hylozoic Ground installation this moisture consists of a fine, barely perceptible blend of water droplets: the densely humid local atmosphere, the heavy mist of the Venice canals, human respiration and condensation that is animated by local air flow, convection, evaporation, and the movement of people through the space. Water molecules absorbed into the hygroscopic islands are made visible by 'indicator' cells containing cobalt chloride, which alternates between blue in its dry anhydrous form and deep rose in its hydrated state. This changing colour gives a direct indication of the relative hydration state of individual hygroscopic islands, rendering barely perceptible atomized water into something strikingly visible.

facing page

15 Hygroscopic islands are integrated into the weed-like layers of glands and traps that line the upper meshwork surfaces of Hylozoic Ground.

The large density of hygroscopic islands tends to form a second-order, gaseous matrix within which environmental conditions can act, amplifying latency and increasing the range of chemical influence. The hydrophilic properties of the islands enables them to act as oases and extract sustenance for self-assembling traube membranes by forming sinks, reservoirs, and sites

of dispersal for water-borne chemicals. Other droplets emerge from their encounter with the hygroscopic islands enriched with aromatic compounds. These diffused scents are dispersed throughout the gaseous layer, influencing the movements of the visitors who in turn create further chemical changes within the cycle. Hygroscopic islands provide a layer of complexity within the Hylozoic soil matrix that is connected with but not fixed to the *prima materia*.[16]

16 Prima materia refers to 'the original material,' an alchemical term used to describe a primordial substance.

hylozoic ground: a model for unanswered questions in the origins of life

The Hylozoic environment embodies some of the principles under investigation in the scientific study of the origins of life. The Hylozoic environment exists in a material reality and might arguably best be described through scientific narratives, while at the same time its complexity, scale, aesthetics, and sublime presence invoke other humanities-based disciplines that value poetics.

There are many gaps in our contemporary scientific knowledge of the transition from inert to living matter. The Hylozoic environments attempt to address pertinent unexplained areas, offering a deeper understanding of living processes and how life arises from terrestrial chemistry. The Hylozoic Ground installation at the 2010 Venice Architecture Biennale could be a useful model for investigating unanswered questions regarding the origins of life.

what is life?

Visitors of Hylozoic Ground are posed a primary question: does the Hylozoic soil matrix show 'life'? This question is reminiscent of the "Turing Test," a classic example of a method of comparative analysis between complex systems. When Alan Turing developed the test in 1951, his subject was the phenomenon of intelligence and how it could be successfully measured in the context of 'artificial' systems.[17] Rather than using traditional decision-making paradigms that require the application of an objective set of hierarchical criteria, Turing exploited observer bias in the decision-making process by having the participant engage in conversation via computer, and then asking them to decide whether their conversational partner was

17 Alan Turing, "Computing Machinery and Intelligence," Mind 44 (1950), p. 433.

of human or artificial nature. The intelligence source passed the Turing Test if the human participant could not reliably tell the machine from a human conversationalist. Similarly, Hylozoic Ground asks its visitors, who are embodied and alive, to make a subjective decision about whether they recognize the adaptive chemistries within the Hylozoic soil matrix as 'living.'[18]

18 Cronin 2006.

what is the architecture of life?

Contemporary scientific discussions regarding the origins of life position the chemistry of modern-day cells as key to understanding the processes that gave rise to the first life forms. There are currently two accepted models of the story of life, the 'information first' theory, and the 'metabolism first' theory. The 'information first' model imagines the most significant event as the emergence of a primordial organizing molecule that is able to orchestrate life support systems around it. The 'metabolism first' model argues that complex, adaptive chemical pathways created the conditions for self-sustaining interactions that subsequently led to living systems. These two different models of organization are not necessarily mutually exclusive in the story of life on Earth. It is likely that at different times in evolutionary history each of these models have been causal to abiogenesis—the transition from inert to living matter—by varying degrees.

However, within these contemporary narratives, abiogenesis tends to be treated as a two-dimensional phenomenon. The traditional tools of science communication are text based and limit the discussion of scientific concepts to forms that are compatible with literary presentation. Chemical interactions are therefore conceived of as cycles of activity, or as linearly diverging pathways that bear many resemblances to ancient drawings of the Tree of Life.[19]

19 Ernst Haeckel, The Evolution of Man: A Popular Exposition of the Principal Points of Human Ontogeny and Phylogeny (London, 1879), Plate XV.

Despite increasingly powerful digital imaging tools, spatial and temporal configurations of adaptive chemistries, and the non-linear influences that they exert on already-complex processes, simply cannot be fully articulated using the contemporary scientific communications tools of symbolism and linguistics. Chemistry is so information-rich, especially at the molecular level, reflecting so many parallel processes and so flexible in its responsiveness to environmental variations, that it seems impossible to create accurate models that represent these systems in a naturalistic way. Even the most sophisticated computer model engages with its subject matter using information

that is so rarefied and symbolic that effectively, the analysis remains as incomplete as a two-dimensional line drawing.

Rather than existing as a disembodied representation, the Hylozoic environment examines the temporal and spatial dynamics of primordial adaptive chemistries as a primary system, since a realistic way to determine the outcome of a complex system is to build it directly. A 'metabolism first' model of organization is used to establish a fundamental set of conditions for the adaptive chemical systems against which the possibility of abiogenesis can be observed. The temporal and spatial positioning of these materials within the Hylozoic environment and its soil matrix is considered to be equally important to the selection of the primary materials themselves.

The adaptive chemistries are distributed into 'nesting' sites, located along the kinetic lines of the cybernetic skeleton where there is a likelihood that the individual responsive materials will encounter perturbations with the potential to persist. It is hoped that a fraction of these transformations will give rise to increasingly complex phenomena and ultimately create self-sustaining processes that could reasonably be considered 'living.'

is it possible to model the environment?

Hylozoic Ground does not attempt to model an environment in order to understand the process of organization, but rather aims to open up the installation space to invite perturbations of chemical, physical or human origin that may encourage change within the participant adaptive chemical systems. Crucially, all aspects of environmental impact are considered critical to the process of abiogenesis within the Hylozoic environment. Flux across the matrix is viewed as being catalytic in creating necessary local instabilities within the system.

These considerations provide a stark contrast to a traditional scientific approach where variability is reduced in the 'control' system so that predictable observations can be made. The scientific approach subtracts environmental context, peculiarities, and incidents in order to simplify and rarefy information from which it subsequently establishes governing principles of organization. The Hylozoic environment, on the other hand, provides a matrix in which it is possible to simultaneously observe general principles of organi-

zation and particular phenomenology in the same context, so that the entire nature of a system that is predisposed to abiogenesis can be appreciated.

how are scale and complexity related?

The Hylozoic environment undergoes a teleodynamic evolution—in other words, it exists in context and process, as opposed to being ordered through centralized systems embodied in the biological theories of genetics. The organizing nuclei that are scattered throughout the Hylozoic environment's soil matrix—as tissue (incubators), organs (protopearl flasks, traube membranes) and associated systems (hygroscopic Islands)—offer a model of how complexity and scale can be related. These elements can also be used to demonstrate transformation of the matrix as a whole within the context of a changing environment. The scale of these various interactions and the emergence of complexity coincides with contemporary notions of cybernetic teleodynamics. Exchanges within the Hylozoic Ground matrix tend to be reciprocal. Form and production are enabled by feedback from optical sensors that prompt the production of more protocells as the density of carbonate rises. This sensitivity guides a logic of evolutionary process selection, maintained through interactions between discrete protocell units. Through this interaction of form and system dynamics, the system gains physical and informational memory.[20]

20 Terence W. Deacon, Emergence—
The Hole at the Wheel's Hub,
The Re-Emergence of Emergence,
The Emergentist Hypothesis from
Science to Religion, Ed. Philip
Clayton and Paul Davis (Oxford,
2006), pp. 111–151.

The Hylozoic Ground structures are responsive to changes over time, but they also retain information that regulates behaviours, and substrates that memory can change. In the Hylozoic soil matrix, the chemical processes are under pressure from many complex factors that alter the tendencies or purpose of the initial system. These give rise to further variations in the performance of the system. Despite possessing no genetics—the information processing which biological systems are classically considered to require in order to experience heritable change—the Hylozoic soil matrix undergoes changing relational properties that are subject to a dynamic past history. These temporal variations subsequently induce persistent change, and ultimately influence the future behaviour and form of the installation.

the unexpected

The open system of the Hylozoic environment invites unpredictable events and engages with them through teleodynamic interactions. The Hylozoic soil

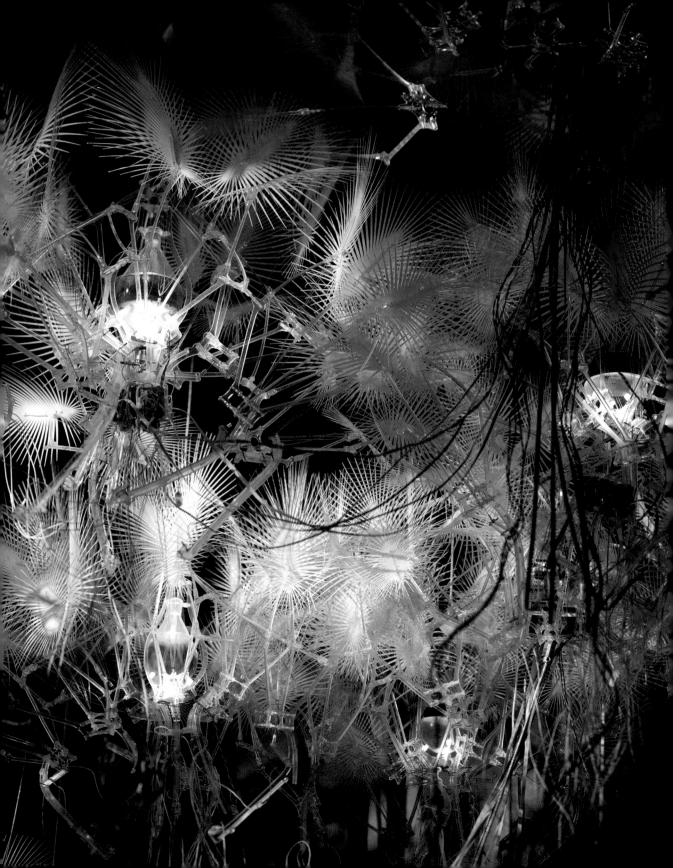

matrix is primed to encounter and engage with unpredictability through the experience of 'surprise,' since the innate dynamic complexity of the system is unknowable. It raises questions about how to incorporate the unexpected into our ways of thinking about materials and processes. While contemporary scientific literature has not been able to fully articulate or explore the quality of unpredictability, this quality can readily be experienced in the Hylozoic environment.

Hylozoic Ground embodies our current fragmentary understanding of the constituent process of life, and engages questions with unknown answers concerning the transition from inert to living matter. Because it is partly authored reflexively by its constituent adaptive chemistry, under the right conditions the Hylozoic environment has the potential to 'fill in the gaps' in our knowledge. In this way, the Hylozoic Ground environment offers a participatory experiment in which visitors can explore the potential emergence of living systems by influencing the dynamic interactions between complex chemical processes. With time, new and emerging persistent patterns in the behaviour of the Hylozoic organ systems will appear. A keen observer may note subtle as well as macro-scale changes taking place within the soil matrix. The dissipative flows of energy and chemical organization that characterize living systems can be observed, embodied and recognizable, in the morphology and behaviour of these evolving organs.

Since the matrix has the potential to reveal how living processes are organized, it is capable of producing surprising results. Living entities may appear with forms that have not previously been encountered. Hylozoic Ground can be described as a birthing matrix that operates at unpredictable scales of chemical complexity, with the potential to spit out 'life'—but not necessarily as we have already experienced it.

facing page

21 Protocells in filter field.
Hylozoic Soil:Meduse Field,
"Mois-Multi Festival," Meduse,
Quebec City, 2010.

Hylozoic Series
Component Detail Plates

1

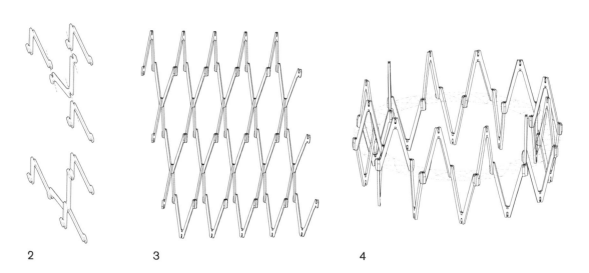

2 3 4

chevron assembly diagrams

1 Chevron cutsheet tessellation 2 Snap-fit assembly 3 Basic mesh assembly 4 Column mesh assembly
5 Column cap plate 6 Transition column taper 7 Basic mesh assembly 8 Kissing pore base plate
9 Column assembly 10 Breathing column assembly

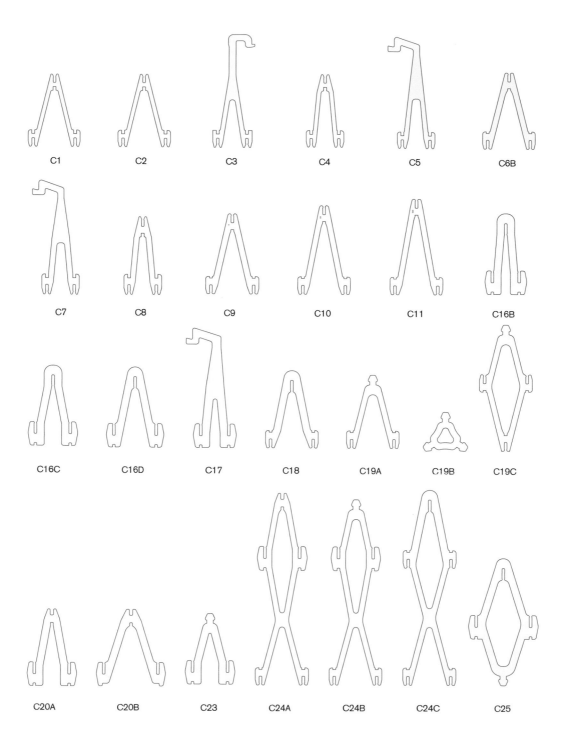

C1 C2 C3 C4 C5 C6B

C7 C8 C9 C10 C11 C16B

C16C C16D C17 C18 C19A C19B C19C

C20A C20B C23 C24A C24B C24C C25

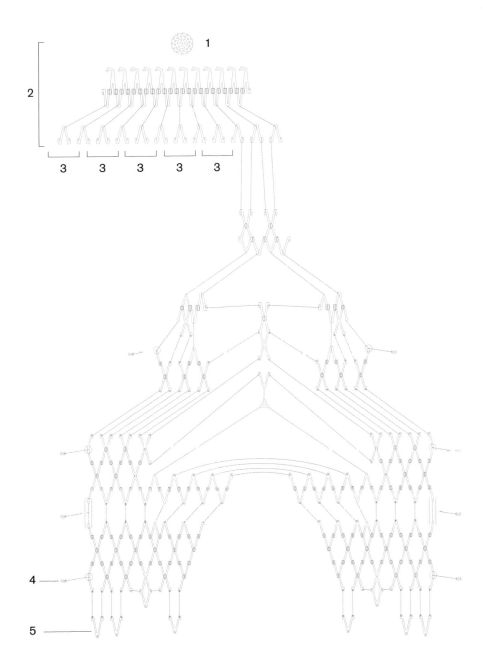

petal assembly diagram

1 Lily cap hanging plate **2** Lily cap assembly **3** Lily petal attachment point **4** Silicon petal attachment point
5 Adjacent canopy attachment point

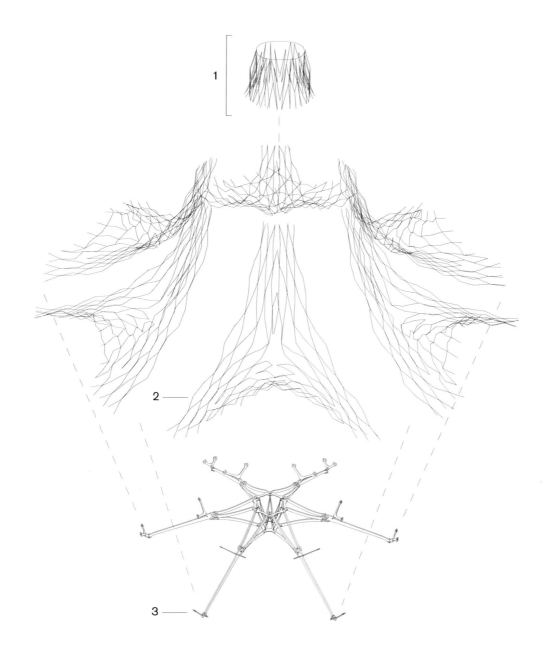

lily canopy assembly diagram

1 Lily cap assembly **2** Lily petal (assembled) **3** Lily umbrella assembly

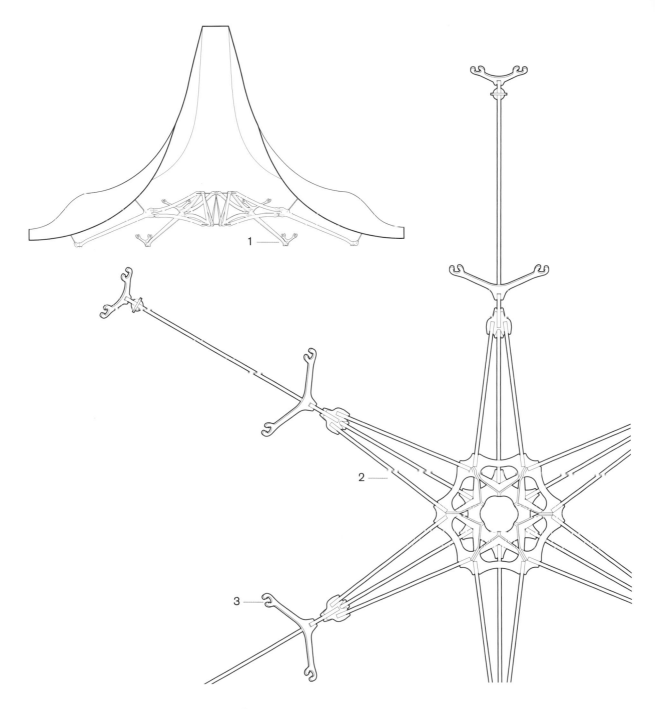

lily umbrella assembly diagram

1 Filter layer assembly attachment point 2 Bifurcatiing members 3 Connection to main lily canopy
4 Main umbrella spine elements 5 Lily canopy assembly 6 Junction plate assembly

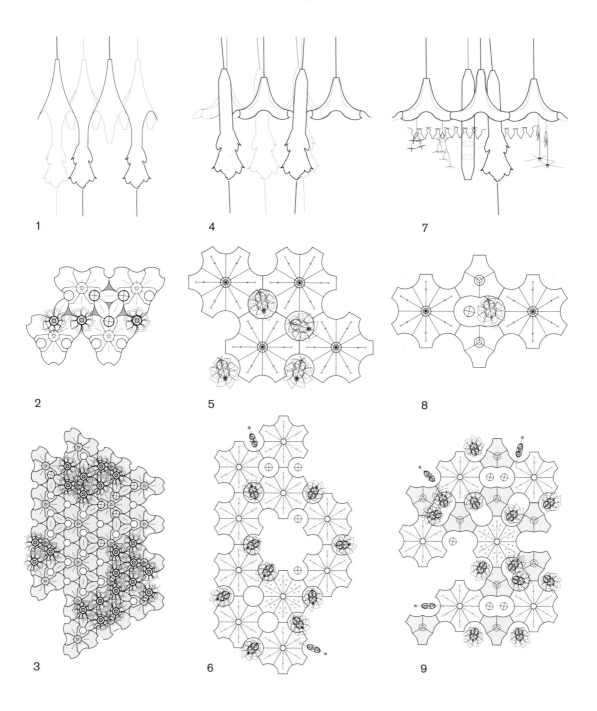

hylozoic plan diagrams

1–3 First generation. **Hylozoic Soil**, Montreal Museum of Fine Arts, Montreal, 2007
4–6 Second generation. **Hylozoic Grove**, Museum of the Future, Ars Electronica, Linz, 2008
7–9 Fourth generation, **Hylozoic Soil**, Biologic Art, SIGGRAPH, New Orleans, Louisiana, 2009
10 Eighth generation, **Hylozoic Ground**, Canada Pavilion, 12th International Architecture Exhibition, la Biennale di Venezia, Venice, 2010

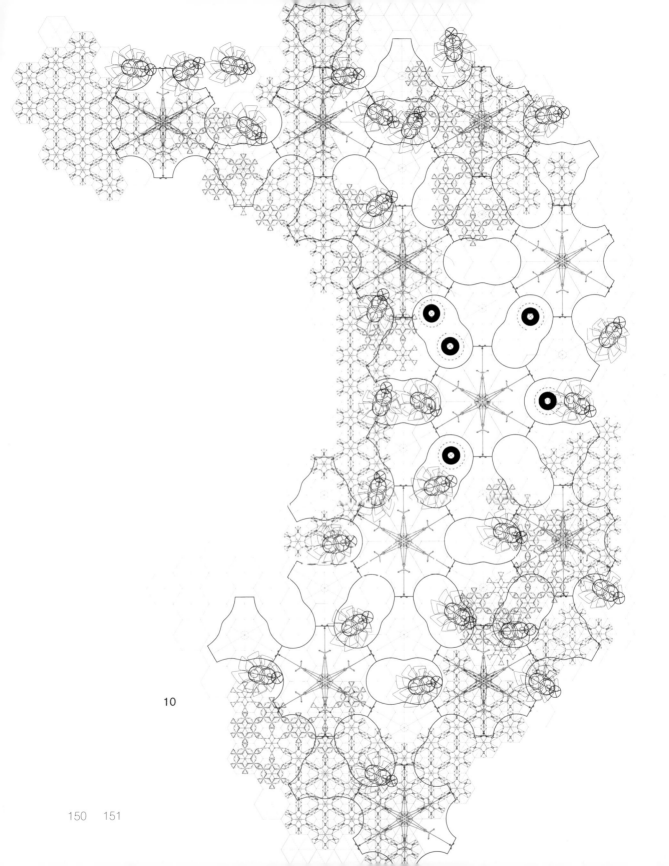

10

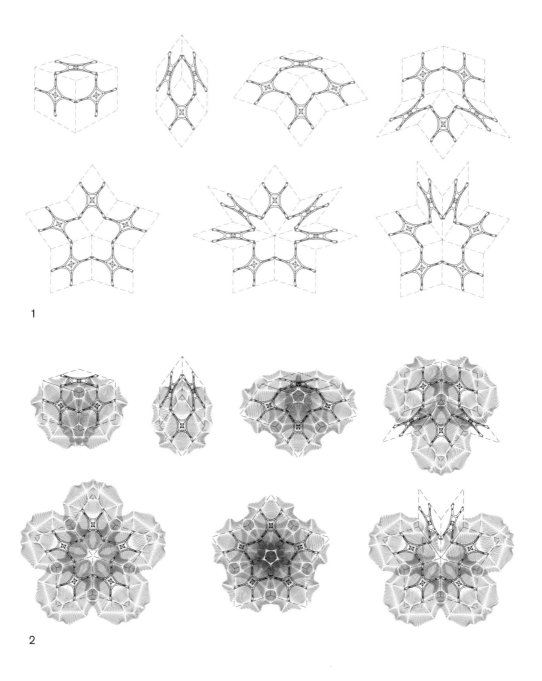

filter layer plan diagrams—first generation

1 Skeleton typical configurations **2** Feather typical configurations **3** Filter layer rhombic assembly pattern
4 Two way connection rhomb tesselation **5** First generation filter layer plan

overleaf
6 Eighth generation filter layer plan
7 Composite floor plan, **Hylozoic Ground**, Canada Pavilion, 12th International Architecture Exhibition, la Biennale di Venezia, Venice,

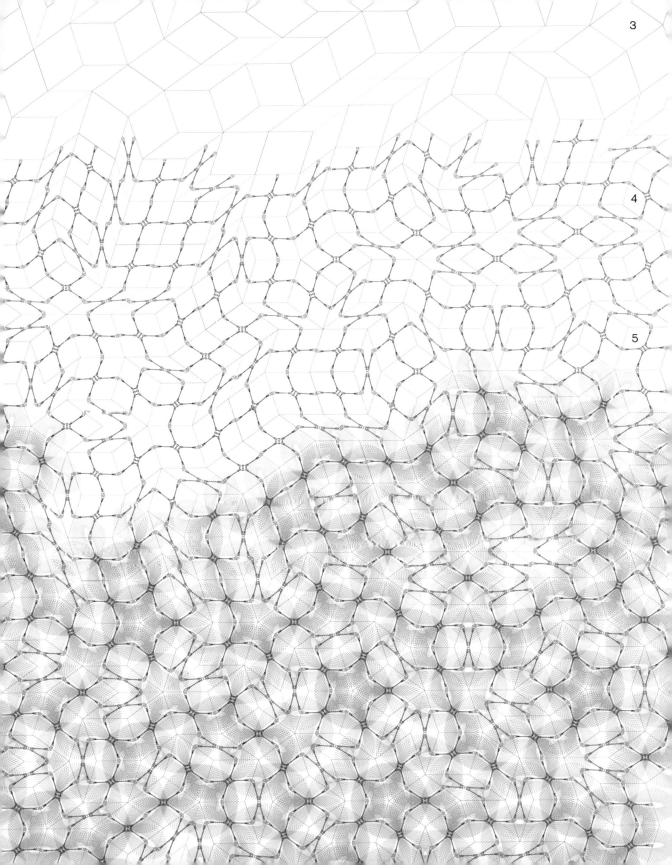

3

4

5

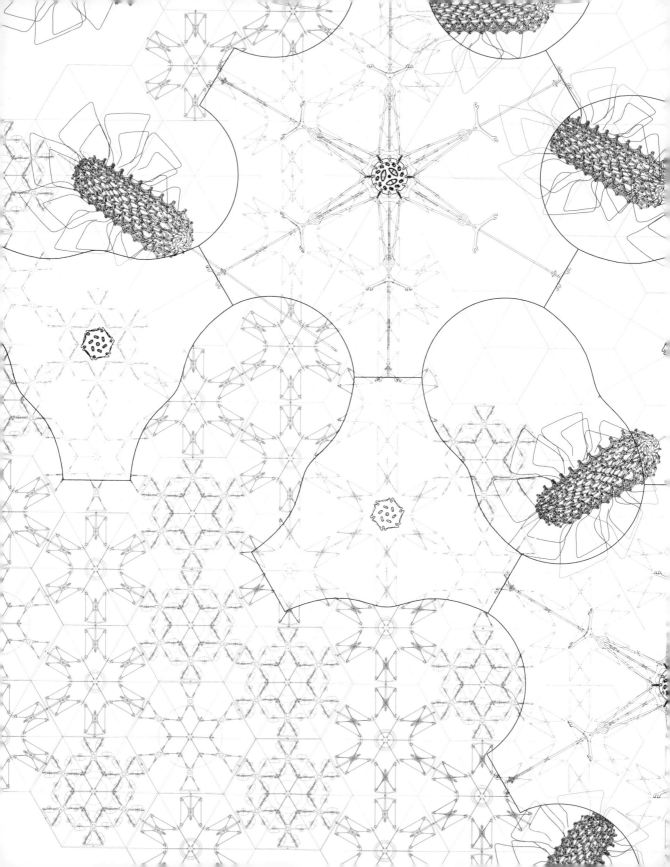

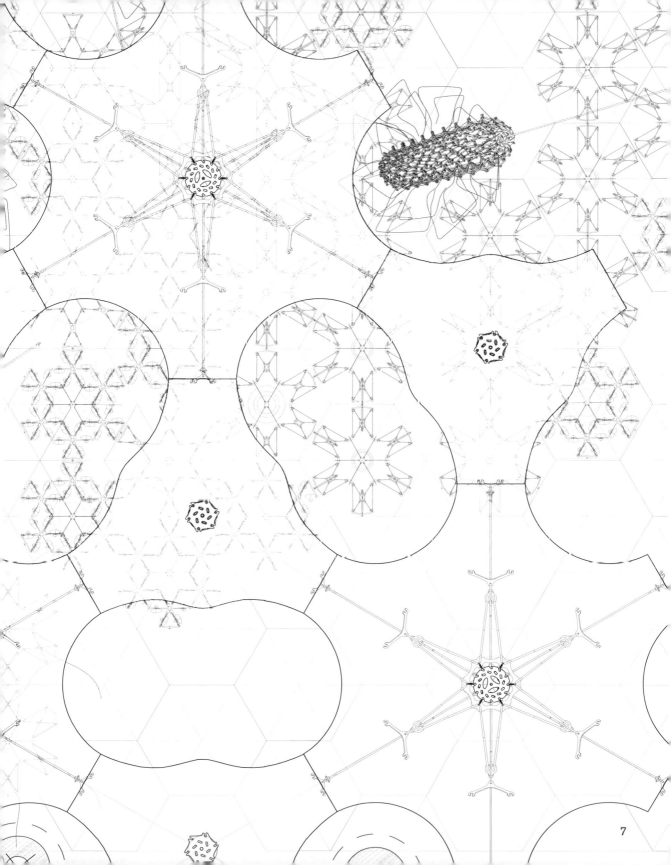

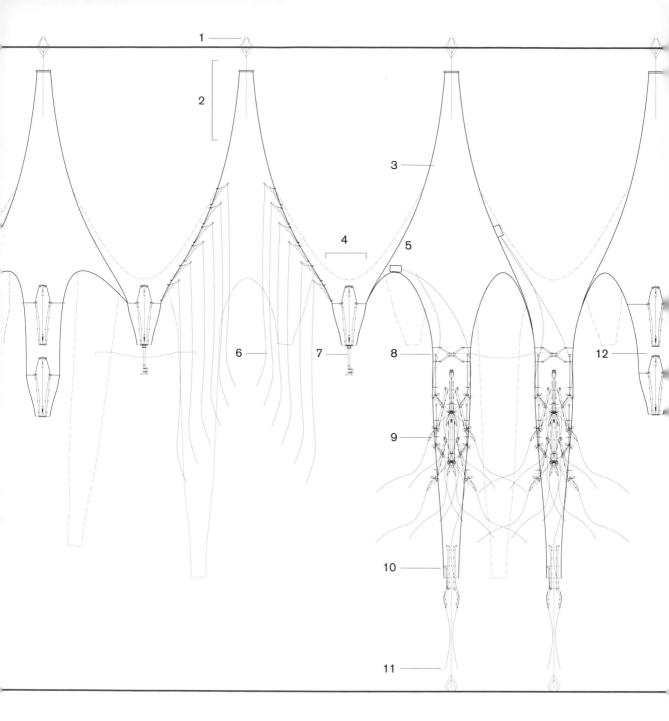

hylozoic section—first generation

1 Lily canopy attachment point 2 Lily cap transition to attachment point 3 Lily canopy element
4 Mesh treo assembly 5 Arduino microprocessor 6 Actuated whisker 7 Swallowing sensor mount
8 Column stabilizer assembly 9 Breathing pore spiral 10 Sensor lash base assembly 11 Claw floor attachment point

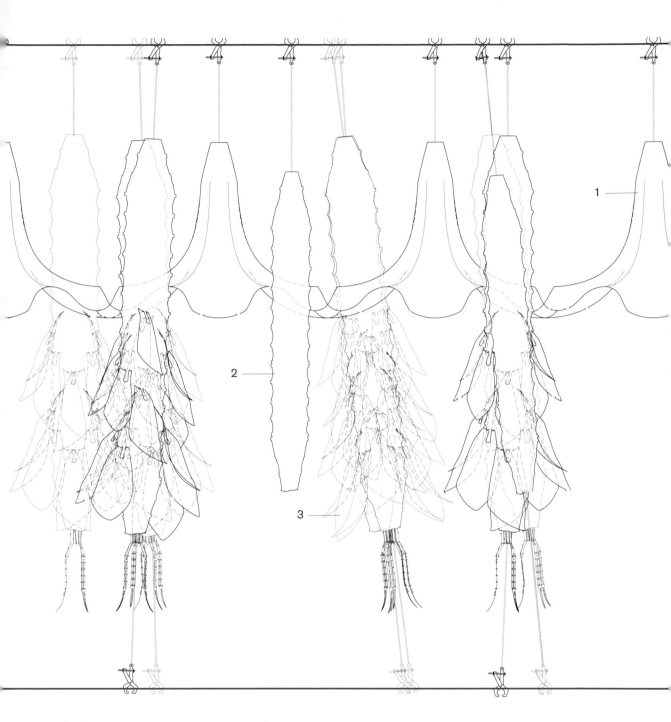

hylozoic section—second generation

1 Discreet lily canopy isolated from column mesh elements **2** Nine chevron column
3 Isolated breathing column disconnected from main mesh canopy

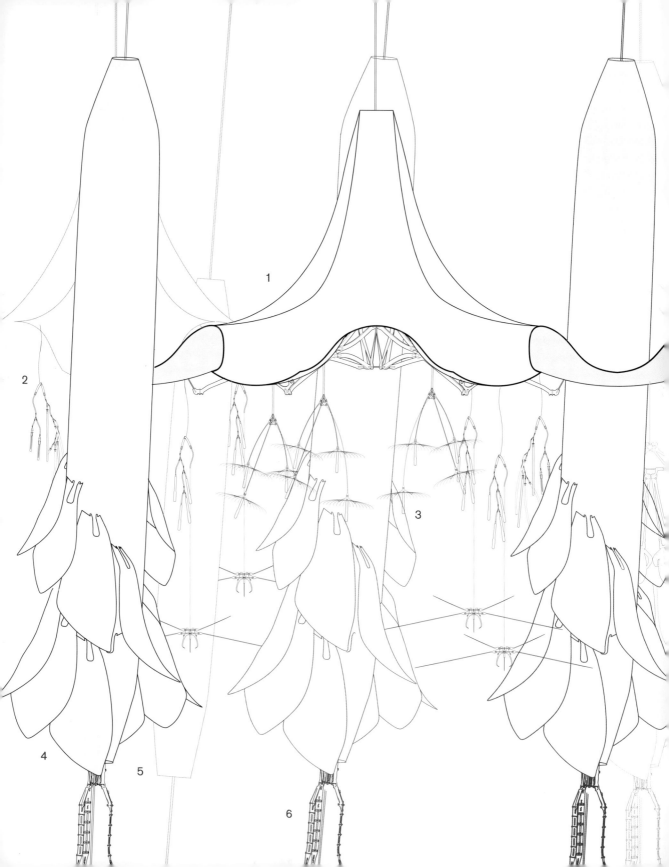

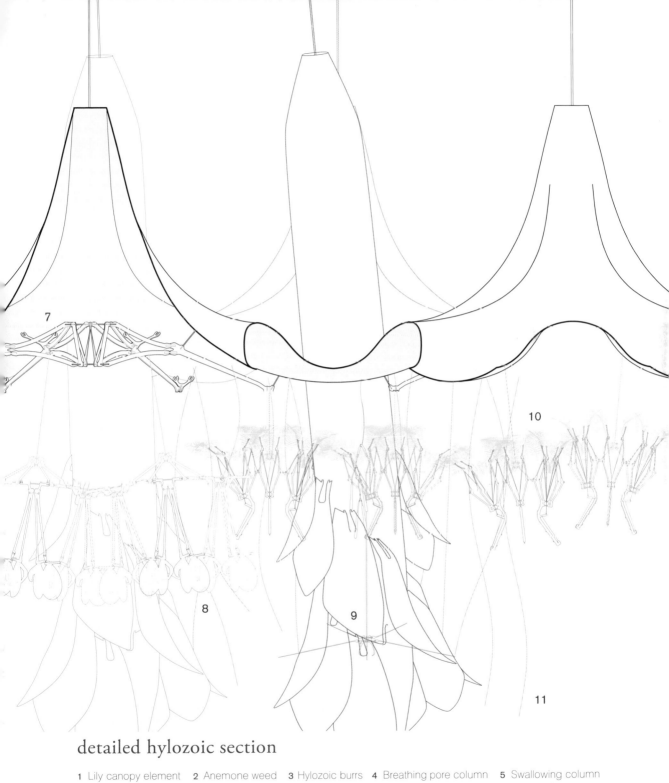

detailed hylozoic section

1 Lily canopy element 2 Anemone weed 3 Hylozoic burrs 4 Breathing pore column 5 Swallowing column
6 Sensor lash assembly 7 Umbrella structural unit 8 Cricket cluster 9 Clamping needle assembly
10 Filter cluster 11 Whisker assembly

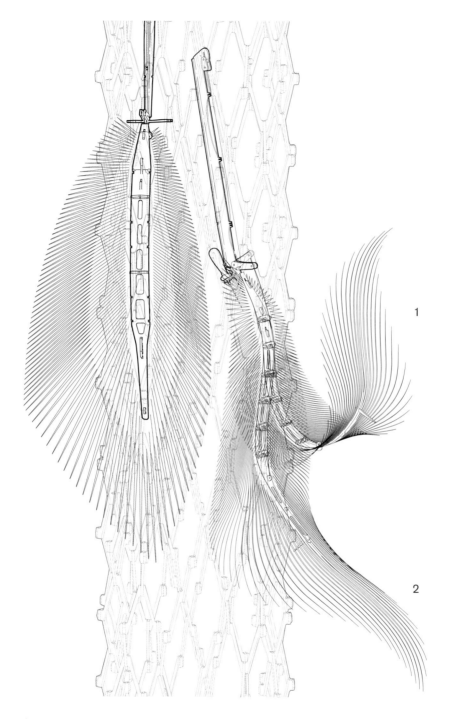

breathing pore assembly diagram

1 Breathing pore assembly actuated position 2 Breathing pore assembly rest position 3 Adjustable SMA clip
4 SMA 5 Lever 6 Tensioned tendon 7 Strengthening gusset for main spine 8 Gland clip
9 Copolyester tongue 10 Tongue clip 11 Arm units for attachment to mesh 12 Tongue struts 13 Feather

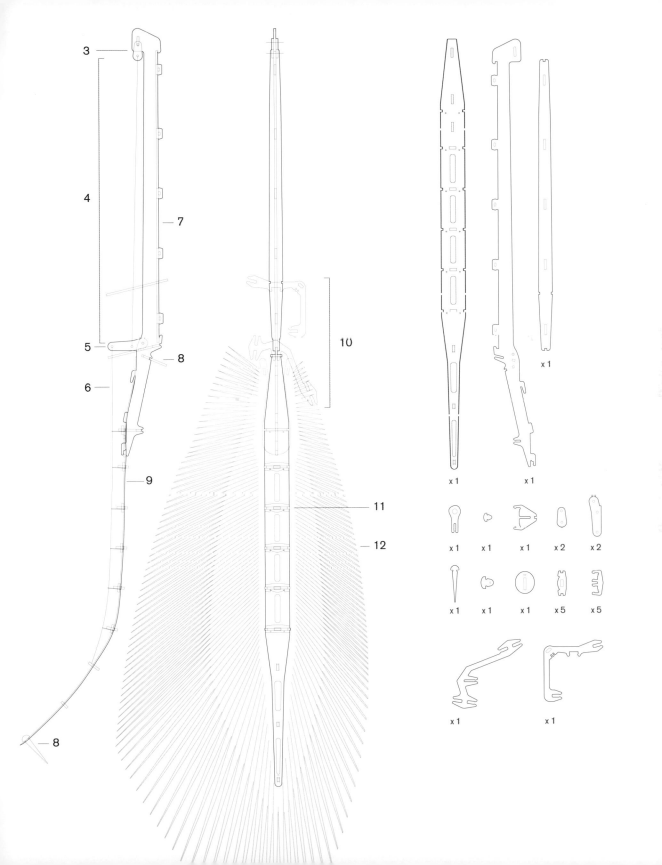

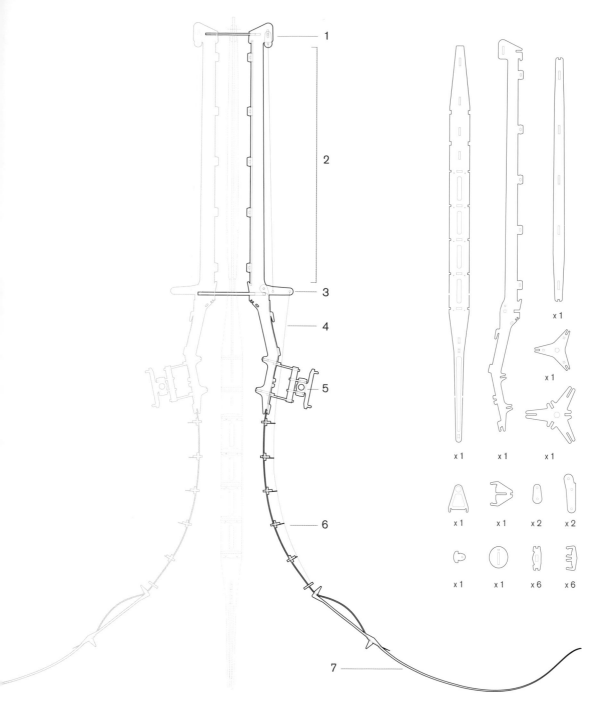

sensor lash assembly diagram

1 Adjustable SMA clip **2** Shape memory alloy (SMA) actuator **3** Lever **4** Tensioned monofilament tendon
5 Proximity sensor mount assembly **6** Copolyester tongue **7** Silicone tongue extension

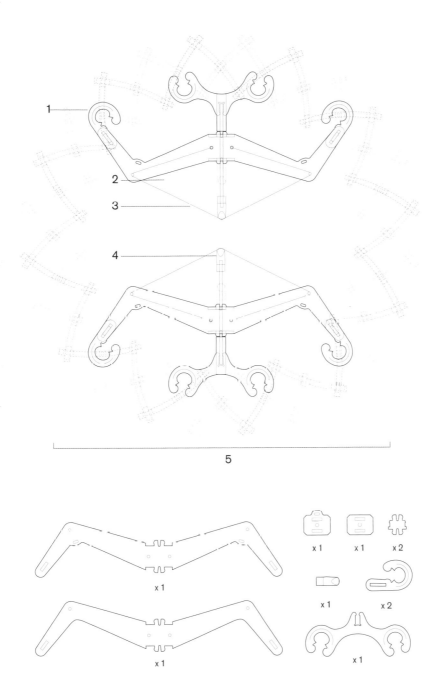

swallowing actuator assembly diagram—second generation

1 Column attachment point with integral leaf spring **2** Shape memory alloy (SMA) actuator in contracted state
3 SMA in rest state **4** ABS plastic 3D printed piston barrel **5** Meshwork column assembly

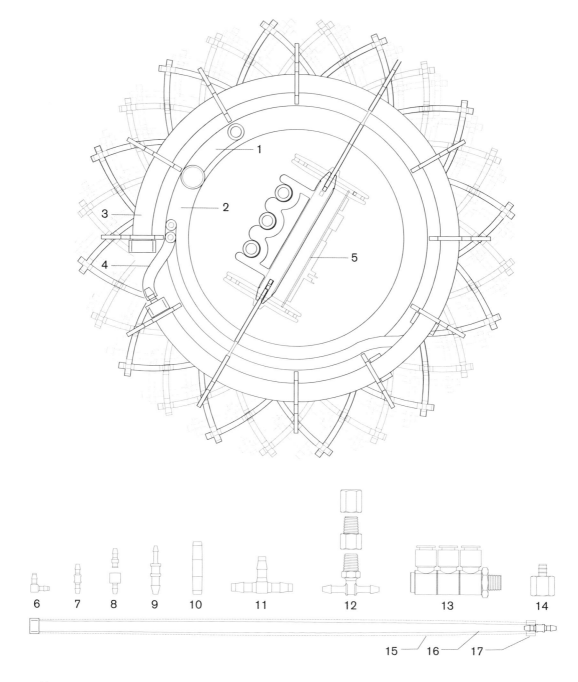

swallowing actuator assembly diagram—third generation

1 Main air supply **2** Main electrical harness **3** Air muscle **4** Local air supply **5** Arduino/SMA valve mount
6 1/8″ elbow **7** 1/8″ coupler **8** Detachable coupler **9** 1/4″ to 1/8″ reducer **10** SMA valve **11** 1/4″ tee
12 Flow reducer/diffuser assembly **13** 3-way mainfold **14** Threaded adapter **15** Braided polyester sleeve
16 Latex bladder **17** Metal hose crimp

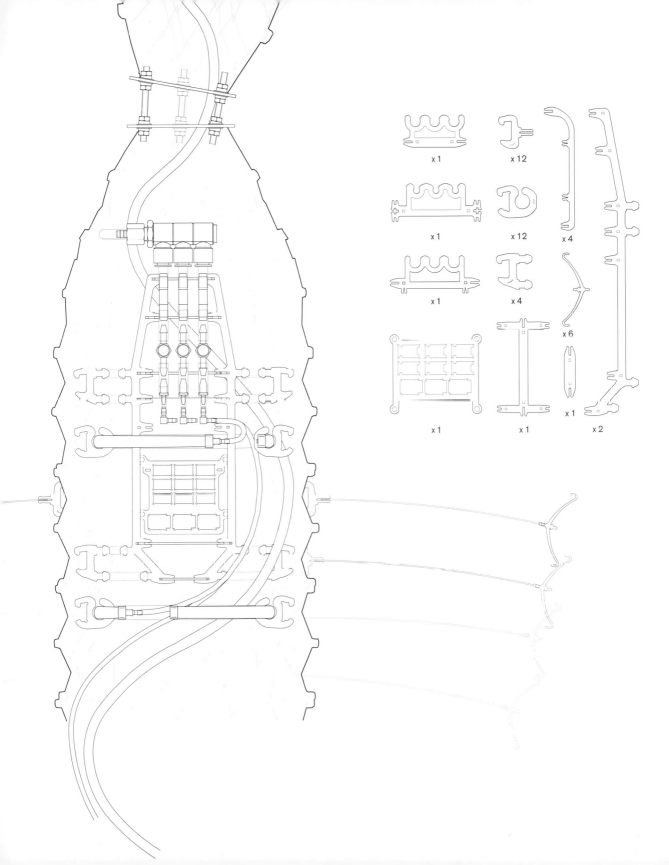

x 1

x 12

x 1

x 12

x 4

x 1

x 4

x 6

x 1

x 1

x 1

x 2

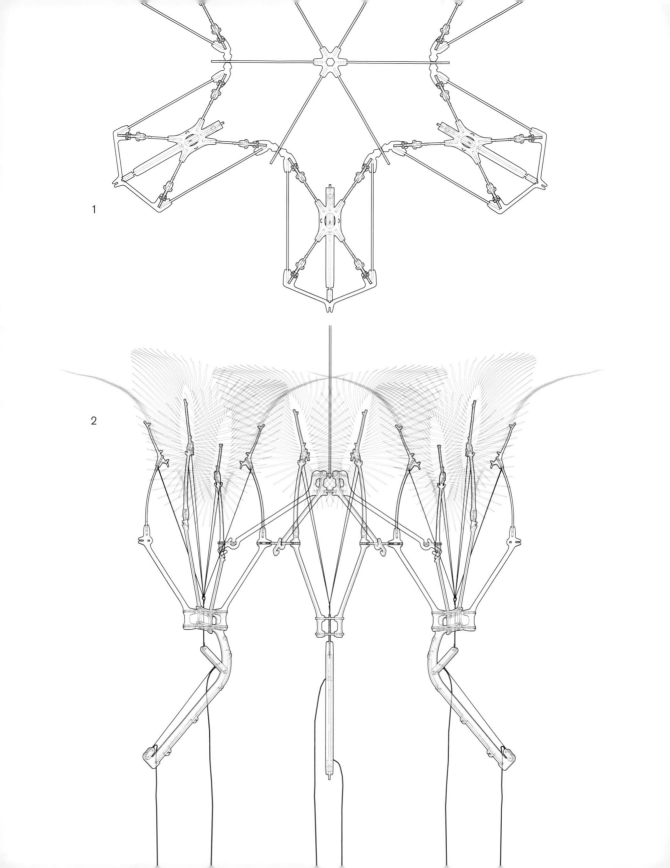

1

2

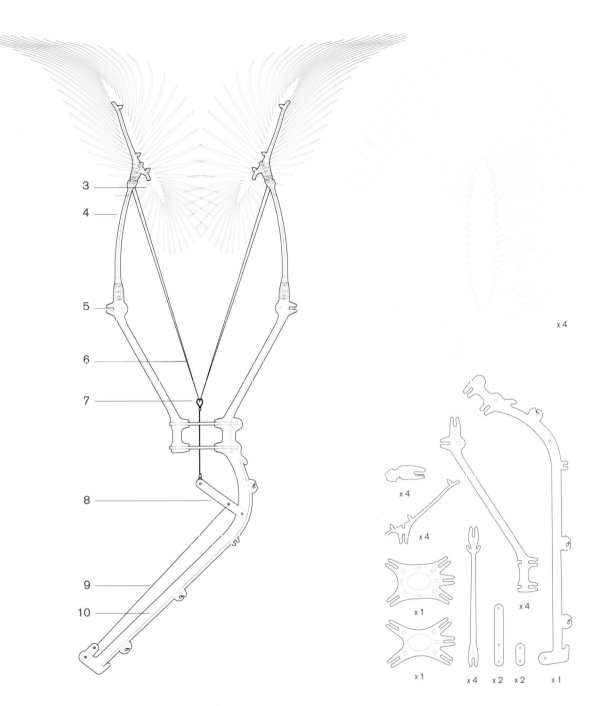

filter layer assembly diagram

1 Filter cluster plan 2 Filter cluster elevation 3 Filter feather 4 Leaf spring 5 Connection to adjacent filters
6 Tension cable 7 Tension hook 8 Lever arm 9 Shape memory alloy (SMA) actuator 10 Sled assembly

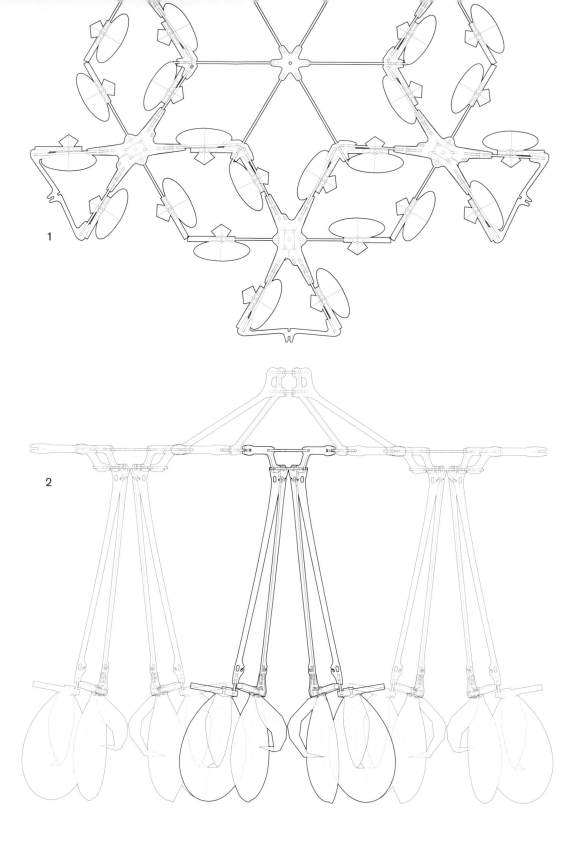

1

2

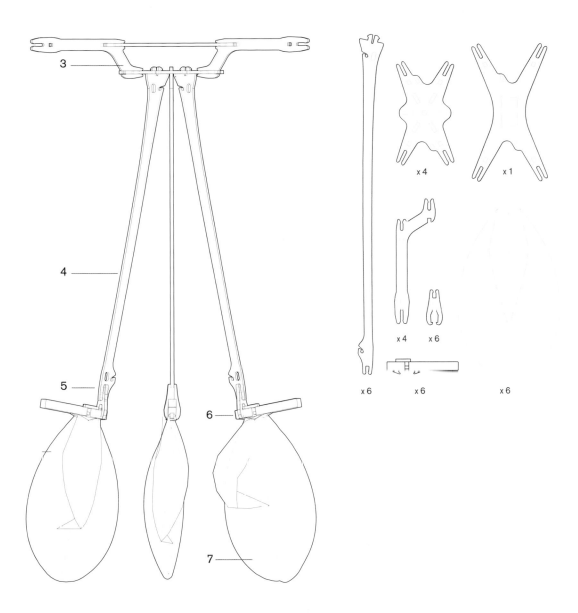

x 4

x 1

x 4 x 6

x 6 x 6 x 6

cricket layer assembly diagram

1 Cricket cluster plan **2** Cricket cluster elevation **3** Cricket rhomb **4** Stalk **5** Actuator mount
6 Shape memory alloy (SMA) actuator **7** Cricket resonator

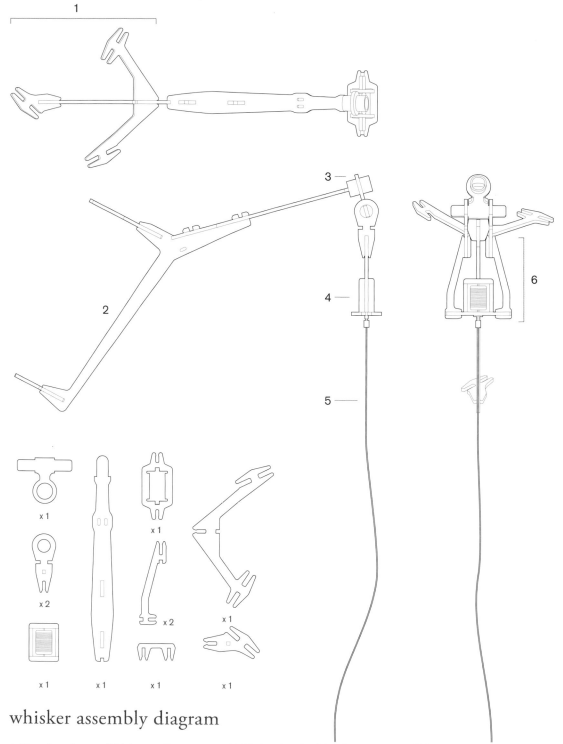

whisker assembly diagram

1 Mounting clips 2 Whisker cantilever arm 3 Multi-directional self leveling mount 4 DC motor assembly
5 Bass string whisker 6 Motor mount assembly

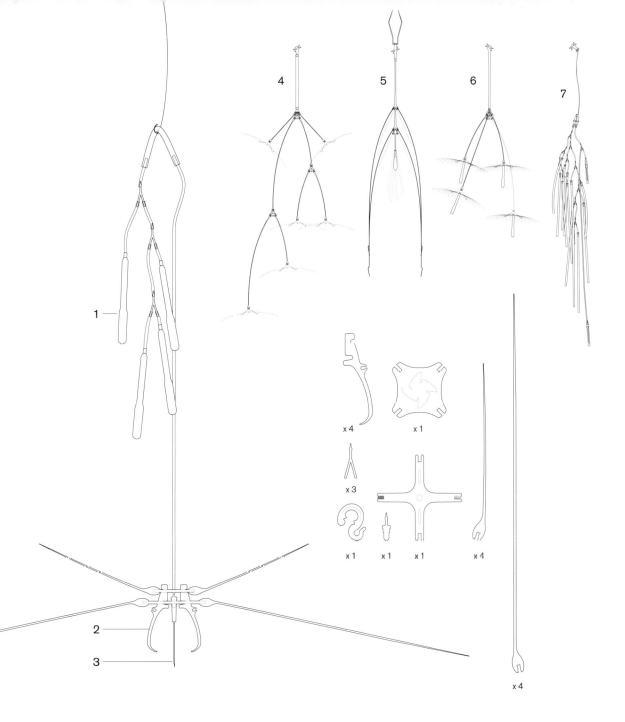

weed layer assemblies

1 Hygroscopic salt bladders **2** Clamping trigger mechanism **3** Moisture syringe **4** Orpheus filter
5 Spine cluster **6** Hylozoic burr **7** Anemone hygroscopic islands fitted with lavender, salt and glycerine

Afterword
Immanence and Empathy

The Hylozoic Ground project began sixteen years ago in Rome, in an encounter with the faintest of traces that indicated that blood had been deposited within the soil of the eternal city. Housed in a uterine pot, accompanied by cup and bowl, rictus-tight swaddling clasped by a moon-shaped brooch at his neck, a tiny first son was placed with infinite care below the threshold of the city's north gate. Vast encrusted layers of a labyrinthine artificial mountain covering this rending sacrifice rose in the centuries that followed. In this past century the flayed foundations of this massive earth were laid bare. What soil, what material could possibly be adequate for covering there? The ensoiled fabric of Hylozoic Ground is an offering.

The organization of the Hylozoic series treads deeply contested ground. The oscillating drifts of hyperbolic and quasiperiodic geometry that guide this work lie far from transcendent, overarching order. Like the shimmering tesserae of an ancient Byzantine mosaic caught between worlds, this fabric oscillates.

1 Castello Annunciation, Sandro Botticelli, Uffizi, Florence, c.1489–90.

2 Flagellation of Christ, Piero della Francesca, Galleria Nazionale delle Marche, Urbino, c.1455–60.

Visions of an orchestrated Earth have a long and confident history, especially in the anthropocentric cosmologies announced by Renaissance and Enlightenment imagery. In canonical Annunciation paintings such as Sandro Botticelli's 1489–90 Annunciation,[1] graceful figures of Gabriel and Mary appear standing upon a gridded stage, with a carefully ordered garden stretching behind into the distance. Gabriel and Mary are clearly the masters in this scene, with nature polarized as the servant. Similarly, the nuanced exchanges of figures standing calmly within Piero della Francesca's Flagellation of Christ[2] emphasize social dimensions. In that scene, historical figures are cast as contemporary Florentine citizens, earnestly conversing while standing in an ordered plaza marked by flooring that recedes in meticulously drafted perspective. The parallax of this scene is constructed to coincide with the viewer's own viewpoint, implying common citizenship. These staged public spaces speak of human domain as a pinnacle of achievement. It is tempting to draw a parallel between this kind of geography and twentieth-century control systems. Such territory seems to coincide with Modern visions exemplified by the twentieth-century American engineer Buckminster Fuller's radiant 'geoscope,' a floating spherical instrument panel connecting to vast networked global systems, focusing the entire world into a coherent, unified vehicle for organized operation.

Yet when preceding generations of theorists considered the nature of these ordering systems, their arguments were often divided. In their widely published 1830 debate, Etienne Geoffroy Saint-Hilaire and Georges Cuvier, founding biologists of the Museum of Natural History in Paris, examined the basis of nature. Against Cuvier's rear-guard defence of a 'Great Design' determining individual species' anatomy, Saint-Hilaire argued that anatomy determined how a species behaved, opening the door to speculations about nature divorced from theology. Saint-Hilaire implied that there was no particular 'transcendent' destiny involved in individual functions, only concrete and 'immanent' functions that would create particular opportunities for behaviour. Saint-Hilaire's argument resonates with the words of Lucretius, two millennia preceding: "Nothing in the body is made in order that we may use it. What happens to exist is the cause of its use." [3]

3 Titus Lucretius Carus, De Rerum Natura, trans. Rolfe Humphries (Bloomington, IN, 1969), p. 833. cf. 835–837.

Similarly polarized debates between transcendent and immanent orders exist in areas beyond Darwin's preoccupations of natural selection and genetic mutation. Building a new kind of stewardship from immersion in complex systems of nature, a reverently transcendent vision of creation was evoked in Haeckel's magisterial illustrated folio *Art Forms in Nature*, which illustrated Darwin's vision of the practical evolution of species. However in the generation that followed Haeckel, options for 'bionic' manipulation became fraught. D'Arcy Wentworth Thompson's 1917 opus *On Growth and Form* offered practical methods for manipulating dynamic forces. While Thompson's benign influence on design has been repeatedly cited, the political application of his methods to 'improving' the human species through eugenics is poignantly evident. [4] Ambivalence takes an explicit form in the sensitive treatments offered by Wilhelm Worringer in *Abstraction and Empathy: A Contribution to the Psychology of Style*, published in 1908. Worringer wrote: "Whereas the precondition for the urge to empathy is a happy pantheistic relationship of confidence between man and the phenomena of the external world, the urge to abstraction is the outcome of a great inner unrest inspired in man... [corresponding] to a strongly transcendental tinge to all notions. We might describe this state as an immense spiritual dread of space." [5] Worringer's polarized treatment of historical, sentimental "empathy" and modern, objective "abstraction" provided key references for the Hylozoic project, especially informing its iconography.

4 Proportional systems of human physiology, D'Arcy Wentworth Thompson, "After Albrecht Durer," in On Growth and Form (1917).

5 Wilhelm Worringer, Abstraction and Empathy, trans. Michael Bullock (Chicago, 1997), p.15.

Increasing this polarized argument within architectural discussions, a hinge for the issue emerged a generation ago in Michel Foucault's *Discipline and Punish*.

Foucault dwelt on the oppressive machinery of prisons and madhouses and, perhaps fatally, linked those institutional building types to spatial models of radiant symmetries and axial orders. By implying that symmetrical, crystal-line systems of unified geometry in urban architecture were tantamount to fascism, Foucault's power analysis caused serious hesitation for proponents of the continuing Enlightenment.

The geologist and theologian Teilhard de Chardin developed a compelling historical vision that I believe offers nuanced resolution of this contested ground. Working between 1920 and 1955, De Chardin voiced hope for the emerging qualities of integrated world organization, rooted in the voluntary organization of overlapping networks of individuals. Increasing multiplication and overwhelming density of networks created coherence that might in turn result in a 'noosphere' of collective consciousness. De Chardin said, "In any domain—whether it be the cells of a body, the members of a society or the elements of a spiritual synthesis—union differentiates." [6] Most poignantly, De Chardin hoped that this consciousness would be accompanied by an emerging 'prodigious affinity,' a tangible collective sympathy, acting at global collective scale.

6 Teilhard de Chardin, The Phenomenon of Man, trans. Bernard Wall (London, 1959), p. 262.

The Hylozoic series follows De Chardin's invitation. The physical fabric of Hylozoic Ground is designed to pursue empathy embedded within the built environment. The oscillating behaviour of this fabric follows the alternating tracks of fear and attraction encoded deep within the limbic brain. Explicitly ambivalent and sentimental qualities offer immersive, enriched fields of expanded physiology. 'Blood' and 'soil' continue to be swept by repulsively violent nationhood, yet their unquenchable archaic origins offer *prima materia* for this fabric. The fabric reaches toward De Chardin's compelling hope: prodigious sympathy might arise in material convergence.

IMMANENCE AND EMPATHY

Hylozoic Series Chronology
2007–2010

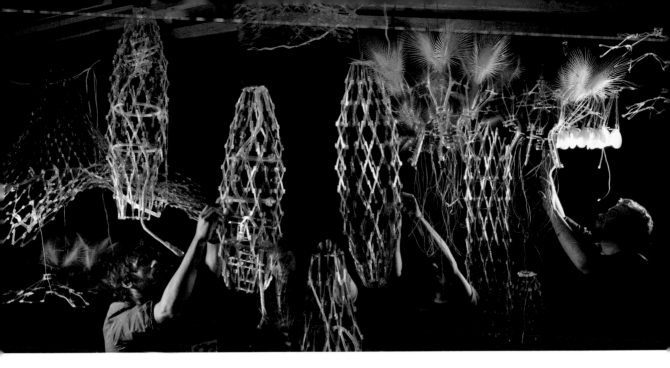

HYLOZOIC GROUND
CANADA PAVILION, 12TH INTERNATIONAL ARCHITECTURE EXHIBITION
La Biennale Di Venezia, Venice, 2010

Collaborators
Rob Gorbet
Rachel Armstrong

PBAI Core Team
Hayley Isaacs Design Director
Eric Bury
Federica Pianta
Adam Schwartzentruber
Jonathan Tyrrell

with
Carlos Carrillo
Andrew Kmiecik
Katherine Kovalcik
Manuel Kretzer
Carlo Luigi Pasini
Tommy Paxton-Beesley
Siobhan Sweeny
Andreea Toca

Production Director
Pernilla Öhrstedt

Gorbet Lab
Brandon DeHart
Andre Hladio

Avatar / Flint Laboratory
Martin Hanczyc

Fundraising/Promotion
Poet Farrell Director
Sascha Hastings

with
Paola Poletto
Paul Hong

Venice Coordination
Tamara Andruszkiewicz
Troels Bruun/M+B studio

Fabrication
Lauron Barhydt
Nadia D'Agnone
Steven Ischkin
Douglas Robb
Natalie Schelew

We would also like to thank
the generous individuals who
joined the Hylozoic Ground
installation team after the
printing of this publication.

HYLOZOIC SOIL
(IN)POSICIÓN DINÁMICA, FESTIVAL DE MEXICO
Laboratorio Arte Alameda/Ars Electronica México, Mexico City, Mexico, 2010

Collaborator
Rob Gorbet

PBAI Core Team
Hayley Isaacs Design Codirector
Jonathan Tyrrell Design Codirector
Eric Bury
Carlo Luigi Pasini
Federica Pianta
Adam Schwartzentruber

Gorbet Laboratory
Brandon DeHart
Andre Hladio

Avatar / Flint Laboratory
Rachel Armstrong
Martin Hanczyc

Fabrication
Andrew Kmiecik
Jad Knayzeh
Katherine Kovalcik
Matthew Lawson
Sophia Radev
Arezoo Tirdad
Andreea Toca

Laboratorio Arte Alameda
Tania Aedo
Ingrid Carraro
Montserrat Castañon
Mariana Delgado
Karla Jasso
Ana Sol

Installation
Sergio Arroyo
Fabiola Aviña
Domenico Capello
Sophie De Saint Phalle
Arturo González
Jordi Graullera
Santiago Itzcoatl
Silvia Piñera
Erika Simancas

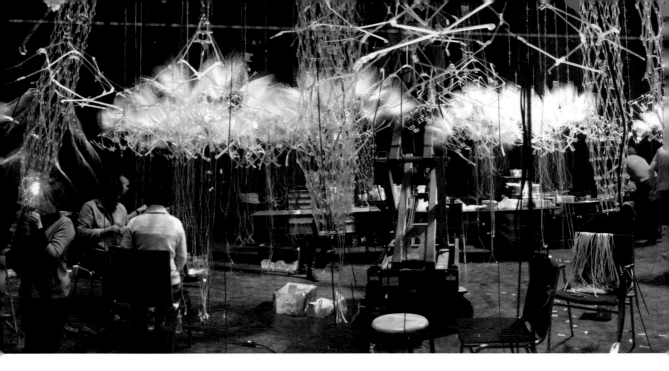

HYLOZOIC SOIL: MEDUSE FIELD
MOIS-MULTI FESTIVAL
Meduse, Quebec City, Quebec, 2010

Collaborators
Rob Gorbet
Émile Morin
Mathieu Thébaudeau
Pieter Coussement

PBAI Core Team
Eric Bury Design Director
Hayley Isaacs
Carlo Luigi Pasini
Robin Paxton
Federica Pianta
Adam Schwartzentruber
Jonathan Tyrrell

Gorbet Laboratory
Brandon DeHart
Andre Hladio

Avatar / Flint Laboratory
Rachel Armstrong
Martin Hanczyc

Fabrication
Andrew Kmiecik
Jad Knayzeh
Matthew Lawson
Michaela Macleod
Sophia Radev
Poonam Sharma
Jennifer Tu-Anh Phan
Ivan Vasyliv

Installation
Charles Bélanger
Lea Bellefeuille-Cossette
Alexandre Berthier
Aline Bertrand
Anne-Marie Bouchard

Marjorie Bradley Vidal
Simon Carpentier
Luce Chamard
Emmanuella Champagne
Nathalie Côté
Cynthia Coulombe
Gulnara Cucota
Jean Daniel
Sarah Darveau
Catherine Desautels
Marie-Christine Desbiens
Alexis Desgagnés
Jean François Dion
William Dion
Rachel Dubuc
Juli Dutil
Lucille Fréchet Martin
Pierre-Olivier Fréchet-Martin
Cecilia Fuentes
Amandine Gauthier
Gaëtan Gosselin
Laurie Gosselin
Élodie Gros
Alexandre Guérin

Sebastian Hudon
Stephane Lacam-Gutareu
Sandrine Lambert
Carl Lampron
Mériol Lhemann
Carmen Malena
Hugo Nadeau
Gabrielle Noël-Bégin
Laurent Pagano
Deni Pelaez
Maël Pinard
Ariane Plante
Lynn Pook
Krista Poulton
Marie Rioux
Josiane Roberge
Claudia Rodrigue
Jonatha Roy
Mathieu Samson
Guillaume Tardif
Loriane Thibodeau
Brigitte Violette

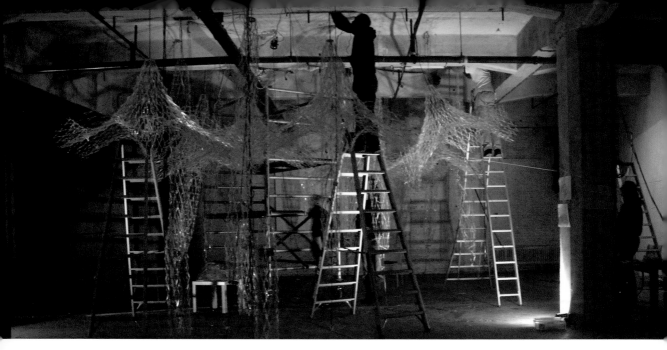

HYLOZOIC SOIL
MEDIALAB ENSCHEDE
Enschede, Netherlands, 2009

Collaborator
Rob Gorbet

PBAI Core Team
Manuel Kretzer Design Director
Eric Bury
Hayley Isaacs
Elie Nehme

Medialab
Wilja Jurg
Anita Koster
Ella Buzo

Installation
Guusje Beeftink
Sandra Chudoba
Wouter Ebbers
Jeannette Hoogenboom
Samal Isidoor
Jaqueline Kommers
Marcel Langeveld
Jan Merlin Marski
T. Miltenburg
Dashad D. Mohammed
Anita Mulder
Iris Aylin Poell
George Poulopoulos
Rizgar Salih
Tom Teggeler
Hendrika Uisser

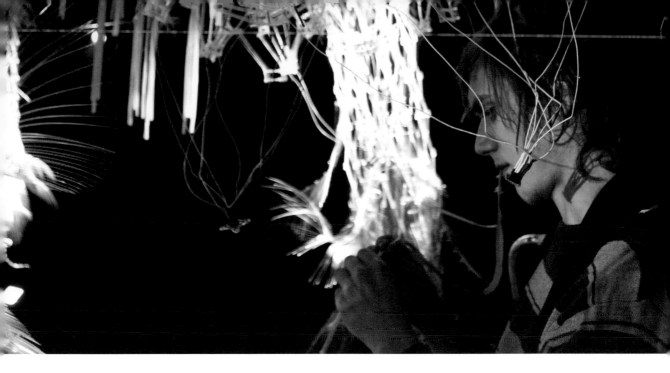

HYLOZOIC SOIL
BIOLOGICART EXHIBITION
Siggraph, New Orleans, Louisiana, 2009

Collaborator
Rob Gorbet

PBAI Core Team
Manuel Kretzer Design Director
Elie Nehme
Eric Bury
Adam Schwartzentruber
Hayley Isaacs

with
Andrew Kmiecik
Andrew Edmundson
Kunaal Mohan
Julia Padvoiskis
Matt Schmidt

Fabrication
Cristina Badescu
Stephanie Boutari
Sung-hyun Cho
Stacie Drost
Erin Finley
Gordon Hunt
Olivia Keung
Serena Lee
Andrea Ling
Carlo Luigi Pasini
Simeon Rivier
Jonathan Schnurre
Bryce Schubert
Poonam Sharma
Danny Tseng
Ivan Vasyliv

Installation Coordinator
Benny Garcia

Installation
Kjelle Apers
Nathaniel Bostic
Beau Brokop
Justine Carey
Cristian Caroli
Lais Célem
Phoebe Y. Coleman
Kavshik Das
Audel Dugarte
Jose Dunig
Bruno Evongelista
Alfanso Fargan
Gomez Fernandez
Pedro Fernando
Mariana Garcia
Elke Haha
Way Ilen

Prajay J Kamay
Lauren Kvalheim
Juan Long
Jose Martero
Estefania Martinez
Aron Notestine
Paola E Paolino
Luke Plikaitis
Reinaldo Rivera
Gabriel Rodriguez
Julian Rojas
Andy Roudubush
Lauren Rutledge
Shad Self
Daniel Sequeira
Sarah Spofford
Noelle Stransky
Nicole Sultanum
Robert Turner
Jef-Aram Van Gorp
Hayes Weggeman
Luis Zambrano

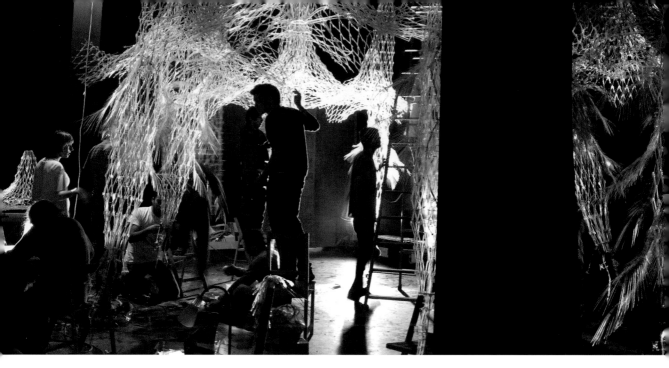

HYLOZOIC SOIL
VIDA 11.0
Matadero, Madrid, Spain, 2009

Collaborator

Rob Gorbet

PBAI Core Team

Hayley Isaacs Design Director
Eric Bury
Manuel Kretzer
Yoshikatsu Wachi

with
David Blackmore
Jane Wong

Fabrication

Maria Alexandrescu
Michael Bootsma
Lisa Hirmer
Susan Ibrahim
Christina Kalt
Farah Kathrada
Skanda Lin
Kuni Mohan
Ping Pai
Dusty Parkes
Simeon Rivier
Saeran Vasanthalsumar

Installation

Javier Alonso Cavanillas
Alvaro Basagoiti Pla-Font
Juan De la Cruz
 Cabrera Arevalo
Carlos Del Solar Valder
Maria Gomez Alabav
Dario Gonzalez
Joaquin Jalvo
Christina Marino Angoso
Daniel Martin Corona
Samuel Nieto Mana
Estefania Ocampos Fernandez
Andres Pachon Arrones
Santiago Pordomingo Castro
David Roldan Sienra
Antonio Romero Garcia
Elvira Saldana Alonso

Guillermo Diego Salvador
Luismi Torres
Alberto Vidal
Mario Vila Quelle

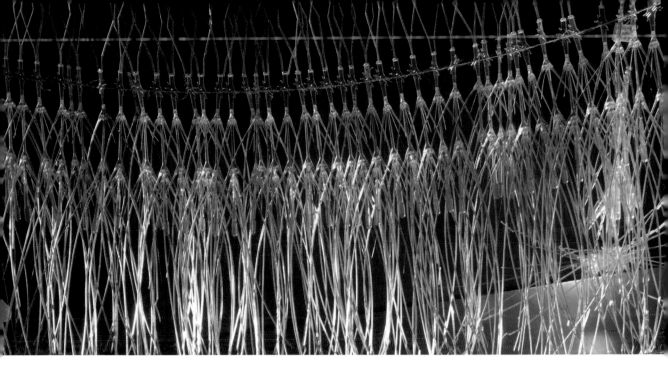

HYLOZOIC GROVE
Museum of the Future, Ars Electronica, Linz, Austria, 2008

Collaborator
Rob Gorbet

PBAI Core Team
Hayley Isaacs Design Director
Manuel Kretzer
Yoshikatsu Wachi
Eric Bury

Installation
Ricardo Nascimento
Johannes Ransl
Ulrich Reiterer
Antoine Turillon

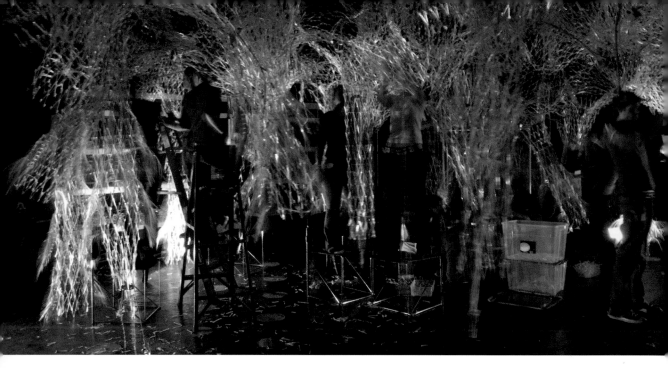

HYLOZOIC SOIL
E-ART: COMMUNICATING VESSELS
Montreal Museum of Fine Arts, Montreal, Quebec City, 2007

Collaborator
Rob Gorbet

PBAI Core Team
Hayley Isaacs Design Director
Christian Joakim
Jonah Humphrey
Kirsten Robinson
Eric Bury
Jon Cummings

with
William Elsworthy
Jonathan Tyrrell
Lawrence Chan
Charisma Panchapakesan

Fabrication
Kyle Anderson
Lauren Barhydt
Adam Bellavance
Erik Boyko
Kate Bowman
Liana Bresler
Tammy Chau
Emily Cheung
Melodie Coneybeare
Jenia Faibusovitch
Hai Ho
Sean Irwin
Alexandra Juzkiw
Laura Knap
Richard Lam
Andrea Ling
Sarah Moses

Sarah Neault
Aaron Nelson
Steph Neufeld
Juhee Oh
Desmond Shum
Catia da Silva
Court Sin
Somya Singh
BJ Smith
Laryssa Spolsky
Susan Tang
Maneu Tataryn
Lubos Trcka
John Wong
Rufina Wu

Installation Coordinators
Brady DelRosario
Lia Maston

Installation
David Blackmore
Olivier Boucher
Justine Chibuk
Aline Daenzer
Claire Dagenais
Chloe Doesburg
Jenia Faibusovitch
Stephanie Geracitano
Hai Ho
Andrea Kuchembuck
Olivier Lajeunesse
François Leblanc
Alejandro Jose Lopez

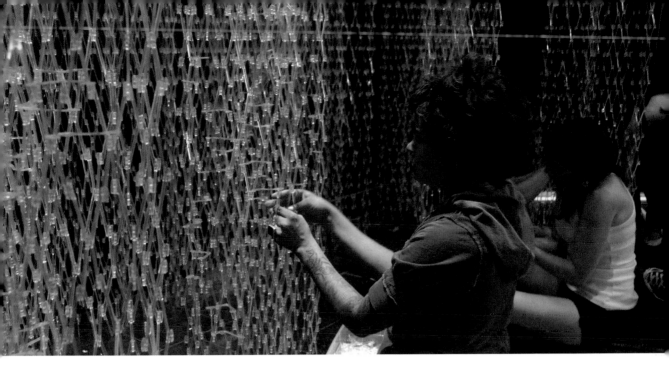

Laurie MacInroy

John Naccarato

Alison Slack

B.J. Smith

Janet Wickland

Rami Abou-Khalil

Marie-Gil Blanchette

Diana Chaumontet

Robert Chirila

Rowan Doyle

Jillian Fernandes

Gabriel Friedman

Keenan Goddard-Donovan

Hiram Gutierrez

Yasmine Hazen

Cindy Heppell

Eglantine Herban

Natalie Heroux

Carmen Holmes

Stewart Jackson

Olivier Jacques

Samuel Jacques

Sharon Lee

Tina Lee

Sara Maston

Imogen Mercer

Veronique Meunier

Stephania Minotti

Peter Moses

Sarah Moses

Viet An Nguyen

Anne Noël

Dino Papaconstantinou

Marie Papazoglau

Lydia Picombe

Ayesha Qaisar

Casey Robinson

Thomas Rowlinson

Robbie Scarborough

Clara Shipman

Sanaz Shrshekar

Shereen Soliman

Luciano Stella

Jake Stoker

Nelson Ta

Andrea Toop

Marilyne Tovar

Melissa Tovar

Alice Trudelle

Genevieve Vaillancourt

Terrence Vun

Image Credits

Biographies

PHILIP BEESLEY

Philip Beesley is principal of the Toronto practice PBAI and associate professor at the School of Architecture, University of Waterloo. Beesley's current work includes immersive digitally fabricated lightweight textile structures. The most recent generations of his work feature interactive kinetic systems that use dense arrays of microprocessors, sensors, and actuator systems. These environments pursue distributed emotional consciousness, combining synthetic and living systems.

Beesley's work has been widely published and exhibited. Distinctions include 2008 FEIDAD Design Merit award and the prestigious *Primer Premio* at the VIDA 11.0 competition in 2009, and the Prix de Rome in Architecture for Canada. He is a director of the ACADIA society and is an examiner for University College London. He has been a member of art collaboratives including Open Series, Studio Six, Free International University, George Meteskey Ensemble, and founding stages of the ANNPAC gallery network. He was previously associate at A. J. Diamond, Donald Schmitt and Company, and a partner at Dunker Beesley Vorster Architects. He was educated in visual art at Queen's University, in technology at Humber College, and in architecture at the University of Toronto.

ROB GORBET

Primary collaborator Dr. Rob Gorbet is Associate Professor at the Centre for Knowledge Integration and is affiliated with the Department of Electrical and Computer Engineering, University of Waterloo. He is a principal at Gorbet Design, a Toronto-based design and consultancy firm specializing in public interactive artwork and experiences. His interdisciplinary expertise includes mechatronics, advanced technology, and visual art. Gorbet is an award-winning teacher, interested in the design of interactive artworks and the process of learning across disciplines. His current engineering research focuses on modelling and control of actuators made of shape memory alloys (SMA), and the specialized development of a new generation of sensing and actuation systems emphasizing tune and subtle, empathy-connoting motion. Gorbet's collaborative interactive artworks have been exhibited across Europe and North America, including at ISEA 2006 in San Jose, the Matadero Madrid, the Ars Electronica Centre in Linz, and the Musée des Beaux-Arts in Montreal. His works have won several awards, including a 2008 FEIDAD Design Merit award and the prestigious *Primer Premio* at the VIDA 11.0 competition in 2009. They have been featured in major print media including *Wired Magazine*, *Domus*, *Leonardo*, and on the Discovery Channel's *Daily Planet*.

RACHEL ARMSTRONG

Dr. Rachel Armstrong is an interdisciplinary practitioner with a background in medicine who has collaborated extensively with artists, scientists, and architects in creating a new experimental space to explore scientific concepts and re-engage with the fundamental creativity of science. She regards the discipline of architecture as holding a unique place in the cultural imagination, being simultaneously iconic and personal, which offers an ideal forum to engage with and re-imagine our experience of the world so that we can reinvent our role within it. Her research investigates a new approach to building materials called 'living architecture,' that suggests it is possible for our buildings to share some of the properties of living systems. Armstrong is Co-Director of AVATAR (Advanced Virtual And Technological Architectural Research) in Architecture & Synthetic Biology at The Bartlett School of Architecture, University College London Senior TED Fellow, and Visiting Research Assistant at the Center for Fundamental Living Technology, Department of Physics and Chemistry, University of Southern Denmark. She is also a member of the RESCUE task force (Responses to Environmental and Societal Challenges for our Unstable Earth) that provides transdisciplinary strategic science advice and approaches for global sustainable development and governance.

MICHELLE ADDINGTON

Dr. Michelle Addington, Professor of Architecture at the Yale School of Architecture, is educated as both an architect and engineer. Her teaching and research explore energy systems, advanced materials and new technologies. Building on her dissertation research, which focused on discrete control of boundary layer heat transfer using micro-machines, she has extended her work into defining the strategic relationships between the differing scales of energy phenomena, and the possible actions from the domain of building construction. Her articles and chapters on energy, system design, HVAC, lighting, and advanced materials have appeared in several journals, books, and reference volumes; she recently co-authored a book, Smart Materials and Technologies for Architecture. Addington also taught at Harvard University for ten years. Before studying architecture, she began her career as an engineer with NASA, and she was an engineer and manager with DuPont for ten years. She received her D.Des. and M.Des.S. from Harvard University, B.Arch. from Temple University, and BSME from Tulane University. In 2009, Architect magazine selected her as one of the top ten Architecture faculty in the United States.

WILLIAM ELSWORTHY

William Elsworthy has been working at Teeple Architects in Toronto since 2006, and has contributed significantly to such projects as the Perimeter Institute for Theoretic Physics Expansion, Waterloo; 60 Richmond East Housing Co-op, Toronto; the Scarborough Chinese Baptist Church, Toronto; and the Langara College Student Union, Vancouver. He has collaborated with Philip Beesley on several sculptures and installations including *Hylozoic Soil*, *Implant Matrix*, *Cybele*, and *Orpheus Filter*. Elsworthy graduated from the University of Waterloo School of Architecture, Cambridge, Canada, in 2005. He is also a co-founder of Elsworthy Wang, a collaborative that engages in speculative projects, architecture, fibre art, and installations, among other dynamic practices of making.

JONAH HUMPHREY

Jonah Humphrey is an avid communicator of architectural concepts and spatial experience, working in various design visualization media. He received his M.Arch. from the University of Waterloo School of Architecture in Cambridge, Canada. His pursuits in research and design are supported by an integration of architecture, landscape design, photography, animation, video, and music composition. Both Humphrey's graduate work and his collaboration on the Hylozoic Soil work exemplify his main pursuit, envisioning architecture as a creative and responsive interface acting between ourselves, our technologies, and the natural environment. His work pursues implementation of adaptive technologies within the built environment, in order to promote understanding, visualization, and transformation of the natural world. He is further intrigued by the experiential and atmospheric qualities that emerge through layering the various virtual, imaginary, and physical spaces in which we are immersed. Ongoing research in the areas of architectural aesthetics and perception have led to international travel including time in Canada, the United States, Europe, Taiwan, and Australia. Jonah currently lives and works in Toronto, Canada.

HAYLEY ISAACS

Hayley Isaacs is a professional visual artist and architect, specializing in time-based new media installations. She is an award-winning graduate of the Masters program at the University of Waterloo School of Architecture. Isaacs has worked at several architecture firms in Canada, the United States, and abroad as a graphic artist and architectural designer. Isaacs has been a member of the PBAI collective working with Philip Beesley since 2007. She has been heavily involved in the design of interactive sculptures and architecturally-scaled installations, including the first prize–winning VIDA installation *Hylozoic Soil*, which has been exhibited in Austria, Madrid, Mexico City, and Montreal; and *Endothelium*, exhibited at the California NanoSystems Institute in November, 2008. Isaacs is currently design director for the Hylozoic Ground project. Isaacs is also the general manager of Riverside Architectural Press (RAP), supervising production and dissemination of design and research publications. She was artistic director and graphic artist for three of RAP's newest publications, *Ourtopias*, *Maison Solaire*, and *North House*.

CHRISTIAN JOAKIM

Christian Joakim currently works for Teeple Architects in Toronto. He has worked with dECOi, a digitally-based architecture practice lead by Mark Goulthorpe in Boston; Delugan Meissl Associated Architects in Vienna; Asymptote Architecture in New York; and Philip Beesley Architect Inc. in Toronto. Christian Joakim holds a B.A.Sc in Mechanical Engineering and a M.Arch., both from the University of Toronto. He is also a LEED Accredited Professional.

Joakim is a founding member of kimiis, a constellation of architects and engineers fully immersed in the digital praxis of architecture. The work of kimiis oscillates between composition and computation, in the pursuit of dynamic architectures and new patterns of creativity. Work by kimiis has been exhibited at *Nuit Blanche* 2009, the University of Toronto, and on the progressive design website suckerPUNCH. Kimiis also published work as part of the 2008 ACADIA Conference "Silicon + Skin: Biological Processes and Computation." Most recently, kimiis partnered with the computing firm Interaxon to design part of the installation space for the Ontario House technological exhibition at the 2010 Vancouver Winter Olympic Games.

GEOFF MANAUGH

Geoff Manaugh is the author of BLDGBLOG (http://bldgblog. blogspot.com) and *The BLDGBLOG Book*, former senior editor of *Dwell* magazine, and a contributing editor at *Wired* UK. In addition to lecturing on a broad range of architectural topics at schools and museums around the world, from Turin to

Melbourne, he has taught design studios at Columbia University, the Pratt Institute, and the University of Technology, Sydney. Manaugh has organized events at the Architectural Association, the Chicago Humanities Festival, the California College of the Arts, and many others, and he continues to write freelance articles for publications such as *GOOD*, *Icon*, and *Volume*, as well as many online publications. In spring 2010, he co-curated (with Nicola Twilley) the exhibition *Landscapes of Quarantine*, an *ARTFORUM* Editor's Pick, at Storefront for Art and Architecture; and in autumn 2011 his solo-curated show *Landscape Futures* will open at the Nevada Museum of Art. He lives in Los Angeles.

PERNILLA OHRSTEDT

Pernilla Ohrstedt is a London-based architect. She received her M.Arch. from the Bartlett School of Architecture, University College London. From 2007—2008, Ohrstedt was the producer of Storefront for Art and Architecture, New York, where she was in charge of the conceptualization, design and production of exhibitions, installations, and events, as well as being extensively involved in programming and curatorial work. Ohrstedt was co-originator (with Joseph Grima) of Storefront's first exhibitions program outside New York, the Storefront Pop-Up series, conceived to open dialogue with cities and institutions around the world. She has worked in several architecture practices, most notably Future Systems in London, founded by Czech architects Jan Kaplicky and Amanda Levete.

Ohrstedt's academic work has been recognized with several awards and prizes, including the Leverhulme Trust Grant for Innovative and Interdisciplinary Work of Outstanding Potential. Her dissertation "In Between Before and After—Exploring the Commodification of the Ideal" was awarded with the University College London prize for distinguished work in history and theory. She was awarded commendation for both her design and thesis work, which explore the notion of a 'hypervisceral' architecture, in the realm of the *Eros* statue on Piccadilly Circus in London.

NEIL SPILLER

Neil Spiller is Professor of Architecture and Digital Theory at the Bartlett School of Architecture, University College, London, and a practising architect. He is the Graduate Director of Design, Director of the Advanced Virtual and Technological Architecture Research Group (AVATAR), and Vice Dean at the Bartlett. He

was the 2002 John and Magda McHale Research Fellow at the State University of New York at Buffalo. Spiller is a highly recognized editor and author. He was one of ten international critics featured in Phaidon's *10x10* and the editor of *Cyber Reader*. He has edited several AD Magazine issues, and his "Spiller's Bits" appear in every AD issue. He is co-editor with Peter Cook of *The Power of Contemporary Architecture* (1999) and *The Paradox of Contemporary Architecture* (2001). Publications authored by Spiller include *Digital Dreams—Architecture and the New Alchemic Technologies* (1998), the monograph *Maverick Deviations* (2000), *Lost Architecture* (2001), *Visionary Architecture—Blueprints of the Modern Imagination* (2006), and *Digital Architecture NOW* (2008). For the last ten years, Spiller has been working on a major theoretical project entitled "Communicating Vessels." The project seeks to create new relationships between architecture, landscape, space, time, duration, and geography. Spiller lectures around the world and his work has been exhibited and published worldwide.

CARY WOLFE

Cary Wolfe is Bruce and Elizabeth Dunlevie Professor of English at Rice University. He holds a particular interest in animal studies and the intellectual, ethical, and political challenges posed by non-human subjectivity, systems theory, deconstruction, pragmatism, and posthumanism. Over the past two decades, he has published widely on critical theory, American culture and literature, and the arts in venues such as *Boundary 2, Diacritics, New Literary History, Cultural Critique, American Literature, Postmodern Culture*, and *New German Critique*. His books and edited collections include *Critical Environments: Postmodern Theory and the Pragmatics of the "Outside"* (1998); *Animal Rites: American Culture, The Discourse of Species, and Posthumanist Theory* (2003); *Zoontologies: The Question of the Animal* (2003); and most recently, *What Is Posthumanism?* (2010). His co-edited collection (with Branka Arsic), *The Other Emerson*, will be appearing in 2010. He is founding editor of the series *Posthumanities* at the University of Minnesota Press, and has delivered numerous lectures, keynote addresses, plenary talks, and seminars in North America and abroad, at venues such as the Museum of Modern Art in New York, the Rothermere American Institute at Oxford University, the Forum for European Philosophy at the London School of Economics, and the Amsterdam School for Cultural Analysis.

Funding and Sponsors

 Conseil des Arts du Canada · Canada Council for the Arts

ARCHITECTURE CANADA
Royal Architectural Institute of Canada

 National Gallery of Canada · Musée des beaux-arts du Canada

UNIVERSITY OF Waterloo

 UCL

 SYDDANSK UNIVERSITET

 DX

 Istituto Italiano di Cultura

NSERC CRSNG

Social Sciences and Humanities Research Council of Canada

ONTARIO ARTS COUNCIL
CONSEIL DES ARTS DE L'ONTARIO

MITACS

TORONTO ARTS COUNCIL

L.A. INC.

aeroplan

Buro Happold

EXPLORA BIOTECH
pioneering nature

AZURE

Hylozoic Ground is presented in the Canada Pavilion at the 12th International Architecture Exhibition, la Biennale di Venezia with the support of: Canada Council for the Arts, Royal Architectural Institute of Canada, National Gallery of Canada and Embassy of Canada to Italy.

institutional partners

University of Waterloo
University College London
Syddansk Universitet
Design Exchange
Italian Cultural Institute

public funding

Natural Sciences and Engineering Research Council
Social Sciences and Humanities Research Council
Ontario Arts Council
Mathematics of Information Technology and
 Complex Systems
Toronto Arts Council

silver sponsor

L.A. Inc.

bronze sponsors

Aeroplan
Buro Happold
The Cronin Group
Explora Biotech Srl

donors

Modern Device
Margaret and Jim Fleck
Phyllis Lambert
European Centre for Living Technology
Uformia

friends

Sascha Hastings & Cathi Bond
Leslie M. Klein, Quadrangle Architects Ltd.
Ralph Wiesbrock, KWC Arch. Inc.
Ottawa Regional Society of Architects
Reich + Petch Architects Inc.
Anonymous

media sponsor

Azure